REMARKABLE
RUGBY
GROUNDS

Pavilion
An imprint of HarperCollins*Publishers* Ltd
1 London Bridge Street
London SE1 9GF

www.harpercollins.co.uk

HarperCollins*Publishers*
Macken House
39/40 Mayor Street Upper,
Dublin, D01 C9WB
Ireland

10 9 8 7 6 5 4 3 2 1

First published in Great Britain by
Pavilion, an imprint of HarperCollins*Publishers* Ltd
2023

Copyright © 2023

ISBN 978-0-00856212-0

This book is produced from independently certified
FSC™ paper to ensure responsible forest management.

For more information visit:
www.harpercollins.co.uk/green

Editor: Frank Hopkinson
Designer: Cara Rogers
Proof-reader: Sarah Epton

Printed and bound in China by RR Donnelly APS

Page 4/5 caption: Alaskan Mountain Rugby,
Anchorage, Alaska.

Acknowledgements
To Helen and Michael
Also, thanks to: Alex Mead, Simon Campbell and Jane
Ditcham at Rugby Journal, Tim Anger, Christian Rees,
Bernard Green, Jean McConnell, Andrew Jones, not
forgetting Miles, Leila, Mathew, Yasmin and Suri

REMARKABLE
RUGBY
GROUNDS

—— RYAN HERMAN ——

PAVILION

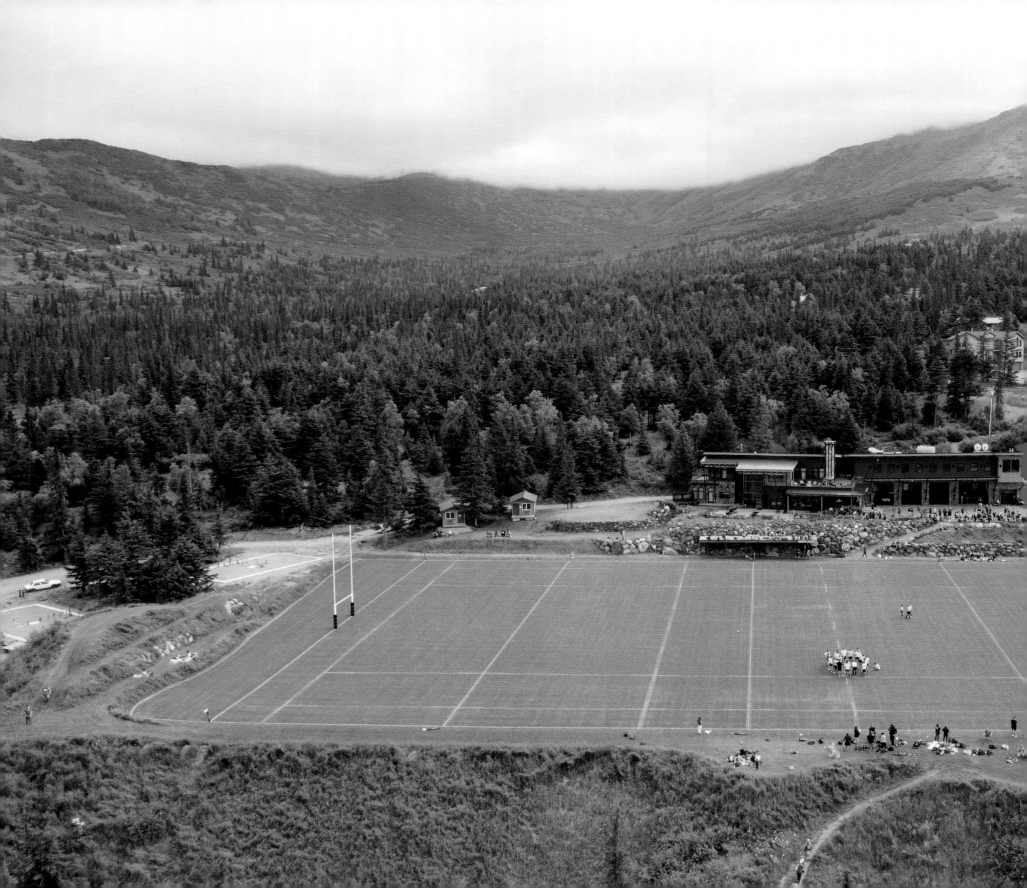

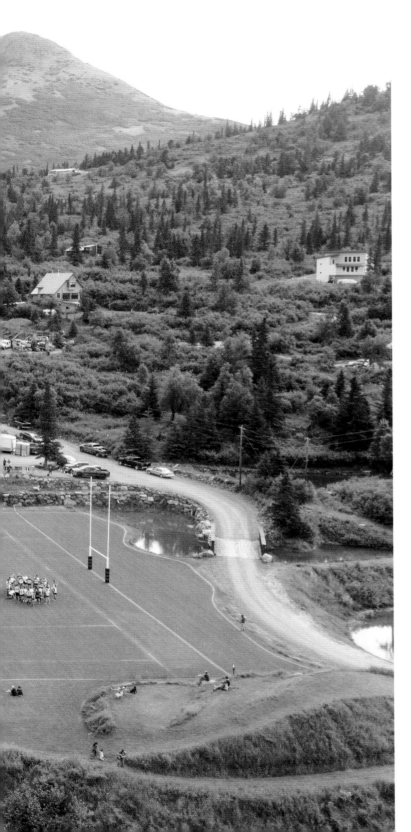

Contents

Introduction

Remarkable rugby grounds come in one basic shape but all kinds of sizes. There are the mega-stadia capable of holding 80,000, and then there are the club pitches with at most a rudimentary shelter to protect the coaching staff, and crowd capacity is how many you can squeeze onto the touchline. This book collects together some of the cathedrals of world rugby along with quirky club grounds and grassroots local pitches where there is still grass with roots. They all have something remarkable, not least the French stadium with a statue to a most remarkable rugby player, who took his own life in a Russian roulette trick that went horribly wrong...

Rugby is becoming a world sport, a fact made clear by more nations vying to enter the Rugby World Cup along with the growing interest, and regular television coverage of the women's game. There has been a notable spike in the popularity

of rugby sevens around the globe. The seven-a-side game is now established in the Olympics and has a big following in Asia. Many of the major grounds used for sevens in Asia are included, along with one in Colombo, Sri Lanka, where the groundsman must be praying for a 3G pitch – the photos of the Racecourse Ground will reveal why.

We have gathered together rugby venues as far north as Alaska, with the if-you-build-it-they-will-come Alaskan Mountain Rugby ground near Anchorage, a personal project for Justin Green that is a lodestone to touring rugby sides. Then there is the most southerly in Dunedin, New Zealand, where the great Forsyth Barr 'greenhouse' can claim to be the largest indoor stadium generating its own turf.

Cape Town, South Africa has three entries all with spectacular backdrops, but each with a different story. The University of Cape Town has some beautifully appointed pitches in front of the lofty Upper Campus; the DHL Stadium by contrast is the modern bowl down by the coast, while the fate of the Springboks' old sporting 'fortress', Newlands, awaits its fate.

There are a host of Welsh Valleys' clubs; Pontypridd, Treorchy, Porth, Cambrian Welfare and Ebbw Vale, along with Bishop's Field at Llandaff and the fading glory of St Helen's in Swansea. The ground that shares an outfield with St Helen's Cricket Club is a venue that is little changed since Wales alternated their international

TOP: The Honourable Artillery Company ground is an oasis of green close to the City of London's financial sector.

LEFT: Cambrian Welfare in South Wales play on a pitch that miners carved out of the hillside and levelled up.

OPPOSITE FAR LEFT: The Richmond Athletic Ground was home to two Championship sides in 2022-23. The club has one of the oldest pavilions still in use.

OPPOSITE RIGHT: There is no mystery in the genealogy of the sevens game. It started in Melrose, Scotland

matches with Cardiff in the 1950s, but has settled back into local club rugby after the game became professional in the 1990s.

Two classic school playing fields are amongst the English grounds. Sedbergh School in Cumbria was the place where England lock Abbie Ward learned her rugby, and Rugby School not only originated the game, the local bootmaker, with premises opposite the school, created the first four-panel rugby ball. Then there is the Richmond Athletic Ground in Surrey which has a schizophrenic existence. One week it hosts Championship side Richmond, the next week the London Scottish box office is wheeled out in front of the old pavilion and the skirl of bagpipes greets the home side taking to the pitch.

Across the channel there are many French grounds with functional 1960s concrete grandstands which come alive when their club's passionate supporters populate the stands on matchday. Béziers Hérault was that kind of ground in the 1970s when French international Armand Vaquerin was at the top of his game and the club were regularly winning the Bouclier de Brennus. Vaquerin found stepping back from the game he loved difficult and his demise shocked the French rugby world.

Few do sports stadia as well as the Aussies who have made sure their modern mega-structures are adaptable to a multitude of uses. Simply hosting rugby games is never going to be enough to justify the investment, and so the bigger the range of activities, the happier the politicians – because these days, unless you're an Arab sovereign wealth fund, inevitably it is public money that eases big projects towards completion (or more likely the starting line).

Perth has the magnificent Optus Stadium which vies with Melbourne's AAMI and Sydney's Allianz for the most spectacular arena... with the least charismatic name. (Though to put this into perspective, rugby stadiums get off lightly compared to US baseball which has Guaranteed Rate Field, LoanDepot Park and the RingCentral Coliseum).

Another remarkable stadium known by its commercial sponsor sits near the banks of the river Dodder in Dublin. Replacing the much-loved Lansdowne Road, the Aviva is a masterpiece of stadium design but the pangolin-shaped edifice cannot match the beautiful location of two club grounds on the west coast of Ireland. Sligo RFC is a strong club side playing its rugby in the shadow of Knocknarea – the mountain is a looming presence overlooking the Strandhill ground. Then there is Donegal Town RFC, located a little way from the centre of Donegal, but hard against the shoreline of Donegal Bay. It is a remarkable location for a game of rugby, as is Terrigal in New South Wales, our cover image. If you are considering a bucket list of rugby grounds to visit, you couldn't go far wrong with the collection assembled on these pages and yet we are certain there are many more still to uncover.

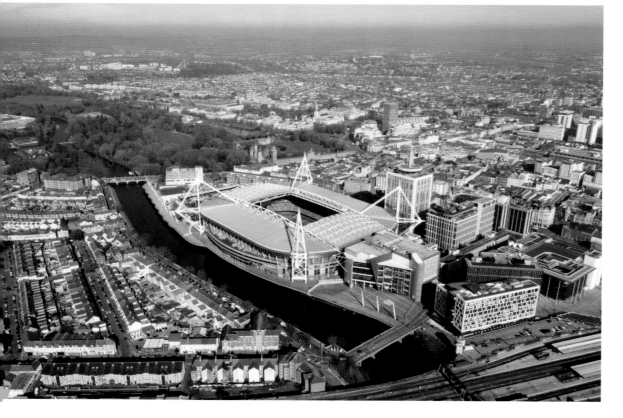

LEFT: A quarter of a century after it was opened and the Principality Stadium in Cardiff still gets many rugby fans' vote as the best all-round international stadium.

OPPOSITE: Taken on a calm day in January, this photo of Donegal Town RFC ground, The Holmes, shows why it would be almost impossible to stumble upon it by accident. And kickers must hate the prospect of a strong westerly sweeping in across Donegal Bay.

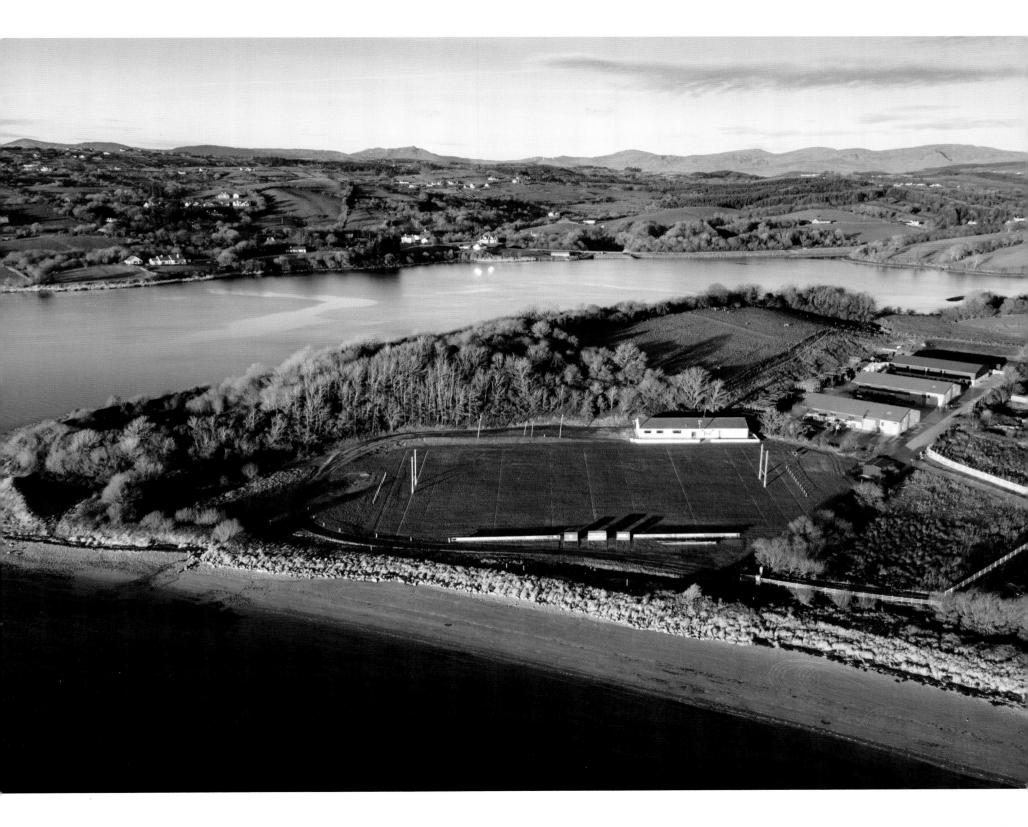

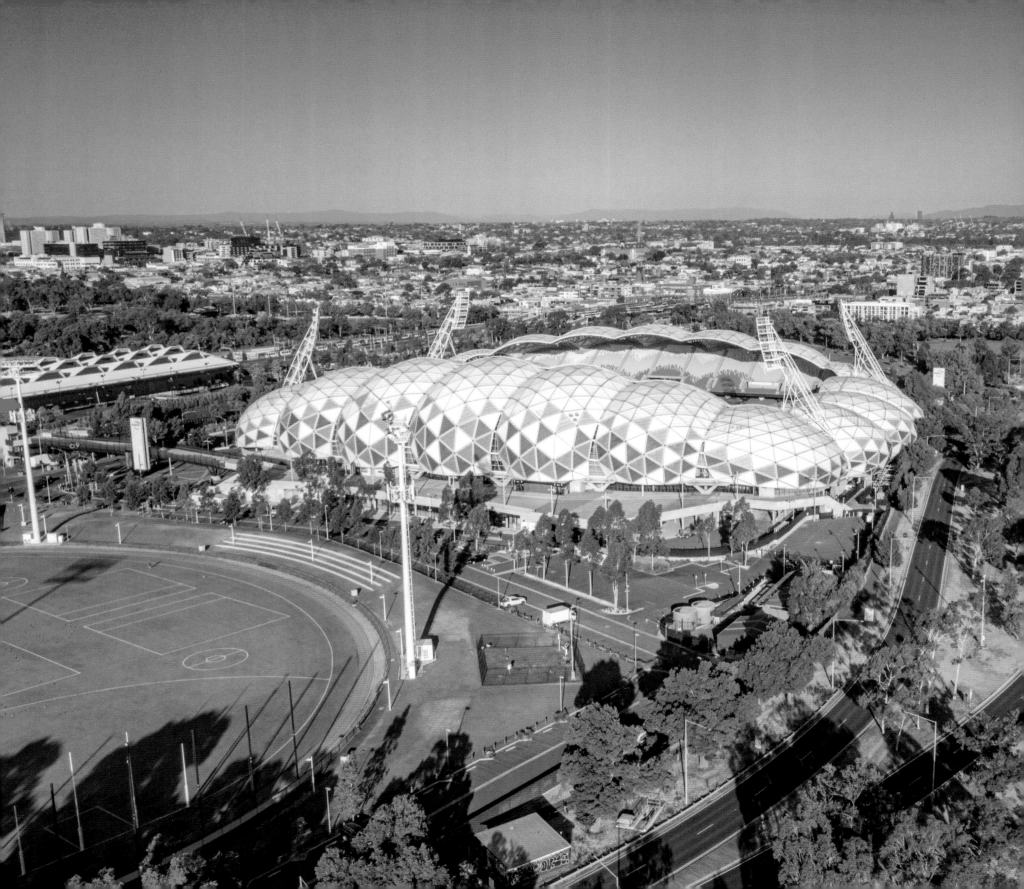

AAMI Park

Melbourne, Australia

Team: Melbourne Rebels

Sometimes the promotional blurb for a stadium can be far removed from the sports fan's experience of the venue. Take AAMI Park: 'The stadium's activated relationship to the streetscape, the civic-scaled entry stairs, and the flanking urban plazas all integrate the facility into its landscaped context, providing a strong visual connection to the city, river and parklands.'

But what supporters really want to find out is: what is the view like from my seat? Are there enough bars? Will the queues be short for the

toilets at half-time? How close is the nearest station? How much leg room is there to the seat in front?

Let's start with that roof. It is a bio-frame, inspired by the structural efficiencies of the geodesic dome, first designed by American

OPPOSITE: It started life as the 'Melbourne Rectangular Stadium', but about the only thing that's rectangular about renamed AAMI Park is the pitch.

BELOW: Anthony Bouthier of France receives the ball in the Test match between the Wallabies and France at AAMI Park in July 2021.

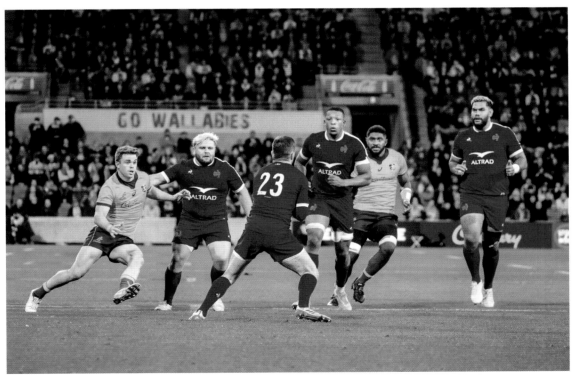

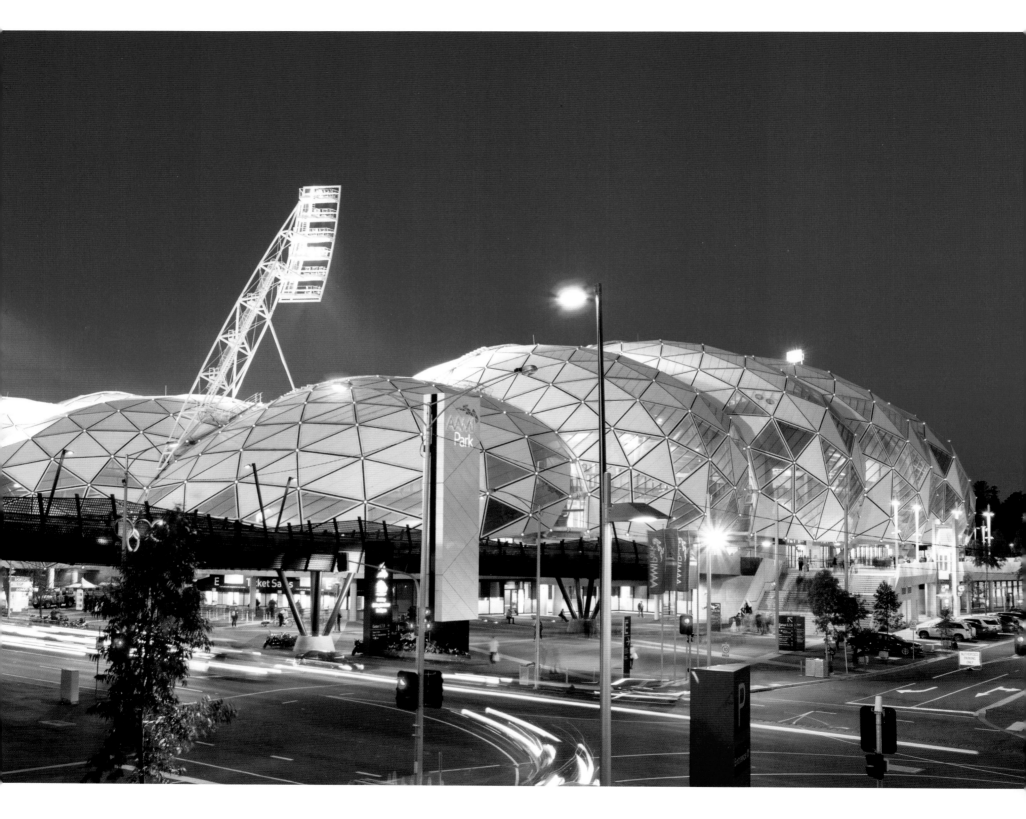

architect Buckminster Fuller. AAMI Park's dome not only stands out visually but also, according to one of its architects, Patrick Ness, 'it used 30% less steel than any other sporting stadium with the same dimensions at the time.' The design also ensures everyone has an excellent view of the action.

Having purloined the Australian Grand Prix from Adelaide, and enlarged the Melbourne Cricket Ground (MCG) to become the second largest stadium in the Southern Hemisphere, Melbourne has become Australia's leading city for sports. So, to win the contract from the local government, Ness and his colleagues at Cox Architects had to come up with a vision that could stand alongside and stand out from the city's other venues.

'It's been a very important thing to realise that every time something new happens there, it's pushed the boundaries,' Ness said, adding that when they went to see the Premier of Victoria, 'we were initially given five minutes of his time to pitch the project, but left one and a half hours later.'

Soon after it opened in 2010, Melbourne Rectangular Stadium won the award for 'the world's most iconic and culturally significant stadium', finishing ahead of 12 other grounds including Moses Mabhida in Durban. Big doesn't always mean best and, yes, there are plenty of bars and toilets, plus the ground is a two-minute walk from the nearest tram stop. So, you can excuse the architects for indulging in a bit of promotional waffle when the end product ticks all the right boxes.

OPPOSITE: AAMI Park looks even more spectacular when illuminated at night.

ABOVE RIGHT: The French and Australian teams line up for national anthems before a 2021 Test.

RIGHT: It's easy to see why Melbourne is a sports city with AAMI Park (29,500 capacity) to the left and the cavernous Melbourne Cricket Ground (100,000) to the right.

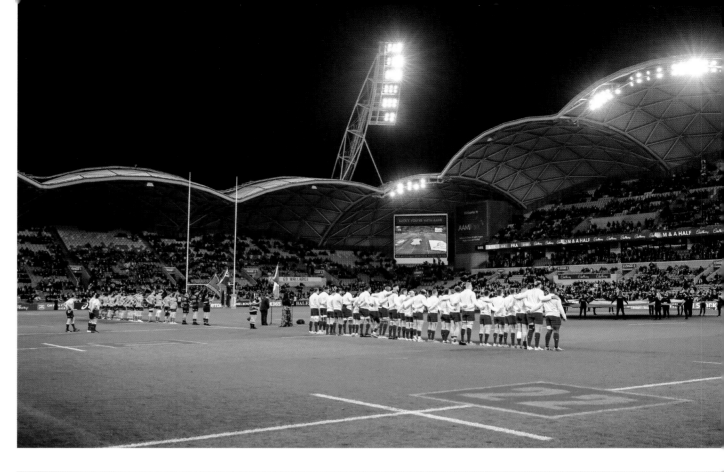

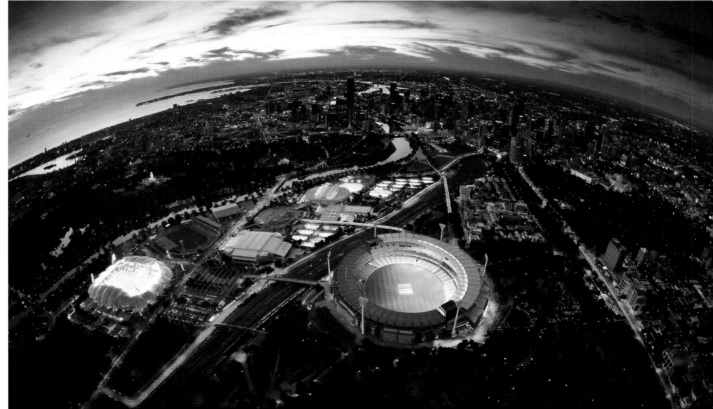

Accor Stadium

Sydney, Australia

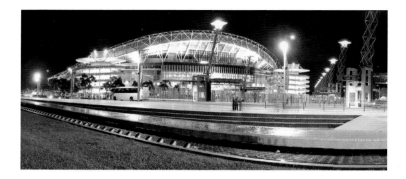

Rupert Brooke wrote: 'There is some corner of a foreign field that is forever England' and for English rugby fans, that corner is actually just outside the 22-metre line of Stadium Australia when it is configured for rugby. It is the place where Jonny Wilkinson kicked a drop goal in the final minute of extra-time to win England's first World Cup in 2003.

Stadium Australia, or to give it the full sponsorship name, Accor Stadium, can lay claim to be one of the most multi of all multi-purpose stadia anywhere on the planet. Located in the Sydney Olympic Park of Homebush it started life as the Olympic Stadium to host the Millennium games in the summer of 2000. It dwarfs its London equivalent, having been built to accommodate circa 115,000 spectators, thus making it the largest Olympic Stadium of all time. Although it has been reprofiled since, it can still hold around 82,000 as a rectangular field.

In the autumn of 2003, the stadium hosted seven matches in the 2003 Rugby World Cup, including both semi-finals and the final on 22 November, which broke Australian hearts and gave England rugby fans their own 1966 moment. Although it has no regular Super Rugby tenant, the stadium has staged games between the New South Wales Waratahs and the Canterbury Crusaders and hosted a Lions game on the 2013 British & Irish Lions tour.

As the largest-capacity stadium in Australia that can be configured for rectangular field sports, it is the home of big games, whatever the sport. Apart from rugby union it hosts the three-game State of Origin rugby league series between Queensland and New South Wales; the Socceroos play soccer here; the NFL has visited with the Broncos taking on the Chargers; a drop-in pitch and an oval outfield means it can be configured for Twenty20 cricket; Aussie Rules games are not a problem; athletics were centre stage at the Olympics; and it has even been used for Speedway.

When it comes to music concerts, the stadium's opening act was the Bee Gees in 1999; but in capacity terms nothing compares to Adele, who stole the show with 98,364 punters jamming in to see her in 2017 ... which is probably about the same amount of English fans who claim to have been in Telstra Australia when that drop goal went over.

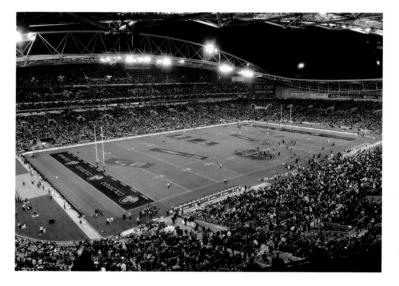

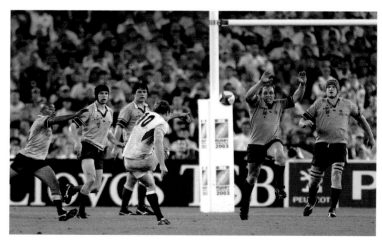

TOP RIGHT: As the former Olympic Stadium, it's a venue with good transport links.

ABOVE RIGHT: The ground set up for a State of Origin game in 2018.

RIGHT: 'That moment'. Jonny Wilkinson receives a pass from Matt Dawson and slots over the winning drop goal at what was then known as the Telstra Stadium.

OPPOSITE: An aerial view shows how the Accor Stadium sits in the former Olympic Park at Homebush. For the Games, the stands at either end were larger and uncovered. After the Games, architects were able to complete the sweeping curve.

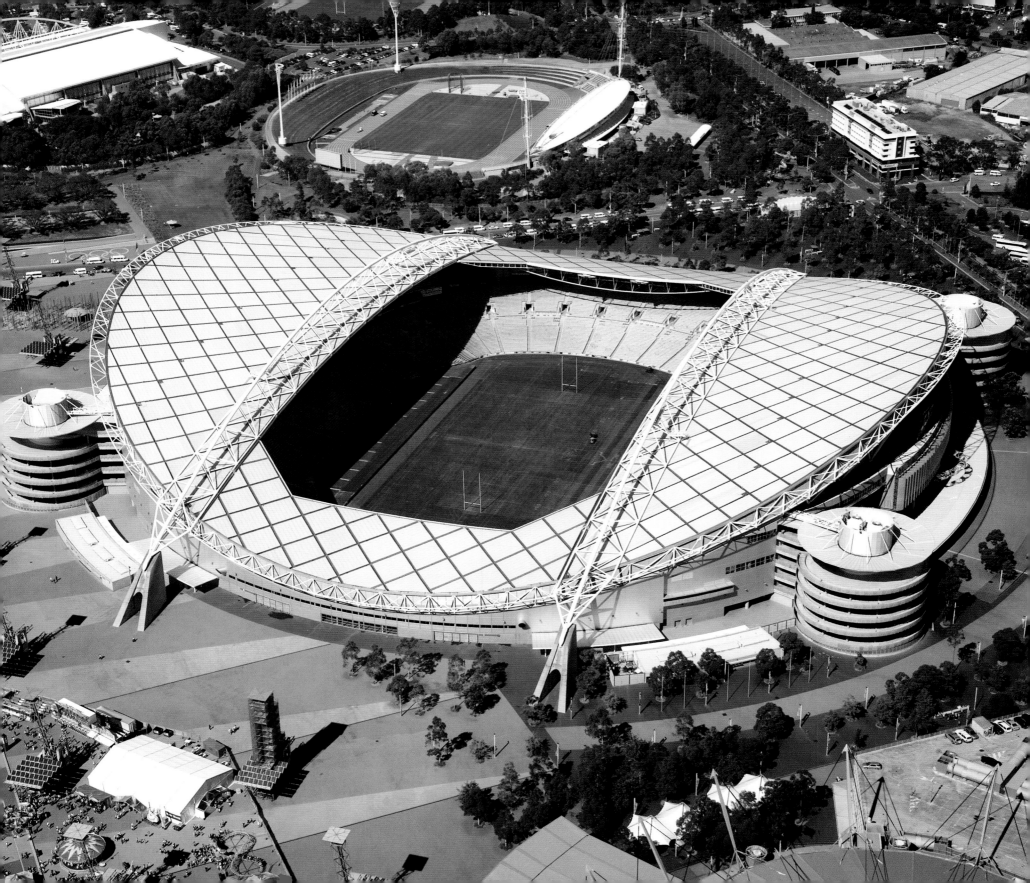

Alaskan Mountain Rugby

Anchorage, USA

Team: Alaskan Mountain Rugby

Justin Green is one of three brothers born in Anchorage, Alaska. As kids, they proved to be quite a handful. Their parents decided they needed some discipline and sent them to St Lawrence College – a boarding school in Kent, England. The head teacher of the junior school was Ian Gollop, who was also a rugby player. He decided that the best way to get them to behave was to teach the Greens how to play the game.

When they returned home, Justin joined Alaskan Mountain Rugby, a local amateur side. One night in a pub, he sketched out on a napkin his vision for what the club could be.

He bought a plot of land with a $1,000 down-payment in the mountains on the outskirts of Anchorage. The players then got together to form their own demolition company. Every scrap of spare material they could get their hands on was used to build the clubhouse and Justin's family home, along with cabins for visiting teams who come from overseas to play here.

But that wasn't all. The bridge you can see behind the posts was going to be left for scrap by the Alaskan Railroad Company. Originally, there was a 40-foot drop from one side of the pitch to the other, so Green got in touch with every contractor in the area to donate whatever dirt they had left over from construction projects to level the land. That process alone took around five years and the whole project was completed in seven years.

The playing surface is immaculate. No mean feat when you consider that for most of the year it will be covered in snow and it's not uncommon for bears or moose to stray onto the pitch. Green says that his mission was to put rugby in this part of the world on the map. In 2019, *Rugby World* magazine visited Alaskan Mountain Rugby and the story was accompanied by the headline 'Is This the Most Beautiful Ground in the World?' Mission accomplished.

OPPOSITE: Unquestionably one of the greatest arenas to play rugby, the Anchorage rugby grounds are a magnet to touring sides. Players can cool off with a dip in the pond behind the less-than-rectangular in-goal area.

LEFT: Justin Green's house is to the left; clubhouse to the right.

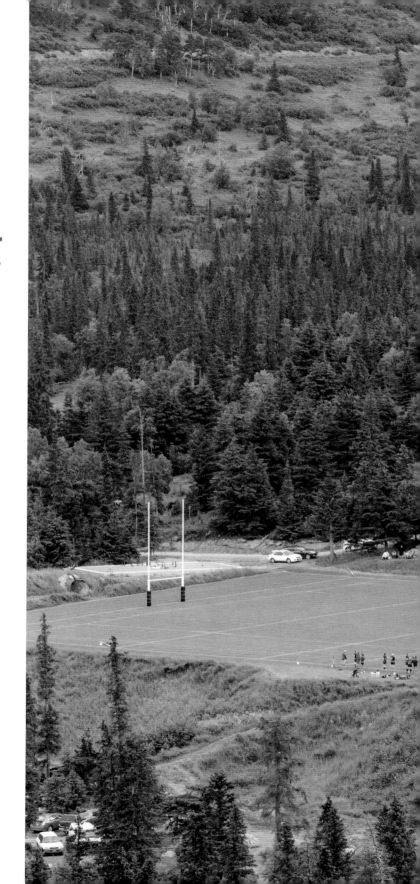

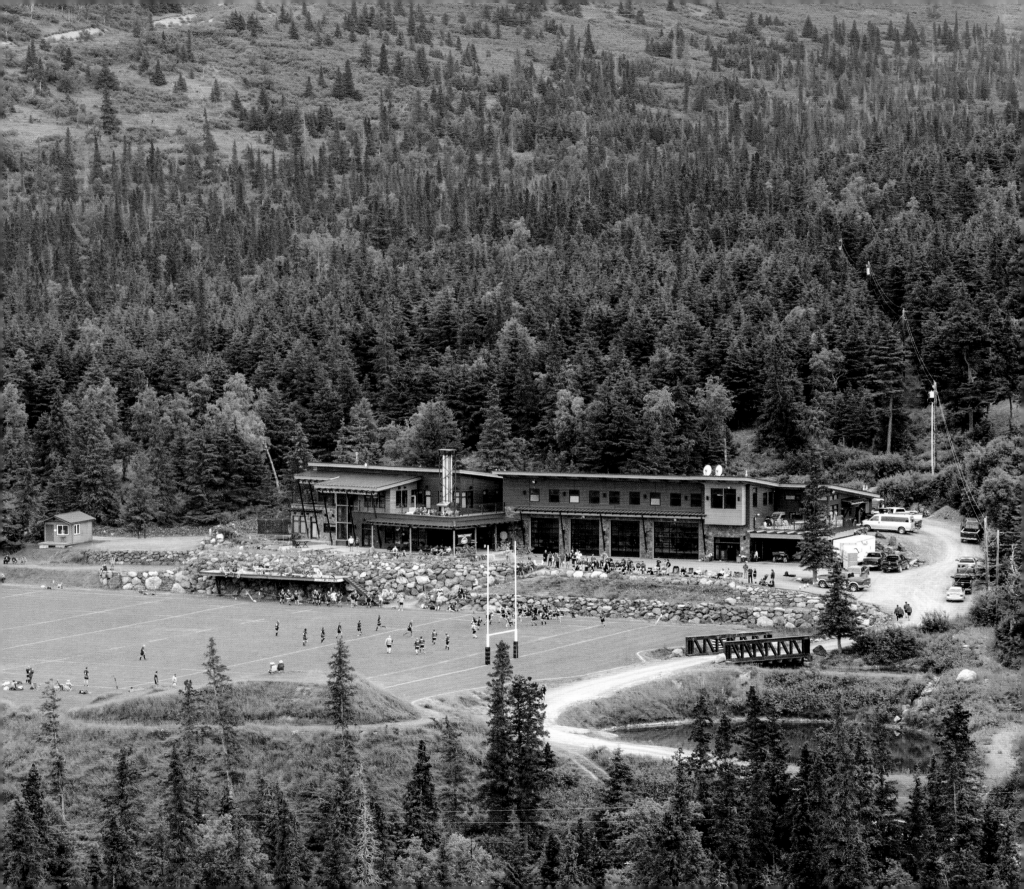

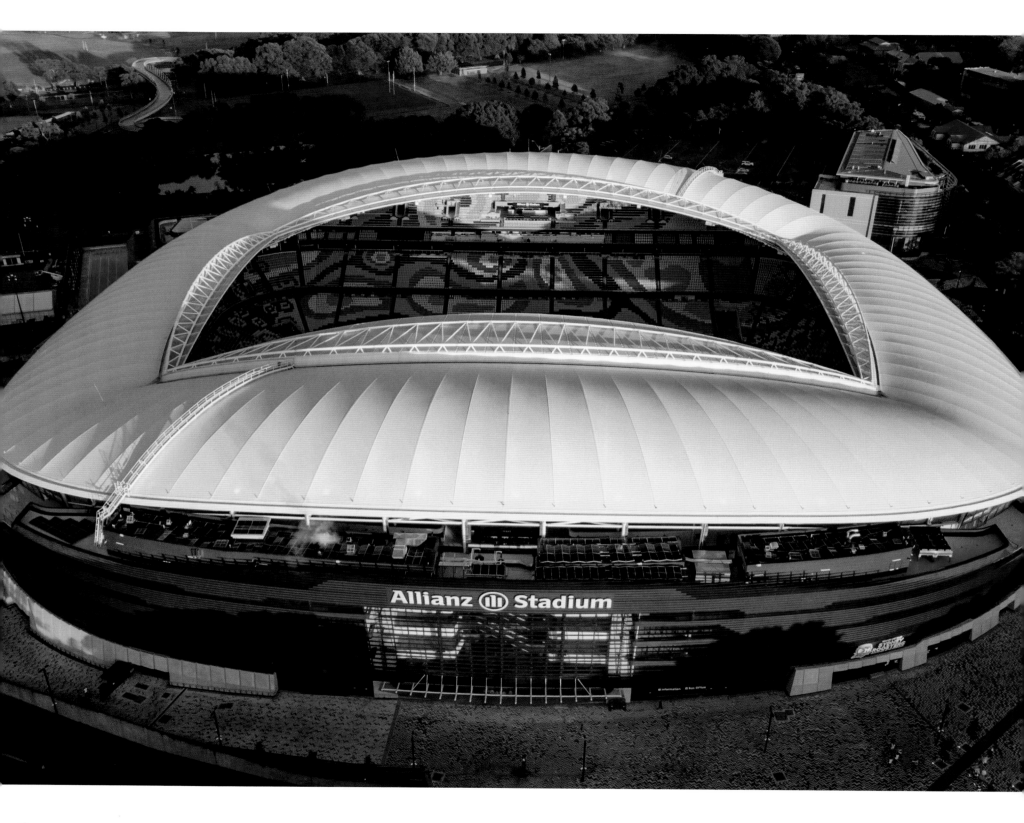

Allianz Stadium

Sydney, Australia

Team: New South Wales Waratahs

'We almost lost an election on the construction of this stadium,' said New South Wales Premier Dominic Perrottet when the Sydney Allianz Stadium finally opened in August, 2022. The old stadium, which is next door to Sydney Cricket Ground, needed a major overhaul. The original design not only made some basic errors but also failed to comply with safety standards. Too many seats weren't covered by the stadium's roof, there was an inadequate number of female toilets, and disabled access left a lot to be desired.

So, the NSW government decided to knock the ground down and start all over again, albeit employing the firm that designed the old stadium to build a new ground on the same site. Work began on Sydney Allianz Stadium in 2018, but problems for the local government began in 2019, when it was revealed that a (previously) confidential report compiled in 2016 claimed that the old ground could be upgraded to meet those safety standards for AUS $18m.

Even if those figures were out of date three years later (and they didn't account for installing a new roof), it still worked out significantly less than the cost of building a new stadium, which stood at $729m. By December 2019 the NSW government admitted the cost had risen by $99m. It prompted the opposition Labour party to go on the attack, at a time when the country was also dealing from the human and financial cost of bush fires.

The new and improved Sydney Allianz Stadium is home to several teams, including NSW Waratahs, as well as being the HQ for Rugby Australia. What the city hopes is that people will feel the stadium experience is such an improvement on the old ground that the cost becomes less of an issue. Spectators now have a roof, which means that unless you're sat in the front row, or the wind blows in your direction, you won't get soaked watching a match.

The seating pattern was designed by celebrated indigenous artist Tony Albert – one end of the stadium has a design symbolising land, the other represents water. It is intended to tell a story about place and country, and the clash of competing teams.

And the corporate lounges include The Garden, a curious idea combining fauna, a DJ, tables and chairs. It's the sort of thing that makes anyone over 60 roll their eyes, but the seats outside The Garden do provide a cracking view of the action.

OPPOSITE: New stadiums are often controversial as they involve spending public money, but the former Aussie Stadium took political wrangling to a new level.

ABOVE RIGHT: Although used for both rugby league and football, it is the Waratahs' home ground, and Rugby Australia's headquarters are located at the north end of the stadium precinct.

RIGHT: Matt Philip wins a line-out for the Wallabies as Australia take on South Africa at the Allianz in the 2022 Rugby Championship.

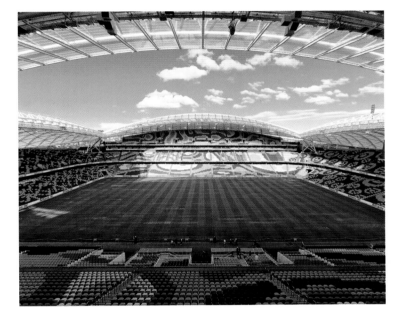

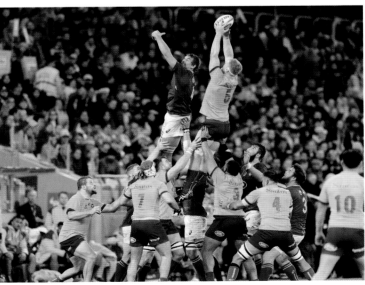

Athletic Park

Wellington, New Zealand

Team: The Hurricanes

Village at the Park is a retirement community made up of villas and serviced apartments on Rintoul Street. This was once home to Athletic Park, Wellington – one of the most remarkable grounds in the history of rugby not least because nobody nowadays would dream of building a ground in such a way.

The street was named after Robert Stephen Rintoul, the founder of the UK political magazine *The Spectator*. In 1893 a private company leased nine acres of land on Rintoul Street and put a rugby ground there.

Archive images from 1921 show how thousands of spectators would stand on two banks, one around 20 feet above the other. When it rained (and it does, on average, every other day in Wellington) spectators would slide down the top mound and crash into the people standing below. Barriers on the terrace put an end to this, but after the war there was another challenge for rugby fans.

The vertiginous Millard Stand opened in 1961. It was named after Wellington Rugby Union chairman J. N. Millard. The first match played in front of the Millard Stand makes one wonder if the architects really considered what it would be like to watch a match in such a steep and high stand completely exposed to extremes of weather. The stand began to sway while it was

LEFT: Two images of Athletic Park from the 1930s, with steep terracing that became tricky in a downpour.

BELOW: The Millard Stand, on the right, was not for the faint hearted.

OPPOSITE: Athletic Park's replacement, the Westpac Stadium, now rebadged Sky Stadium, is a spectator-friendly venue.

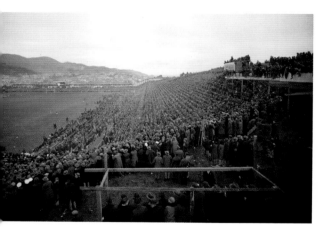

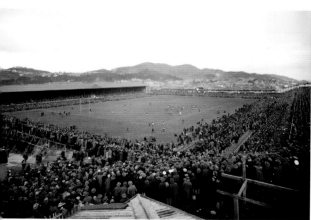

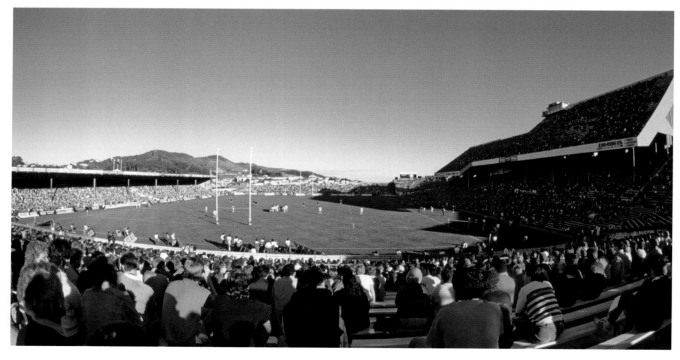

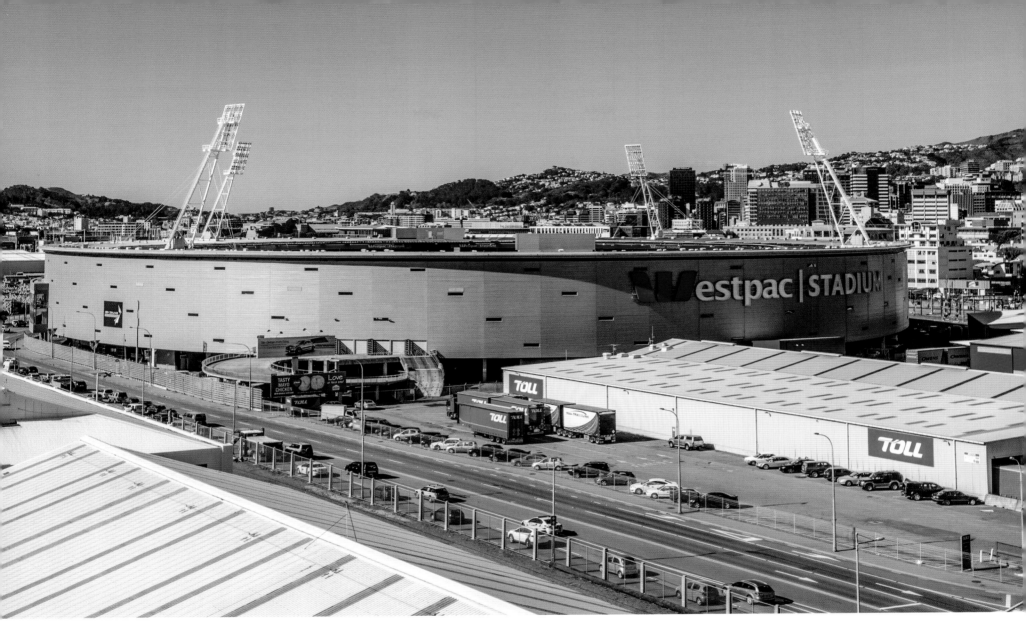

being buffeted by a hurricane, with winds getting up to around 130mph. The game between New Zealand and France became known as the Cyclone Test. Renowned French sports writer Denis Lalanne described the sight of those fans who grimly and stoically remained in the stand as 'pitiful and at the same time wonderful'.

The weather didn't stop people from packing the Millard Stand for the next 38 years. And when the conditions were more benign, few places offered you a better view of the action, providing you didn't suffer from vertigo. But as the stands became ravaged by rust, and the facilities became woefully outdated, time was called on Athletic Park in 1999, to be replaced by the Sky Stadium (formerly Westpac).

Ahead of Athletic Park's final match, fittingly against France, Chris Rattue wrote in the *New Zealand Herald*, 'There's enough rust on its support structures to decorate a Taiwanese fishing trawler. Instead of going to the expense of demolishing the stadium, they could just leave it out for the inorganic rubbish collection.

'But love it or hate it, as many people from outside the capital do, that rusty old heap of scrap-iron and those limb-numbing winds will be missed. Well, sort of.'

Aviva Stadium

Dublin, Ireland

When architectural firm Populous was tasked with designing a new stadium on the site of Lansdowne Road, which had been the home of Irish rugby since 1876, the project presented a unique challenge. For starters, a train line ran under the main stand.

Plus, Lansdowne Road could hold up to 48,000 spectators but half of that was made up of terracing. If you replaced those stands with seats, you would have a vastly reduced capacity. Yet Populous managed to create a 51,700-all-seater stadium, covering a smaller footprint than the old Lansdowne Road, which is set away from the train line, in the middle of a built-up residential area.

The stadium had to be constructed without causing years of transport chaos but also had to provide those homes closest to the stadium with what is known as the 'right to light'. This explains why one end has no spectators.

It was also the first stadium anywhere in the world to have a curved roof – an effect that has since been replicated at the Orange Vélodrome in Marseille – and is an example of parametric design. In a nutshell, whereas designing buildings used to be about straight lines, sharp corners and conventionalism, parametricism is about curves and unconventional shapes, which

RIGHT: The Aviva Stadium dominates the Dublin skyline to the east of the city.

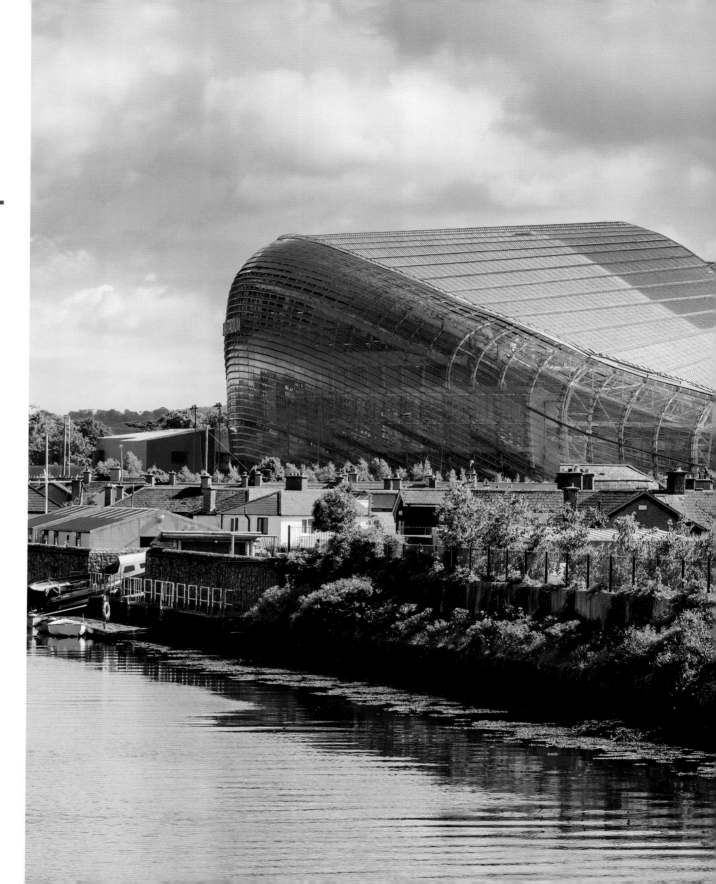

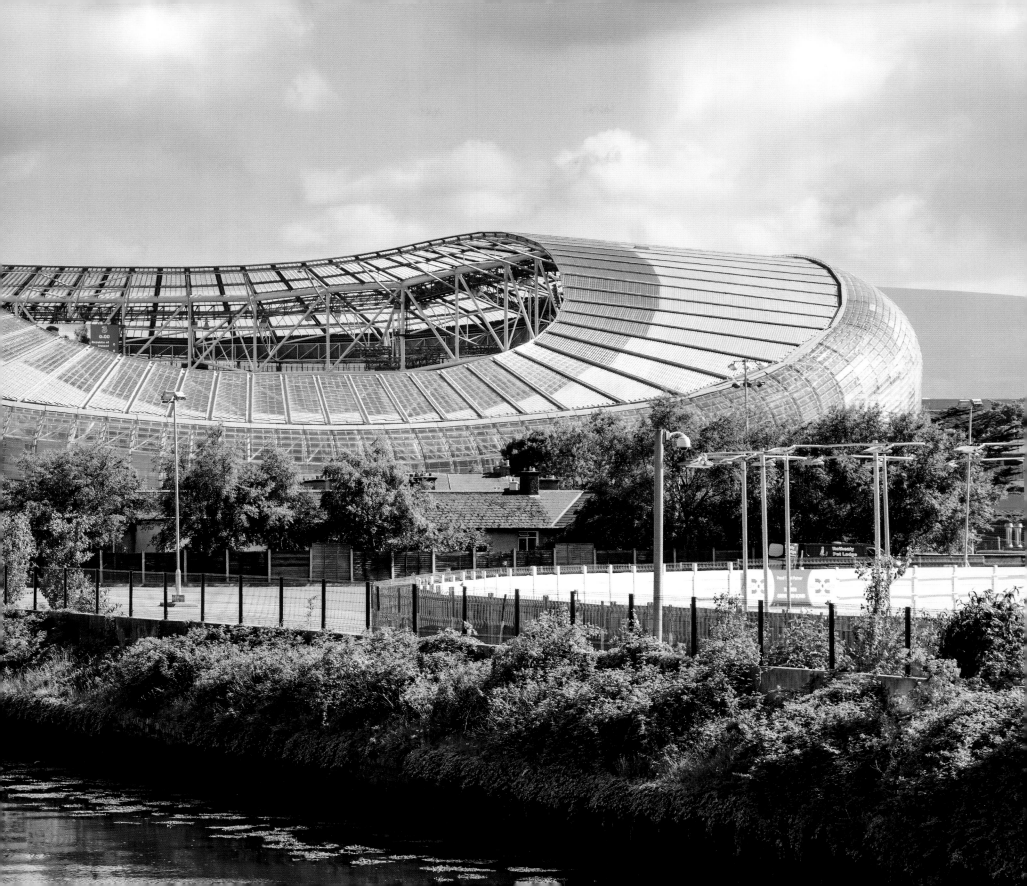

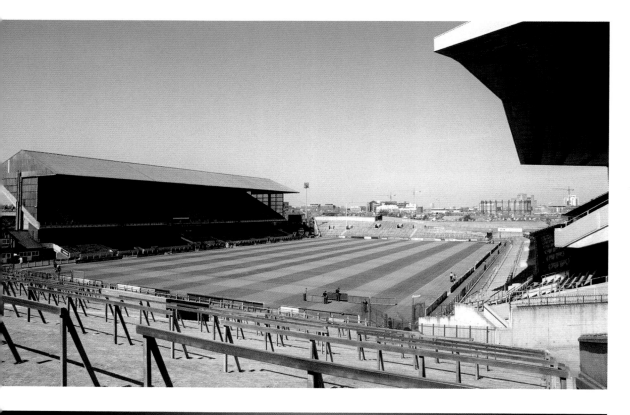

LEFT: A view of the old Lansdowne Road from the terraces in its last years.

BELOW LEFT: With no towering floodlight structures, the Aviva takes on the appearance (like many in this book) of a 'landed spacecraft' for night games.

BOTTOM: The old grandstand bridged the rail link to Dún Laoghaire and Bray.

BELOW: There are some who regret the loss of Lansdowne Road as the name of the ground, but the title is not gone entirely.

OPPOSITE: While the old grandstand straddled the rail line, the neat new Aviva is within the bounds of the old ground.

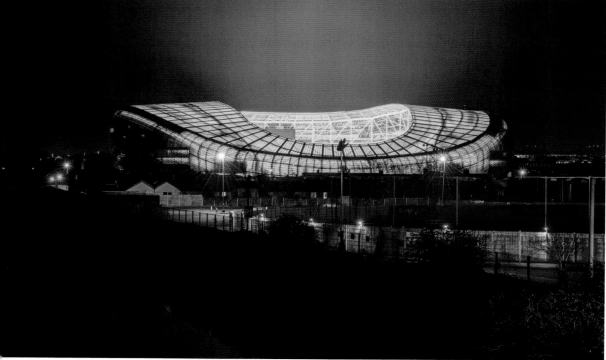

gives those buildings a distinctive, futuristic look, unconnected with the 'two grandstands, two terraces' approach of old.

Even if traditionalists preferred Lansdowne Road, nothing helps to win over doubters like a winning team. The stadium opened in 2010 and since then Ireland has won three Six Nations titles; it has coincided with a golden era in club rugby. The Aviva Stadium also provided the setting for two epic games with New Zealand. The first one was in 2013, a match that had everything. The All Blacks trailed 19-0 after just 20 minutes and stormed back to win 24-22. Five years later, the hosts won 16-9 with All Blacks coach Steve Hansen calling Ireland 'the best team in the world'.

Whereas Lansdowne Road was the home of the Irish RFU, the Aviva Stadium is also home to Ireland's football team. More recently, it also became a temporary home for over 100 Ukrainian refugees before they resettled in Ireland.

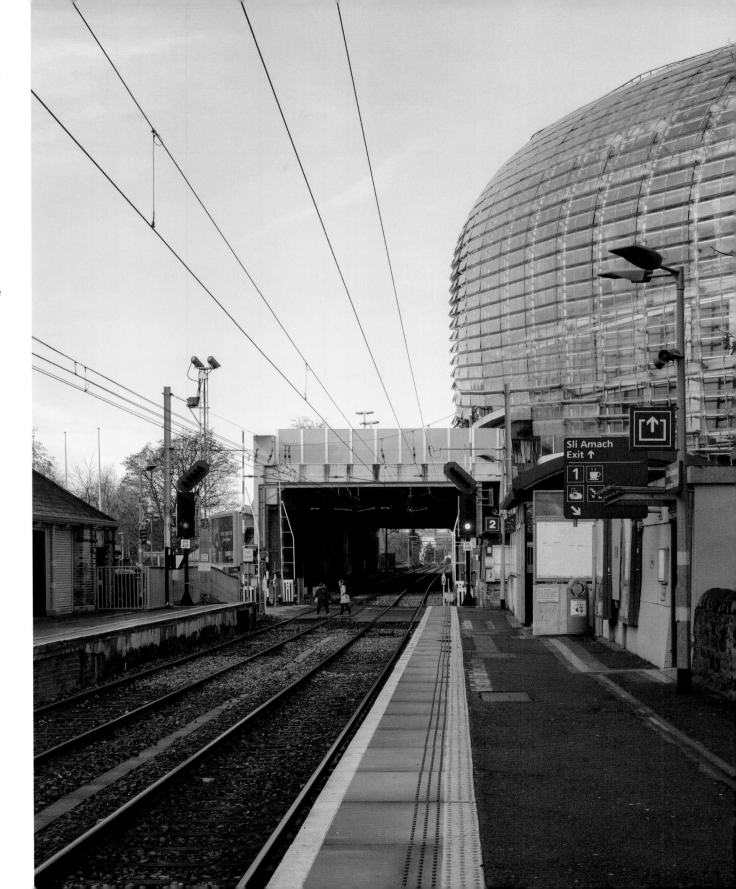

Battleship Memorial Park

Mobile, Alabama

Team: Battleship RFC

Battleship Memorial Park in Mobile, Alabama is home to the USS *Alabama* warship, the USS *Drum* submarine, and a collection of US military aircraft. Oh yes, and it is also where you can find two-time US National Championship winners Battleship Rugby.

The warship that provides that amazing backdrop is known as 'The Mighty A'. Although USS *Alabama* only saw five years of active service, that period included World War II and the Pacific War. Initially, USS *Alabama* was stationed in the North Atlantic to guard against any possible raids from German heavy ships.

By 1944, she had moved to the Pacific Ocean and took part in the capture of the Gilbert and Marshall Islands. Three years later, however, The Mighty A had been decommissioned and by the early 1960s was set to be turned into scrap metal. At this point, a campaign was launched by the state of Alabama to save the ship and make it a war memorial to the Alabamians who lost their lives in both wars.

School children throughout the state raised nearly $100,000 by donating any spare nickels, dimes, and quarters, and by 1965 the USS *Alabama* had a new home in Mobile, which is one of the largest ports in America.

Every autumn, Memorial Park plays host to a two-day rugby event known as BRIT – Battleship Rugby Invitational Tournament. BRIT attracts over 40 teams of all ages, from U12s through to the Old Boys.

The tournament was first held in 1980 and has become established as one of the key rugby tournaments in America's Deep South and also helped to confirm Battleship Rugby as one of the leading teams in that part of the world.

Although Mobile is the rainiest city in America (yes, even wetter than Seattle), the tournament is held in November, which tends to be one of the driest months in the year. And you can expect the players to party just as hard as they play, given that Mobile is the city that hosted the first-ever Mardi Gras way back in 1703.

OPPOSITE: Rugby fans who like military hardware cannot fail to be impressed with the array of planes and vehicles on display, along with the *Alabama* and the submarine USS *Drum*.

BOTTOM LEFT: The park entrance adorned by a McDonnell Douglas Phantom jet. The playing area is beyond.

BELOW: Two views of the home team at the BRIT Sevens.

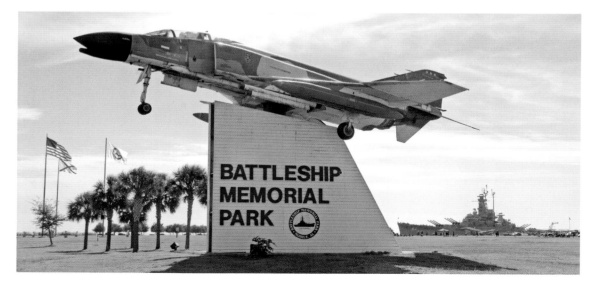

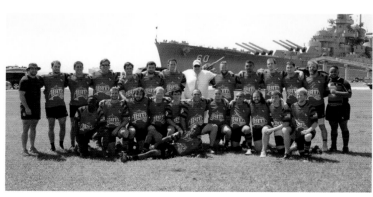

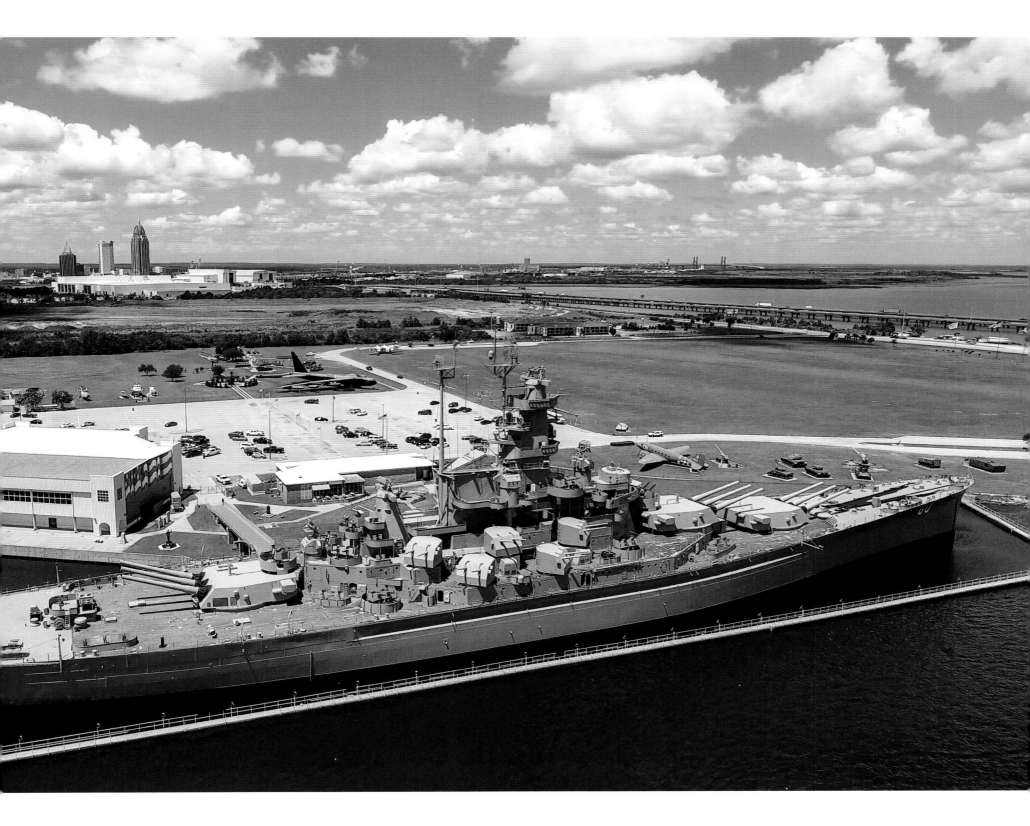

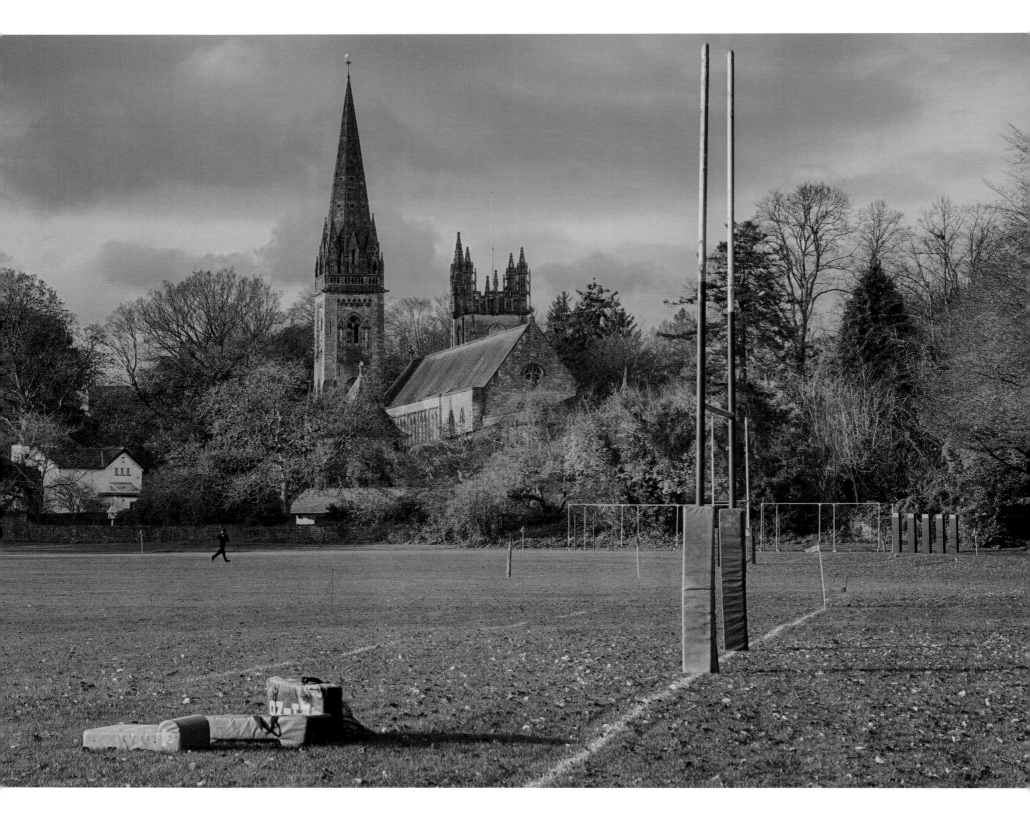

Bishop's Field

Llandaff, Wales

Team: Llandaff RFC

If you want to visit a ground that is steeped in history, then welcome to Llandaff. The town is just four miles from Cardiff, and the team plays its rugby on Bishop's Field in the shadow of Llandaff Cathedral, which dates back to 1120.

Soon after the cathedral was completed, the body of Saint Dubricius was brought here from Bardsey Island (sometimes known as the Island of 20,000 Saints). Not only was Saint Dubricius thought to be the first Archbishop of Llandaff but also the man who crowned King Arthur.

Llandaff RFC was founded in 1876 and Bishop's Field has always been the home ground, but it isn't the only team that plays its rugby here. The Cathedral School is virtually next door to the ground and has produced two British & Irish Lions, who also played for Llandaff; Rex Harris and Louis Rees-Zammit. Harris represented Cardiff and Wales when they beat New Zealand in 1953 – the last time either team beat the All Blacks. The school was attached to the Cathedral until 1941 when a German Luftwaffe raid bombed the site, causing extensive damage and the need for some major reconstruction.

In 2021, Rees-Zammit – who turned out for Llandaff's junior teams before moving on to Cardiff Blues (now Cardiff Rugby) youth teams – became the youngest player called up for a British & Irish Lions tour since 1959 at the age of 20 years and 93 days. Although, the honour of most famous Llandavian goes to children's author Roald Dahl who, like Rees-Zammit, attended the Cathedral School almost a century earlier and based one of his most enduring characters, the headmistress in *Matilda*, on a shopkeeper in Llandaff.

Although the past looms over Llandaff RFC, almost literally, this is also a forward-thinking club. It was among the first crop of teams to tour South Africa in 1993, shortly after apartheid was banned. And although grassroots rugby across Wales is at a crossroads – post-pandemic, some teams are struggling to make up the numbers and fulfil their fixtures – at Llandaff the juniors section has a waiting list of kids wanting to join, no doubt inspired by Rees-Zammit.

In 2021, new changing rooms were completed, costing £100,000 – a significant investment for a team playing in League Four East Central. It prompted club secretary Endaff Williams to say, 'Rugby is in the entertainment business and you need to have really good facilities to attract players and fans alike.'

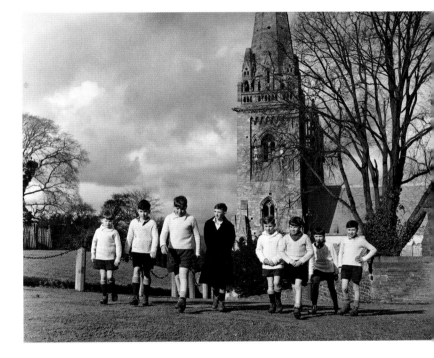

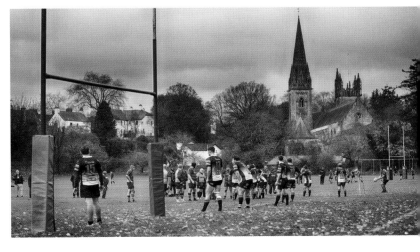

OPPOSITE: Llandaff's Bishop's Field.

ABOVE RIGHT: Duty done, scholars and choirboys of Llandaff Cathedral head out onto Bishop's Field in 1954.

RIGHT: The large grounds host games for six minis, five juniors and four adult teams, including Llandaff University, as there is a campus of Cardiff Metropolitan in Llandaff.

Bombay Gymkhana

Mumbai, India

Team: Bombay Gymkhana Rugby Club

Mumbai is home to one of the world's oldest active rugby clubs, and one of the sport's most distinctive grounds. The Bombay Gymkhana opened in 1875 and was originally founded by members of the Bombay Lighthouse Cavalry. Admittance was strictly limited to Britons who also played sports in an era when the best athletes competed across multiple events, including polo, cricket, tennis, squash, badminton, football and rugby.

In 1892 the inaugural Bombay Cup was held with teams representing 65 British regiments across India. It was an era when the only Indians allowed into the club were servants, and women were excluded.

The original building, designed by architect John Adams, was a temporary structure. In 1917, Claude Batley was brought in to give the Gymkhana a new look and a striking permanent façade. Several of Batley's buildings can also be found in the Back Bay Reclamation area, off the coast of Mumbai, which is a UNESCO World Heritage site. He also helped introduce Art Deco design to India, with buildings like the Breach Candy Hospital that wouldn't look out of place on Miami's South Beach. India's independence in 1947 opened up the club to the men of Mumbai, although it wasn't until the 21st century that women were allowed to join.

With a history that is inextricably linked to colonialism, the Gymkhana has a chequered past to say the least. The club also recently became embroiled in a story that exposed how the city's top bureaucrats wield power. After the Gymkhana's inexpensive, 99-year lease ran out in 2006, those bureaucrats wanted to extend the width of a road, which would have put the club's future in doubt. They dredged up any number of rules and regulations that the club had been breaching, which included serving alcoholic drinks outdoors. Which begged the obvious question of why they had failed to raise these issues any time previously.

Reports then emerged that many of those pulling the levers of power wanted lifelong memberships to the club to allow the Gymkhana to stay open for business. Eventually, the Gymkhana relented, even against the wishes of some of its members. The decision means that the club is still going strong and the home team won the 87th edition of the All India & South Asia Rugby 15s Championship when it was held here in October 2022.

And for sports trivia fans, the Gymkhana also holds an important place in the history of cricket, as it hosted the first Test match on Indian soil on 15 December 1933, with England beating India.

OPPOSITE: The historic sports ground has been slow to admit women members.

BELOW: India take on Sri Lanka in a Rugby World Cup qualifying match held at the Gymkhana.

BOTTOM: Brett Gosper, World Rugby CEO (L), and actor Rahul Bose pose with the Webb Ellis trophy on the Rugby World Cup 2019 Trophy Tour as it stops in Mumbai.

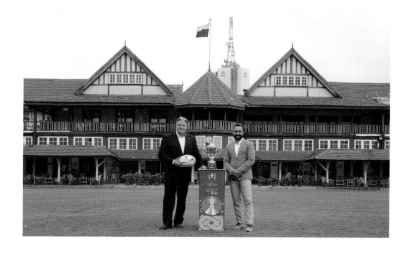

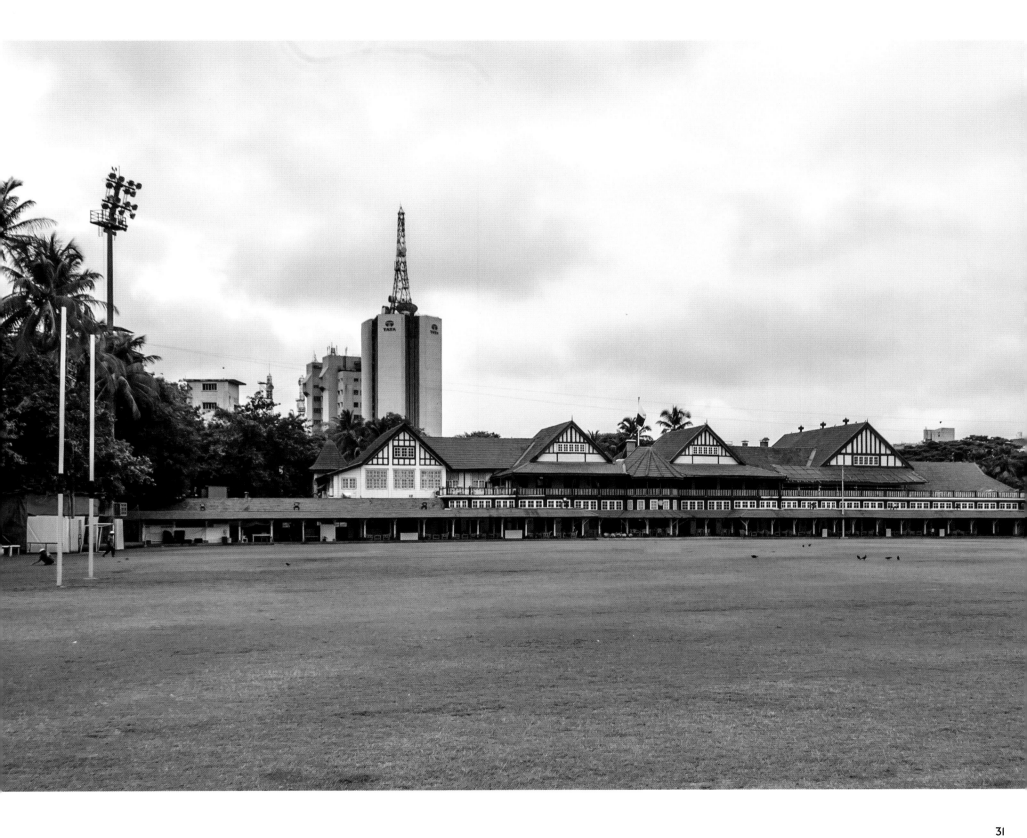

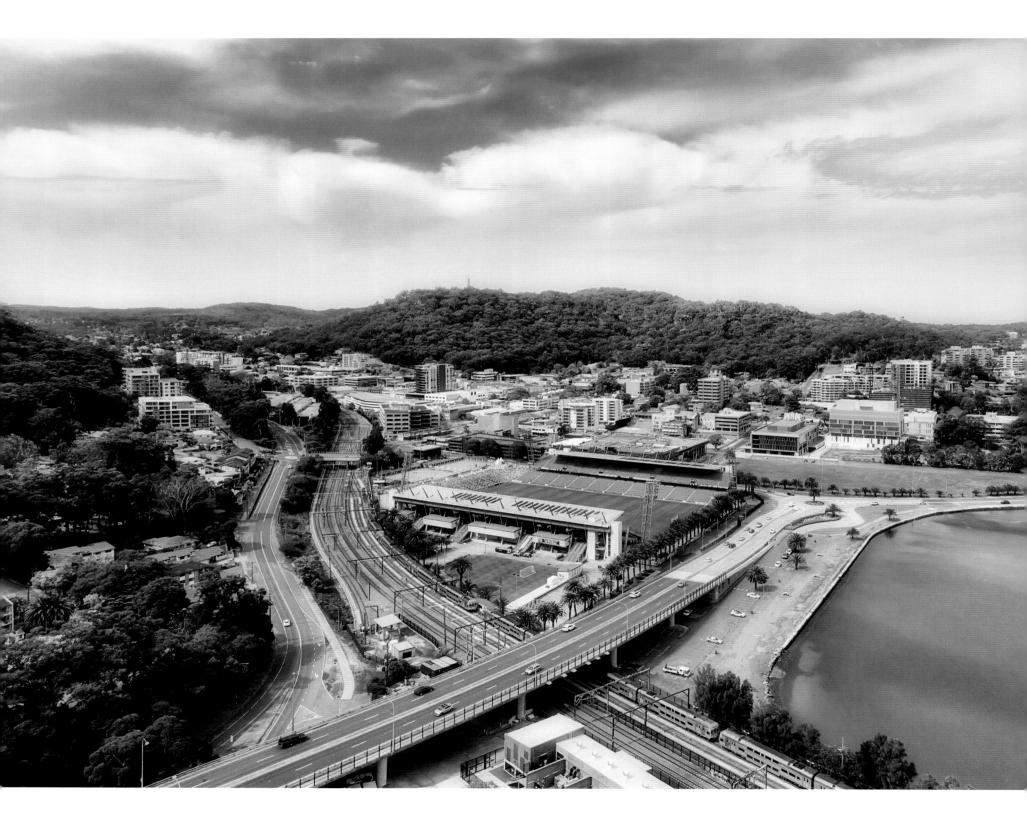

Central Coast Stadium

Gosford, Australia

When the Central Coast Stadium was being built at the end of the 1990s, it appeared to have several factors in its favour, the obvious one being its waterside location. The stadium was built on the site of what used to be Grahame Park, a fairly ramshackle ground with one small stand for spectators. The playing area was reconfigured, so whereas before the length of the pitch ran parallel to the coast, after it was moved 90 degrees, it was end-on.

All that separates the southern end of the ground from Brisbane Water (much further south than Brisbane, Queensland) is a big screen, a row of 22 palm trees, and the Central Coast Highway. At sundown, it looks like a venue that was made for Instagram.

The stadium is in Gosford, a city that grew rapidly during the 1990s, and was going to be the home of National Rugby League (NRL) team North Sydney Bears. Between striking that agreement and the Bears moving in, the team had merged with the Manly-Warringah Eagles to become Northern Eagles. The new club initially played half its games at the Brookvale Oval on the outskirts of Sydney, and the other half at Central Coast, which is 75 kilometres (47 miles) away. It's not hard to see why the idea of arranging home games at two grounds so far apart played out badly with supporters.

Midway through the 2002 season, with attendances declining, the Eagles left Gosford. The following year the ground received a much-needed boost by hosting two games at the Rugby World Cup but still needed a regular tenant. Step forward the Central Coast Mariners football team, which was founded in 2004 to join the newly formed A League.

Again, though, attendances have been somewhat disappointing and hover around the 6,000 mark, especially given the club's on-field achievements and the publicity generated by Usain Bolt playing a trial match here in 2018 – he didn't get a contract because the club couldn't afford him, but he did score twice.

In 2006, the Central Coast Waves rugby team moved in, and played just one season in the Australian Rugby Championship – the tournament was terminated in 2007.

Throughout all that time the seating in the ground continued to spell out the name 'Bears', which was finally removed in 2020. The city council, which owns the ground, hopes that the introduction of a new management team in 2022 will reverse their fortunes. Come what may, they can always rely on somebody posting a picture on social media of that sunset from the stands.

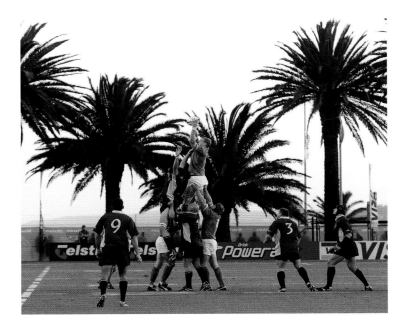

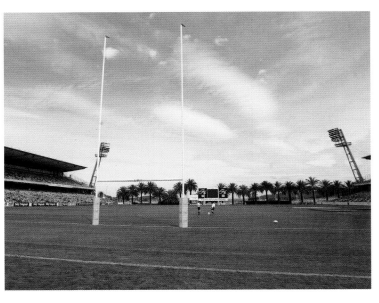

OPPOSITE: Central Coast Stadium on the shores of Brisbane Water. A palm-fringed rugby pitch tells you this is unlikely to be a Northern Hemisphere ground.

ABOVE RIGHT: Ireland's Paul O'Connell wins a lineout during Ireland's 45-15 victory over Romania in their Rugby World Cup pool match in 2003 at the Central Coast Stadium.

RIGHT: Apart from hosting one-off rugby union games, the stadium has been home to the Central Coast Waves team.

Chichibunomiya Rugby Stadium

Tokyo, Japan

Team: Sunwolves Super Rugby team

Chichibunomiya Rugby Stadium is the spiritual home of Japanese rugby – for the moment at least. It's also referred to as Prince Chichibu Memorial Rugby Ground, and it is the Prince's involvement that has elevated the status of this ground in the Aoyama district of central Tokyo.

Chichibu was the younger brother of Emperor Hirohito. Born in 1902 he had the obligatory royal military career but sat out most of World War II after contracting pulmonary tuberculosis in 1940. He was a supporter of Scouting in Japan and after World War II, became the president of many athletic organisations, collecting the nickname 'the sporting Prince' thanks to his efforts to promote skiing, rugby and other sports. He had been alerted to the benefits and physical discipline in rugby by president of the Japanese Rugby Football Union, Shigeru Kayama, though he never played the game himself.

The Tokyo Rugby Stadium, as it was first known, was completed in 1947. On the Prince's death in January 1953 it was changed to Chichibunomiya Rugby Stadium. A statue of the prince in rugby gear – that he never wore – has been erected outside the stadium.

Today the ground can accommodate 27,188 spectators. It has hosted both club games and international fixtures in its time. From 2012 to 2015, it was the home stadium for the Japan Sevens, which has now morphed into the World Rugby Sevens Series. However, after the 2014–15 series, Japan lost their round of the competition to Singapore.

It is more than the loss of a tournament that the historic stadium is facing up to today. In 2019, a number of corporations along with the Japan Sports Council agreed to redevelop both Chichibunomiya rugby stadium and the Jingu baseball stadium next door. Under the plans, the new rugby stadium would be built on the baseball stadium's second field. The venue would feature grandstands on three sides, with a large screen to be sited on the remaining side. It would have a smaller capacity of around 15,000 for rugby, although this would be expandable to 20,000 for other events. Already delayed by the global pandemic, the worldwide recession may impact it further, but work was slated to start in 2024 with a completion date of 2027.

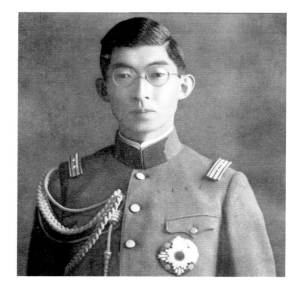

OPPOSITE: The stadium's fate hangs in the balance. A group, named 'Scrum for Shin-Chichibunomiya' has been selected to create a new stadium by 2027.

BELOW: Japanese fans on the safe standing terraces celebrate a try by Tevita Tatafu during the match with Uruguay in 2022.

BELOW LEFT: Hirohito's rugby-loving brother Prince Chichibu.

BOTTOM: Packed stands for the 2022 clash between Toshiba Brave Lupus Tokyo and Kubota Spears Funabashi Tokyo-Bay.

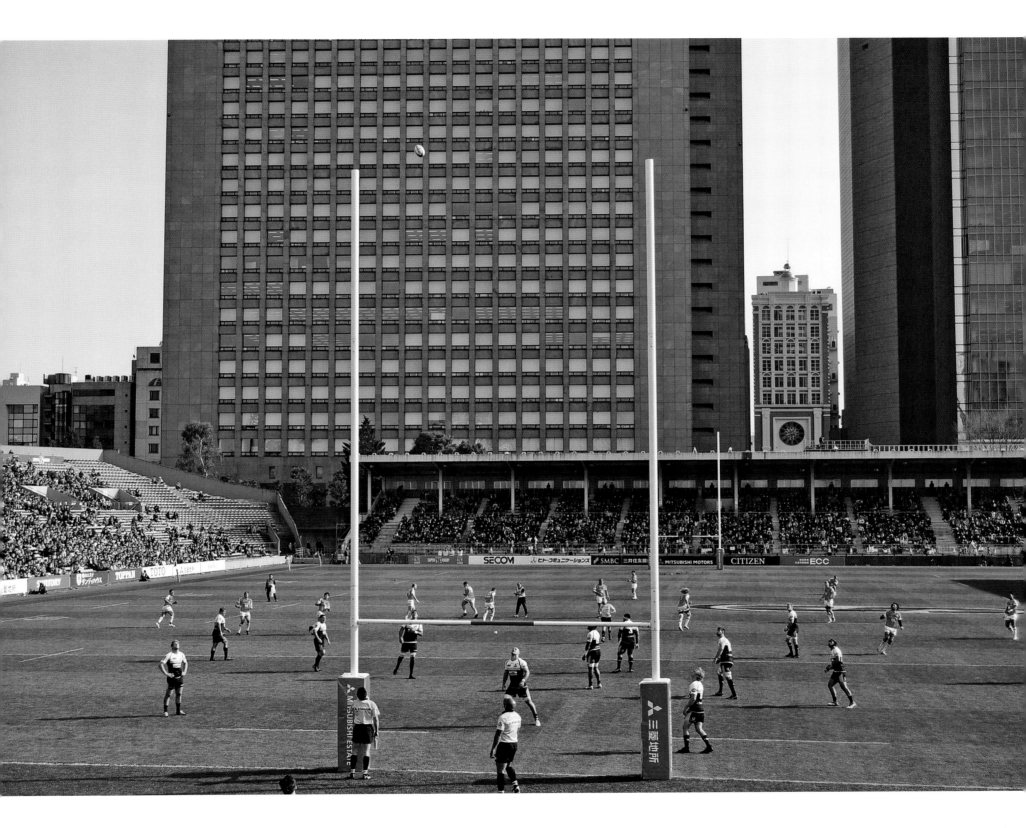

Ciner Glass Community Stadium

Ebbw Vale, Wales

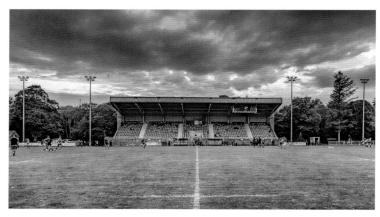

Team: Ebbw Vale RFC

The Welfare Ground, or as it has been known, Eugene Cross Park, and officially the Ciner Glass Community Stadium, was once home to the 'Tongan Embassy'. It all started in 1997 when Tonga toured the UK and several players were snapped up, including two that would join Ebbw Vale. That was quite a culture shock, especially for the players' families, who lived on islands surrounded by deep blue seas, where it never gets cold.

The house, which was set within the grounds of the rugby club, was a meeting place for Tongans across Wales, including the Vunipola family. Whatever happened to Billy and Mako? Ebbw Vale RFC moved here in 1920, when it was known as the Welfare Ground after the land was bought by the local Welfare Association, hence its name. One part of it is a cricket pitch, while the other is a rugby ground situated at the top of all the old steelworks.

While other places (and rugby clubs) in the Valleys flourished because of the boom in the coal industry, at one point Ebbw Vale was home to the biggest steel mill in Europe and, for some years, the fortunes, both of the town and the team, were tied to the industry. A lack of investment and the Great Depression resulted in the steelworks closing its gates in 1929 and players leaving Ebbw Vale. Ten years later a new mill brought prosperity and full employment to the town and the team became a major force in club rugby.

OPPOSITE AND ABOVE LEFT: Two views of Ebbw Vale's distinctive old-school banked terrace, the perfect place to watch rugby on a sunny afternoon.

ABOVE: For days when you can't see the Brecon Beacons and it's raining hard, there's also a grandstand.

TOP: The Ebbw Vale clubhouse.

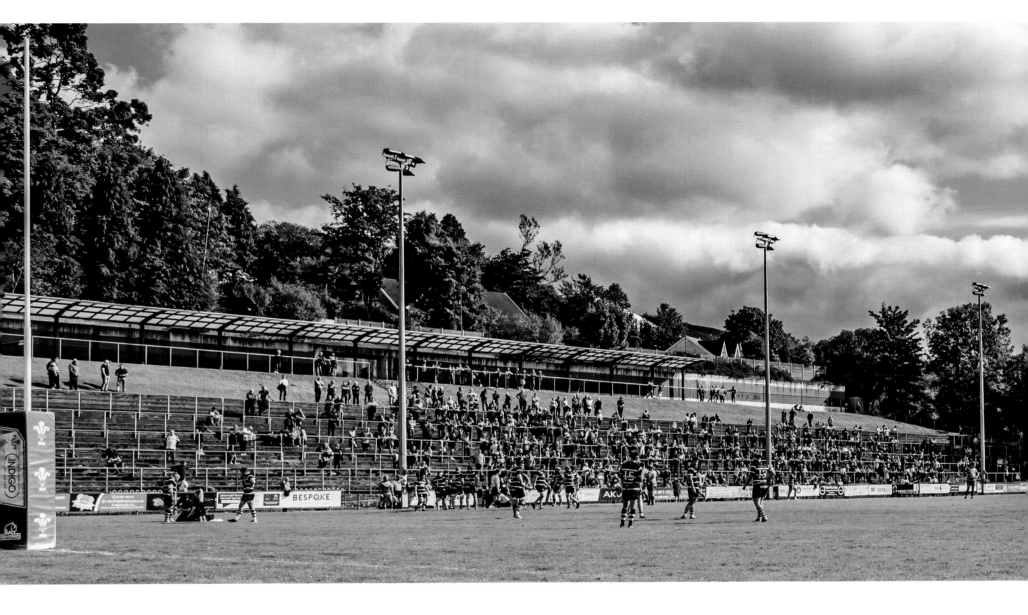

The post-war period would see Ebbw Vale crowned unofficial Welsh champions four times between 1952 and 1960. Soon after that, when floodlights had been installed, the Welfare Ground hosted games under the Floodlight Alliance – an attempt to make the attritional, low-scoring rugby of that time more entertaining by having a league where only tries counted (no conversions, no penalties), and the Alliance ran for eight years. The ground has

also entertained the best international teams including Australia, New Zealand and South Africa, as well as becoming the UK's unofficial capital for Tongans.

It was during the 1990s that the late Paul Russell was brought in to run the club. Russell was best known for bringing Ashes cricket to Wales with the redevelopment of Sophia Gardens in Cardiff. At the same time, Paul's brother,

Marcus, was managing Britpop upstarts Oasis. This prompted Paul to comment that running Ebbw Vale was way harder than looking after the Gallagher brothers.

Colombo Racecourse Stadium

Colombo, Sri Lanka

After years of steady decline following a decision by the Sri Lankan government in 1956 to ban gambling, a project was unveiled in 2011 to reinvent the Colombo Racecourse complex. The masterplan would see the impressive Turf Building renovated and converted into a shopping mall, while the grandstand and the playing area would become the first international standard rugby ground in Sri Lanka, signalling a return to the ground which staged the country's first international match when the All Blacks met Sri Lanka here in 1907.

The racecourse opened in 1893 on a site in Cinnamon Gardens that was once a psychiatric hospital. Racing was introduced into Sri Lanka by Britain – the country was under colonialist rule at the time. Harness racing, or trotting, would take place here and attracted all walks of society including British soldiers and Buddhists. It continued right up until World War II and the bombing of Pearl Harbor.

The racecourse was converted into an airfield and would become the base for two RAF squadrons. On 5 April 1942, Japan launched an attack on Colombo known as the Easter Sunday Raid, but the raiding party had no idea there was now an airstrip at the Racecourse, and this allowed the RAF to launch a successful counterattack.

Racing resumed after the war, and Sri Lanka gained its independence from Britain in 1948. Eight years later, the government imposed its ban because it saw gambling as 'immoral' which, in turn, spelled the end for the racecourse.

Following the ban, the racecourse buildings were sporadically used by various state bodies but became abandoned and neglected until 2011, when a restoration project injected new life into the grand old stadium. National games are played here, and Sri Lanka plays in Division One of the Asian Five Nations tournament, though they are yet to qualify for the Rugby World Cup. The Sri Lanka Sevens/ Colombo Sevens has become part of the Asian Sevens Series, with Monsoon rains (as our accompanying pictures demonstrate) making the pitch like something from the Fran Cotton era. Millennial rugby fans will have to ask their parents for that particular reference.

OPPOSITE AND LEFT: Action from the Asia Rugby Sevens of 2017 held at the Racecourse Ground in Colombo, including teams from Sri Lanka, Japan, Malaysia, Philippines, Korea and China.

BELOW LEFT: The elegant old grandstand building, successfully restored in 2011.

BELOW: With an impressive grandstand the Racecourse Ground has a capacity of 10,000.

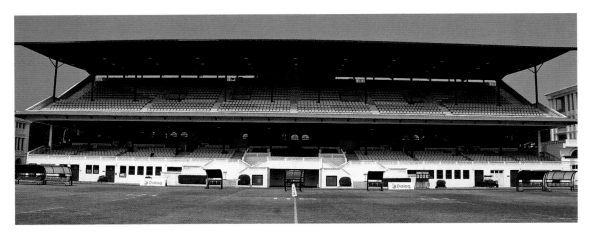

La Défense Arena

Nanterre, Paris, France

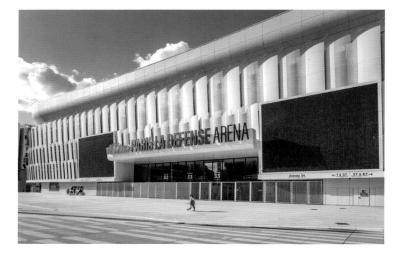

Team: Racing 92

'If you've been here you'll already know. If you haven't then you'll just have to add this to your bucket list.' So said rugby commentator Nick Mullins ahead of a Champions Cup tie between Racing 92 and Toulouse at La Défense Arena in 2019.

When Racing 92 moved to La Défense Arena from Yves-du-Manoir two years earlier, they became the first professional outfit to play all their home matches indoors. Then again, this is a club used to doing things differently. The team once celebrated winning the Top 14 title by drinking champagne on the pitch ... at half-time ... wearing pink bow ties.

Yves-du-Manoir was brimming with old-school charm but began to resemble one of those stately homes in constant need of repair, and for Racing 92 owner Jacky Lorenzetti, the move to La Défense was a 'no-brainer'. When he took over in 2006 the club was in the second division and – so the story goes – attracted just one paying customer for his first game as owner.

Three years later the property magnate set out his plans to move to a purpose-built indoor stadium. La Défense is Europe's largest business district, to the northwest of Paris and at about the same distance from the centre as Saint-Denis, home of the Stade de France. It wanted to attract new visitors and shed its image for being cold, clinical and functional.

The arena can hold 40,000 spectators, although the capacity for rugby is set at 30,000, with one end covered by a gigantic screen that runs the full width of the pitch, and it's the world's second biggest indoor stadium behind the Philippine Arena.

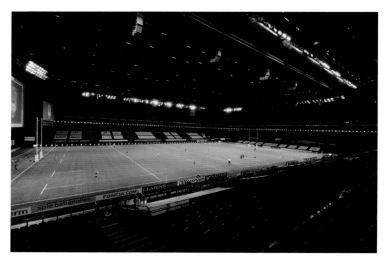

Moving to La Défense meant Lorenzetti could stop bankrolling the club out of his own pocket – he has a significant stake in the arena – although it was only after he put the project out to tender that an idea was put forward to make it a multi-use stadium. The first music act to play here was the Rolling Stones, so not a bad way to start.

Yet the move was fraught with difficulties, including 21 legal injunctions trying to block the development, and the club was all set to merge with Stade Français in 2019, only for the deal to collapse at the 11th hour. The reality is that a 30,000-capacity arena is far too big for Racing, and Paris doesn't 'do sport' like other capitals such as London, New York or Madrid.

Even so, this city will host the 2024 Olympics and Paralympics, when Racing's home ground will stage the swimming events and accommodate 16,000 spectators. The arena can be converted from a rugby pitch to a concert venue in around 11 hours but it may take a bit longer to install two Olympic-sized swimming pools.

ABOVE RIGHT: During the winter months, Racing 92 can guarantee they won't lose fixtures, by playing all their home games indoors.

RIGHT: A Top 14 match between Racing 92 and Agen behind closed doors on 27 December 2020.

OPPOSITE: For lovers of funerary sculpture, La Défense sits neatly between two large cemeteries: Cimetière de Neuilly and Cimetière de Puteaux.

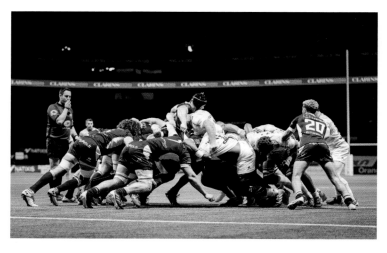

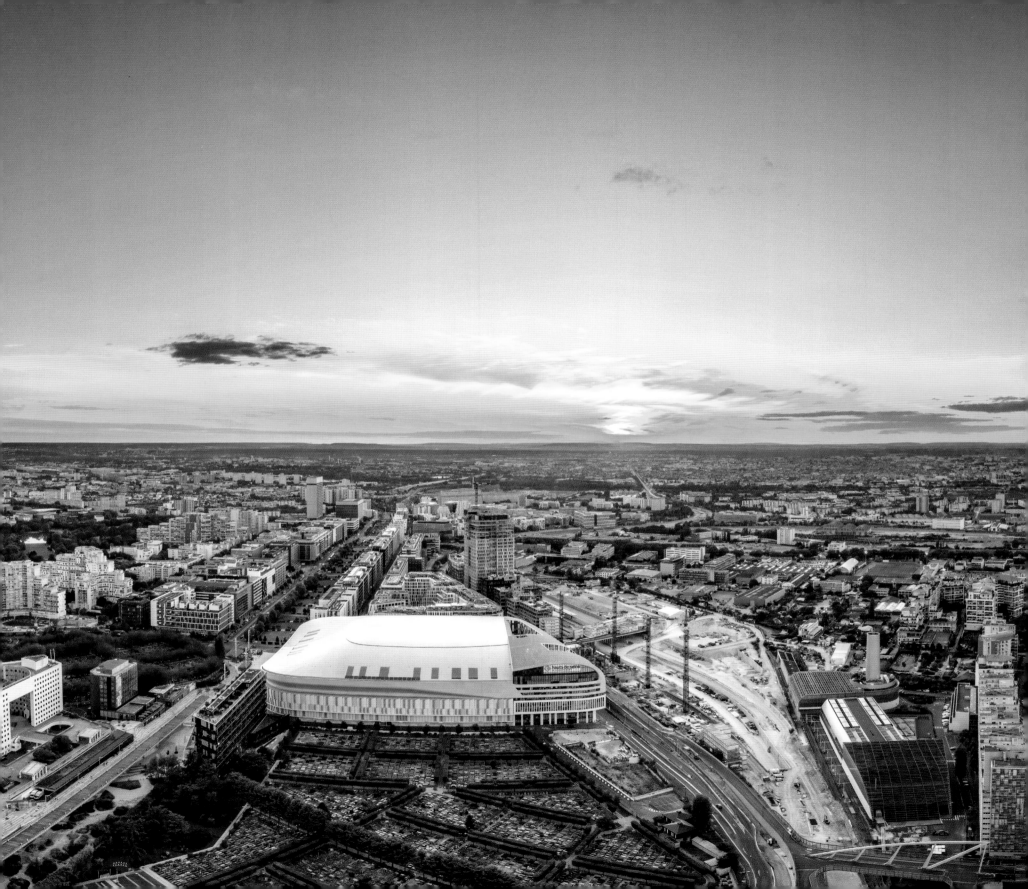

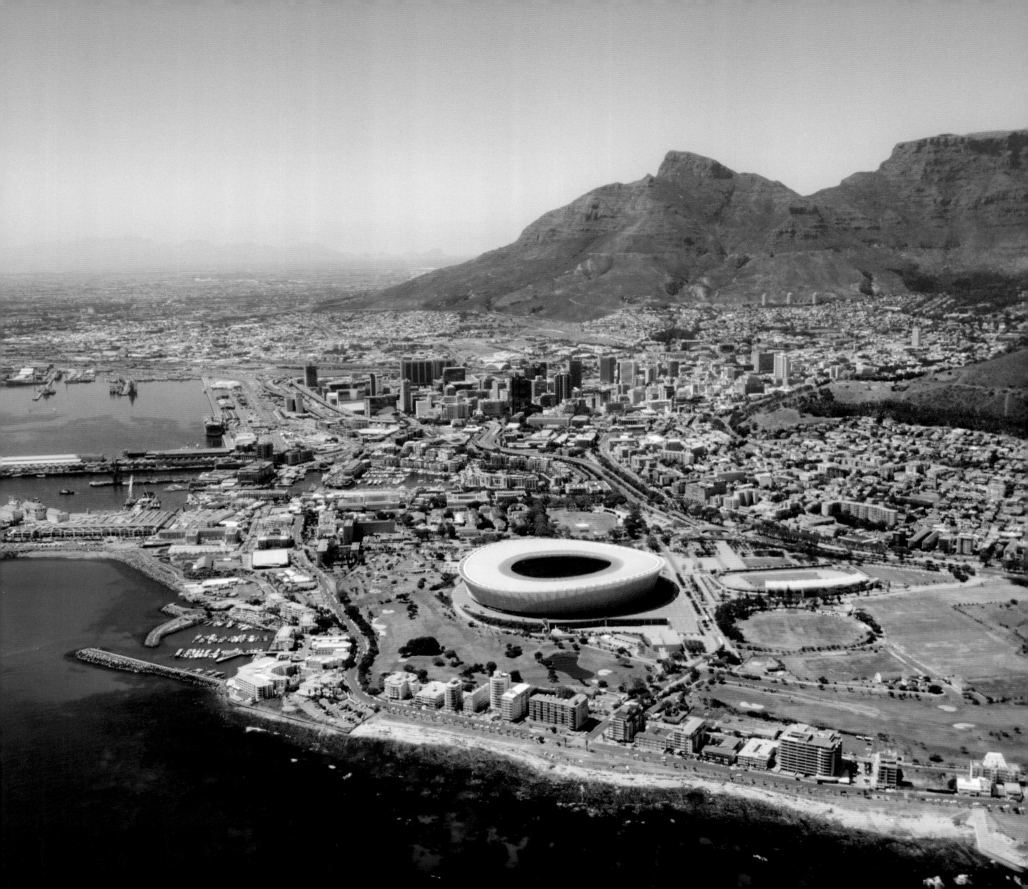

DHL Stadium

Cape Town, South Africa

Team: DHL Stormers

In May 2022, three South African construction firms made out-of-court settlements, each agreeing to pay the government of Cape Town $1.8m in compensation after inflating the costs of building what is today called the DHL Stadium. It drew a line under what had been a chequered history for the stadium since it opened in 2009.

With naming rights secured in 2021 (it was previously known as the Greenpoint Stadium) and regular tenants for football and rugby, the stadium is now viewed by the local government as being an important part of the city's post-Covid financial recovery. Aside from the controversies, the DHL Stadium deserves to be on any shortlist for the best location when it comes to international rugby grounds.

In the background, there is Signal Hill, with Table Mountain looming over it. Due north is Robben Island, where Nelson Mandela was held captive for 18 years. It provided an evocative backdrop as the mist enveloped the stadium before each of the British & Irish Lions' Test matches against South Africa in 2021 – sadly the matches themselves failed to match the drama of the setting.

Yet the location also presented several challenges for designers, GMP Architekten.

They couldn't build into the ground because the stadium is built on rocky subsoil. Also, the building couldn't be too high, otherwise wind coming in from the Atlantic could create a suction effect within the arena, and in any case it didn't want to look like some sort of blot on an otherwise spectacular landscape.

The exact location changed from the original plans, and the neighbouring Metropolitan Golf Course had to be reconfigured, resulting in a construction delay of a year. The stadium opened to rave reviews from critics and has thankfully been spared the ignominy of becoming another ground built for a global sporting event that became a white elephant.

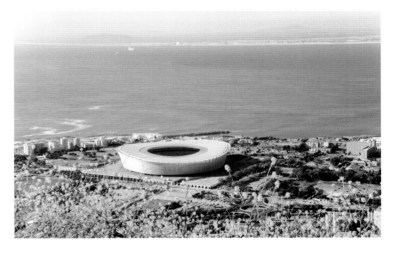

ABOVE RIGHT: Two differing viewpoints of the award-winning DHL Stadium. Like many 21st-century stadia, the building becomes a light show after dark.

RIGHT: The DHL Stadium is visible beyond the Springbok Experience Rugby Museum, which was located in downtown Cape Town, but closed in 2019.

OPPOSITE: Not only is the DHL Stadium modern and fan friendly, it is within easy walking distance of the city centre.

FOLLOWING PAGES: A photo looking past the DHL Stadium, overlooked by Signal Hill and beyond by Table Mountain.

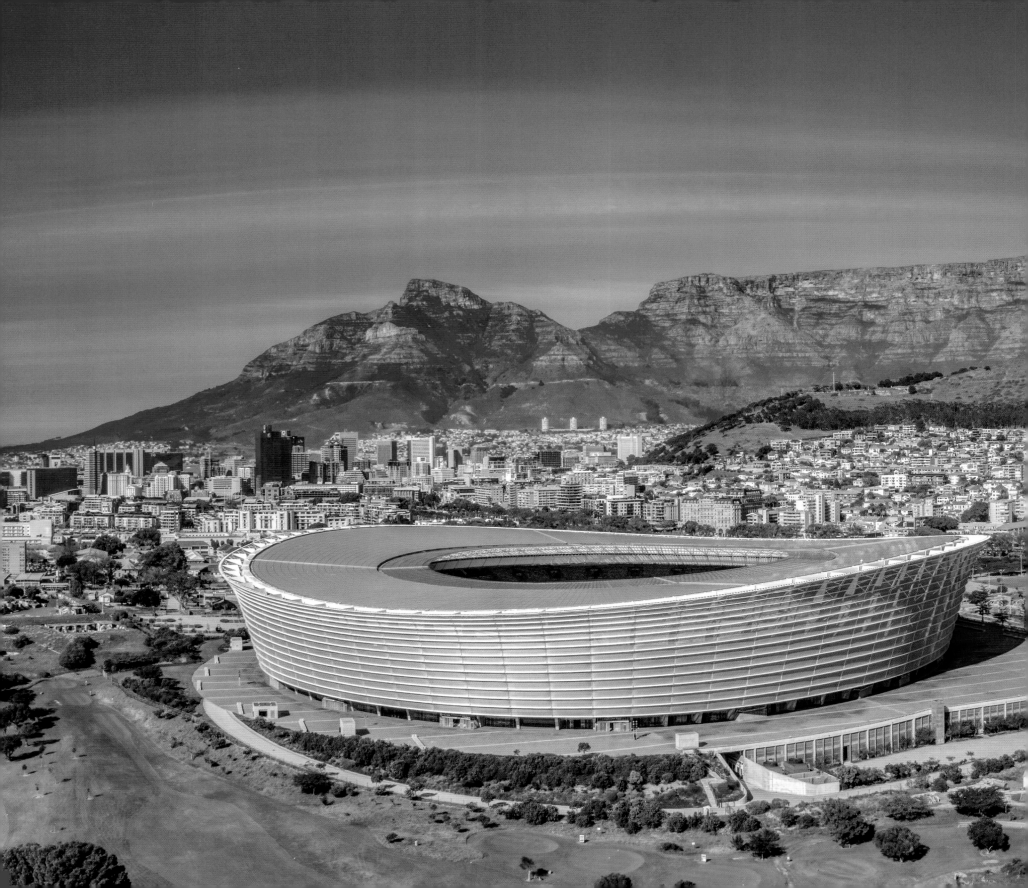

Eden Park

Auckland, New Zealand

Team: Auckland Blues

When New Zealand won the bid to host the 2011 Rugby World Cup, the city of Auckland faced a multimillion-dollar decision. Should it construct a brand-new waterside stadium in the heart of the city or give Eden Park, on the outskirts of Auckland, a major facelift? Some New Zealanders will still argue the merits of the waterside option. That would ultimately have burned a big hole in public finances, and as it turned out, construction would have taken place at a time when the global economy was tanking.

In 2006, the green light was given for Eden Park to be redeveloped. And not before time. The old ground created a unique spectator experience. The Eastern terraces, in particular, were famed for producing one of the booziest crowds in rugby. There were only 23 entrances into the ground for a stadium that could hold 46,000 spectators. Once inside, getting a good vantage

OPPOSITE: Looking down on Eden Park from Mount Eden in Auckland.

BELOW: The Red Roses sing the national anthem before their heartbreaking defeat in the Rugby World Cup final in November 2022.

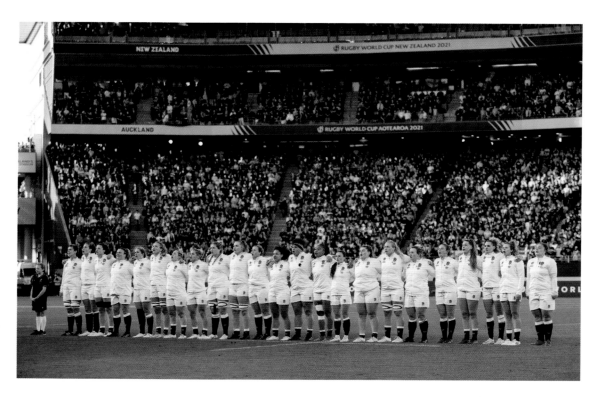

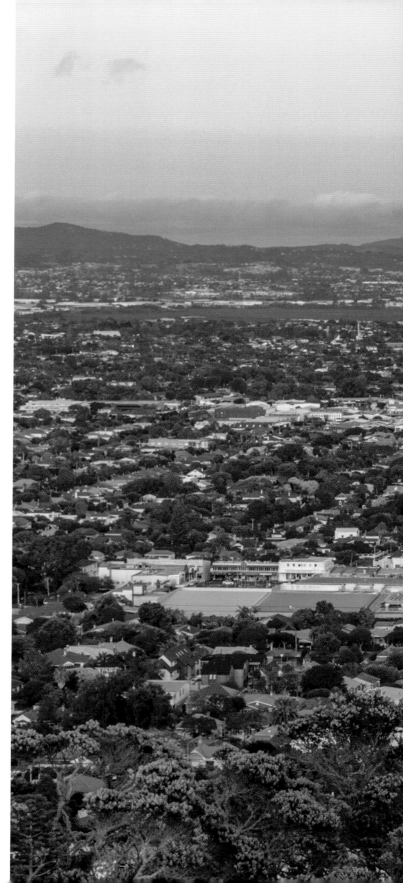

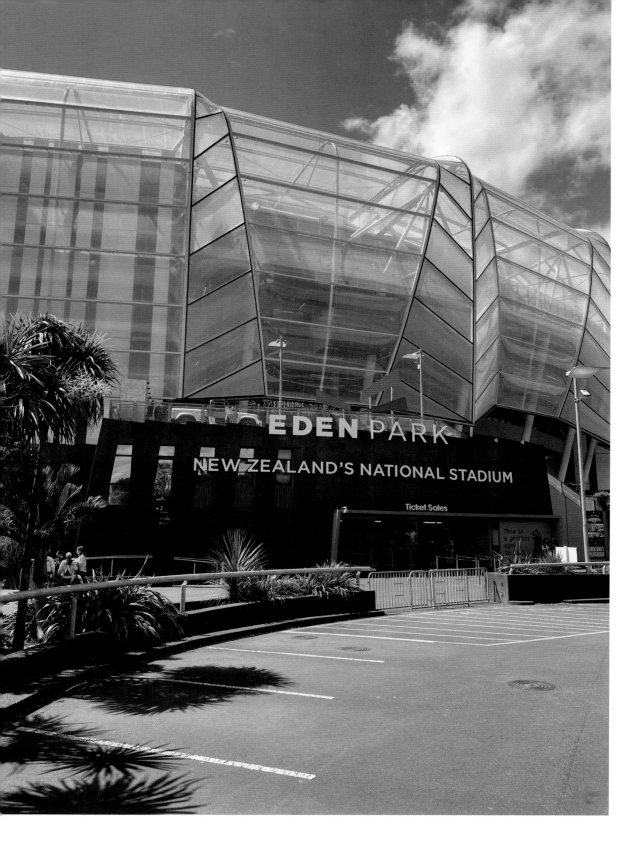

point to watch a match could also be a bit of a challenge. And the electricity supply could be hit and miss for vendors of hot (or cold) pies.

In 2008, work began on the new and improved Eden Park, to make it a modern multi-use stadium that would be capable of hosting the 2011 World Cup Final, with improved transport links to and from the ground. The redevelopment, which included a new, six-level, 21,500-seat South Stand, and featured temporary seating on the East and West Stands, brought the stadium's capacity up to 60,000 for the tournament, but now stands at 50,000. When it's not being used for rugby or cricket, the

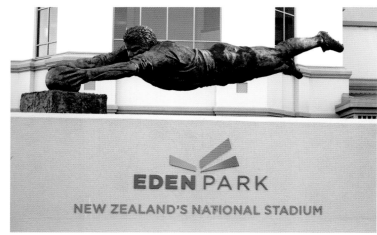

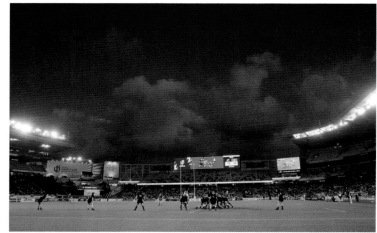

owners have found some curiously creative ways to generate new revenue streams, one of which is to convert the playing area into a nine-hole pitch and putt course, where golfers can tee off from the roof of the stadium.

All a far cry from when Harry Ryan leased the land in 1902. It soon acquired the nickname of 'Ryan's Folly' because it was originally a cow paddock and just up the road from an area known as Cabbage Tree Swamp. In those early years an awful lot of work was put into improving the drainage, and Ryan ultimately proved his doubters wrong. At first it was purely a cricket venue, but in 1913 the park was leased to the Auckland Rugby Football Union for 21 years, and it was used summer and winter. Bigger crowds for the 15-a-side sport obliged the Union to construct a grandstand for 2,500 spectators in 1913. The first rugby Test was played against South Africa in 1921 and the hosts lost 5-9 (in the days when it was three points for a try and two for a conversion) before a crowd of 40,000. Eden Park would go on to stage the first post-WWII Commonwealth Games, in 1950.

The more questionable decision rests behind calling it Eden Park. The ground was named in honour of George Eden, the first and only Earl of Auckland, who never so much as visited the city.

OPPOSITE FAR LEFT: Eden Park's management continue to find innovative way to make money from their fixed asset. In February 2023 they ran the 6th Powerade G9 mini-golf tournament, which includes one hole in the players' changing room.

OPPOSITE TOP: Auckland artist Natalie Stamilla's bronze sculpture of Michael Jones diving across the line for the All Blacks at the inaugural 1987 Rugby World Cup.

OPPOSITE BOTTOM: The Women's Rugby World Cup semi-final match of 2022 with the Black Ferns taking on France.

BELOW: The Black Ferns perform the Haka in their first match of the Rugby World Cup, on 8 October 2022. Despite falling behind by 17 points, they scored 41 unanswered points to win 41-17.

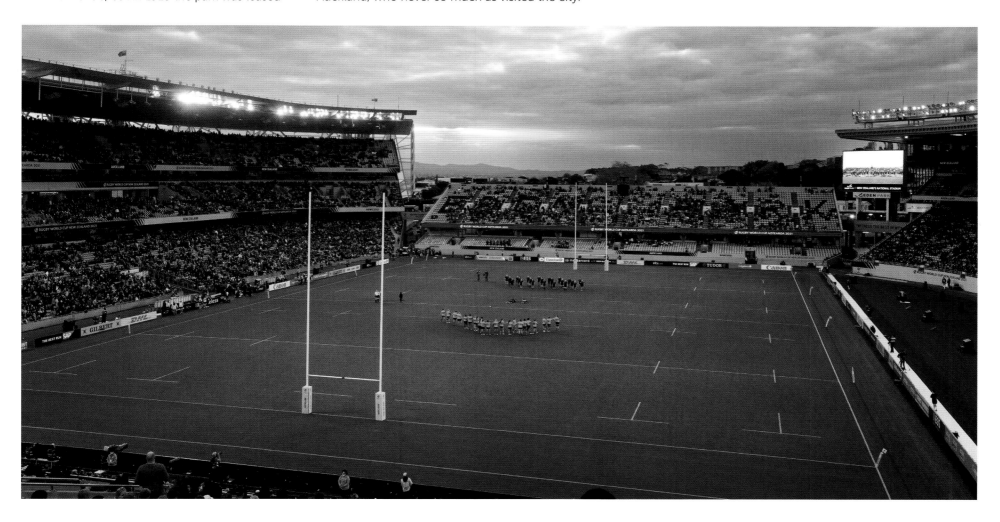

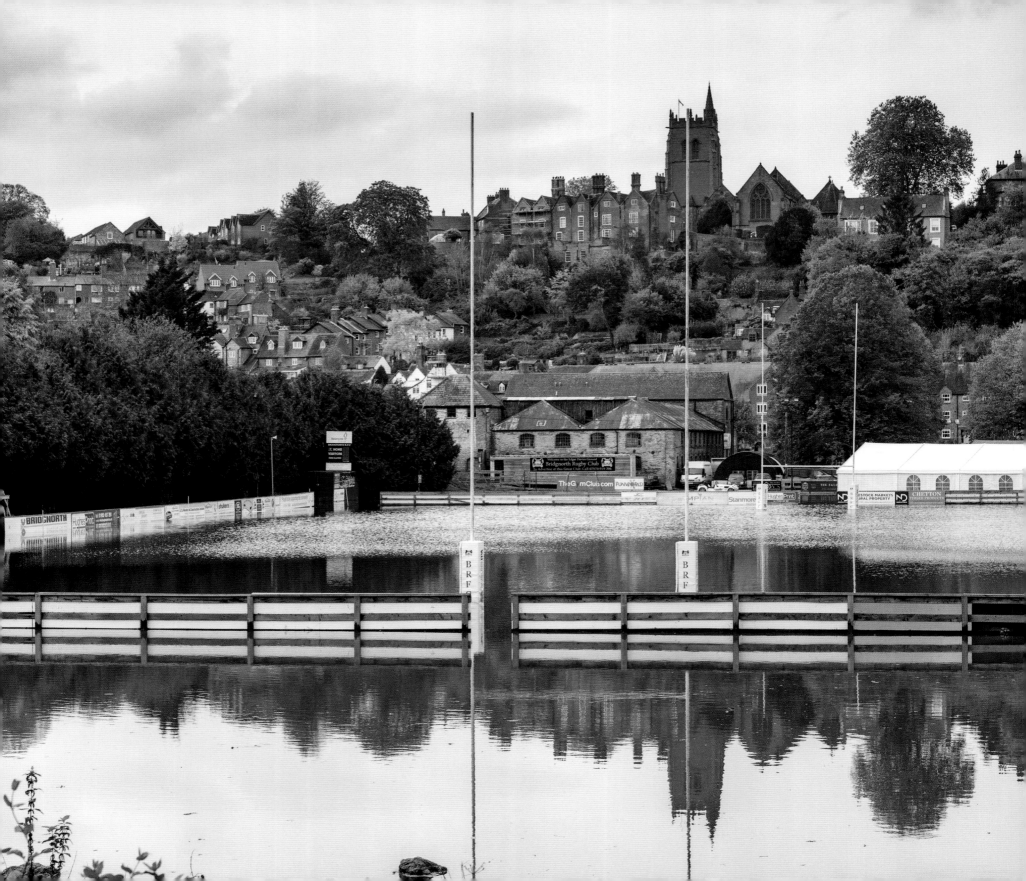

The Edgar Davies Ground

Bridgnorth, England

Team: Bridgnorth RFC

On 9 February 2022, a plan was approved by the local council that would allow Bridgnorth RFC to build a new clubhouse on stilts that would make it 'flood-proof'. Four times in the previous two years the clubhouse had been flooded, and the wisdom of that plan was demonstrated less than two weeks later when the banks of the nearby River Severn were breached yet again following a period of torrential rain.

If predictions for climate change prove to be accurate, or even just a bit off-target, then extremes of weather are likely to become increasingly frequent, and we are already seeing that happen across different parts of the world.

It means that homes, businesses, and particularly sporting grounds built on marginal land (just ask Worcestershire County Cricket Club, also at the mercy of the Severn) close to rivers, need to take action to prevent their buildings from being flooded or raise them up to new levels.

Bridgnorth is split into the high town and low town, and the Bridgnorth Cliff Railway, which is England's oldest and steepest inland electric funicular railway, transports you from the top to the bottom. No prizes for guessing that the rugby club is in the low town. While this creates a wonderful backdrop, with sandstone hills in the distance, it also means the pitch is always at risk of becoming submerged.

The club was founded in 1964, and in 2015 Bridgnorth made history by qualifying for the Intermediate Cup Final at Twickenham. Thousands made the journey to the home of English rugby, and although Bridgnorth were no match for opponents Maidstone, it remains an 'I Was There' moment for everyone who made the 300-mile round trip.

Building the clubhouse on stilts will cost north of £2 million, yet it will protect the future of the club that plays at one of the most picturesque grounds in English rugby. And you can't put a price on that.

OPPOSITE: The River Severn has a familiar habit of cancelling Bridgnorth's home fixtures. Whereas in the past these inundations were confined to winter or spring, in the 21st century they can come in any season.

BELOW: The Edgar Davies Ground in playable condition.

Ellis Park

Johannesburg, South Africa

Team: Golden Lions

There are sporting moments that represent something far greater than simply who won. Think Jesse Owens' four golds at the 1936 Olympics, or North and South Korea marching under the same flag at the 2018 Winter Olympics. Then there is Nelson Mandela handing Francois Pienaar the Webb Ellis Trophy at Ellis Park on 24 June 1995 after South Africa had beaten New Zealand to win the World Cup.

It was a pivotal moment for a nation, with Mandela choosing to wear the Springboks' jersey, a team viewed by black South Africans as the sporting embodiment of apartheid. John Carlin, who wrote the book that became *Invictus*, the movie about South Africa winning the 1995 World Cup, wrote, 'Mandela's genius was to recognise that this symbol of division and hatred could be transformed into a powerful instrument of national unity.'

The All Blacks also provided the opposition for the first match played here in 1928, after city councillor J. D. Ellis had made the land available to build a ground. By the 1960s Ellis Park was in danger of becoming a relic and was finally demolished, rebuilt and reopened in 1982.

When the crew for *Invictus* went to Johannesburg to shoot scenes for the film, the ground had changed. This was partly in response to the worst sporting disaster in the nation's history.

In 2001, 43 people died at a football match caused by a crush outside the ground. Even though games between Kaizer Chiefs and Orlando Pirates had a history of trouble, and it was anticipated that ticketless fans would turn up, little or nothing was done to stop crowds from getting close to the stadium, and thousands got in without tickets.

An inquest later revealed a litany of failings, including serious flaws in stadium management, corrupt security officials, 4,000 missing tickets, and poor policing, but nobody was held directly accountable. The disaster led to an overhaul of ticketing and security for events across the country.

The stadium was also being renovated to host matches at the 2010 FIFA World Cup. So, to recreate the effect of Ellis Park as it was in 1995, everything had to be pieced together using archive material and then generated through special effects.

If opposition teams don't feel the weight of history when they come to Ellis Park, they may feel the effects of altitude sickness. At over 1,700 metres (or 5,600 feet) above sea level, this is international rugby's highest stadium.

ABOVE: Teams warm up before the match between the Durban-based Sharks and British & Irish Lions held at Ellis Park in July 2021.

OPPOSITE: The stadium is a stroll from downtown Johannesburg. In 2005 Ellis Park made history by becoming the first black-owned stadium in South Africa.

Estadio Municipal de Hanga Roa

Easter Island/Rapa Nui, Chile

Team: Matamu'a Rugby Club

James Grant Peterkin first visited Easter Island in 1996. He wanted to experience what life was like on the world's most remote inhabited island. To give you an idea of just how remote Easter Island is, the nearest neighbours can be found 1,200 miles (1,900km) away on Pitcairn Island, while it's 2,200 miles (3,540km) to the west of Chile – Easter Island falls under Chile's jurisdiction.

For Peterkin, it was a life-changing experience. 'By the time I left three months later, I was captivated by the island, its people, and their unique culture,' he wrote.

He would return in 2001 and eight years later was appointed honorary British Consul for Easter Island. However, some would say Peterkin's greatest contribution was becoming one of the founding members of Matamu'a Rugby Club, which was named in honour of the island's ancient warriors. Peterkin became a key figure in popularising rugby here.

The team is made up of Chileans – who moved to Easter Island having grown up playing rugby in their native country – and the locals, aka the Rapa Nui.

Easter Island forms part of the Polynesian Triangle, which also includes New Zealand and Tahiti, and the team has its own version of the Haka, known as the Hoko. In 2016, the island started hosting a Sevens tournament at the Estadio Municipal de Hanga Roa, a ground with a backdrop quite unlike anything in any sport, let alone rugby.

Two permanent spectators are 20 feet tall and weigh around 20 tons each. They are the Moai, giant statues made from solidified volcanic ash, which are monuments to the dead.

The ground used to be little more than a bumpy patch of land with pitch markings, but as sport has become more popular on Easter Island, the local government decided to invest in an artificial playing surface and introduced facilities to make it a 3,000-capacity multi-purpose sports arena. In 2014, Pele opened the new Hanga Roa Municipal Stadium.

And given its location, when there is a lull in play, spectators can look out to the ocean, and have a moment of spirituality while staring at a Moai.

OPPOSITE: The Moai by Hanga Roa harbour, which overlooks the Municipal Stadium's pitch.

BELOW: Teams from Chile and across Polynesia compete in the Rapa Nui Rugby Sevens.

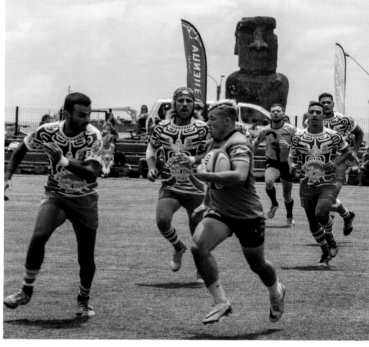

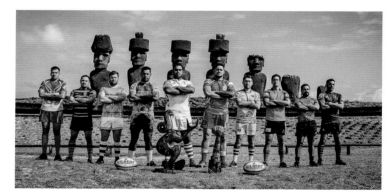

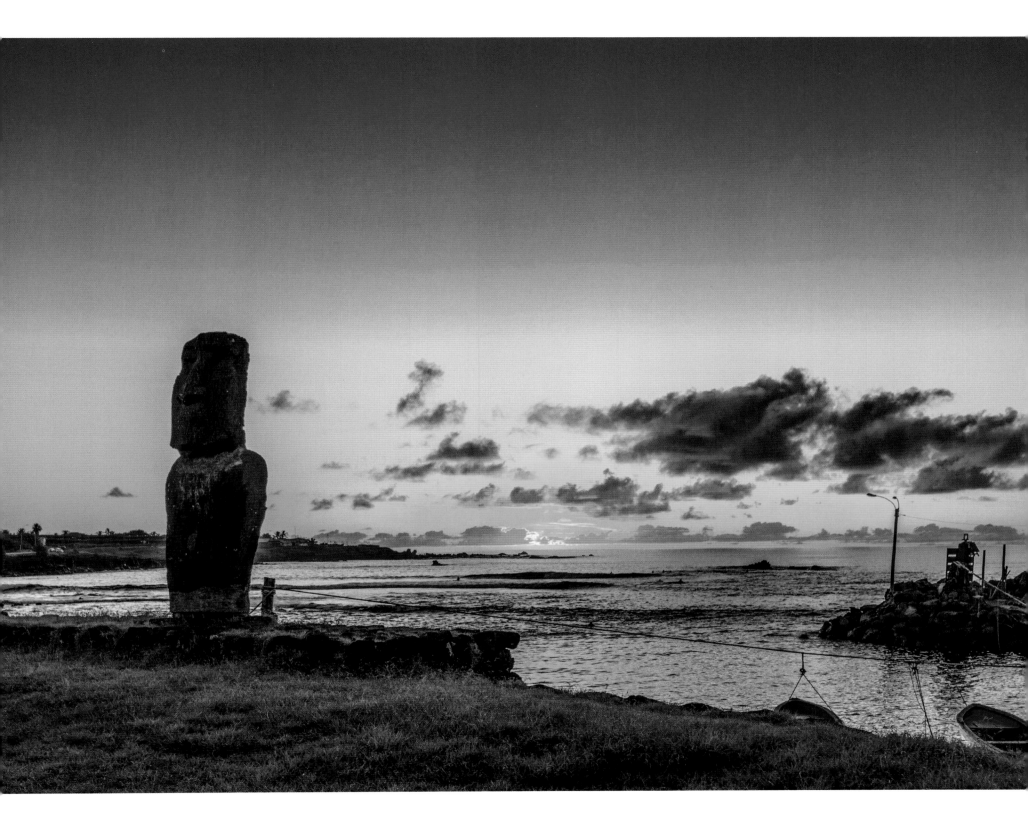

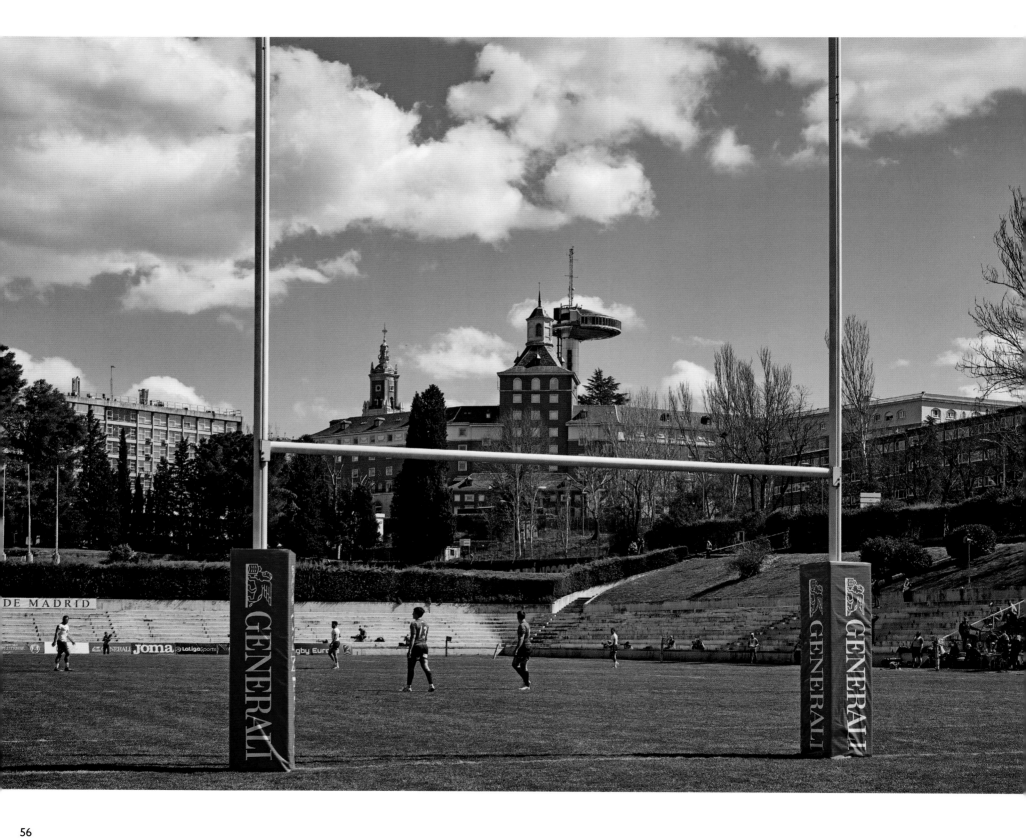

Estadio Nacional Complutense

Madrid, Spain

Team: Olympus Rugby XV Madrid

Spain's national rugby stadium is often simply referred to as El Central. The venue is both a blessing and a curse for the Federación Española de Rugby (FER). It is certainly one of the most picturesque international grounds and feels like a wonderful, tree-lined throwback to a bygone era before corporate hospitality.

There are few finer places to watch the game if the sun is shining; you can grab yourself a seat and crack open a cold Mahou. As much as players, supporters (and sports writers) love El Central, the land is protected, which means there is no scope to develop it. That also means the federation can't make any money from staging matches there because El Central sits within the grounds of, and is owned by, Complutense University in Madrid.

The university's history dates from 1499, when Cardinal Cisneros was given permission by Pope Alexander VI to construct a College of Scholars located in Alcalá de Henares, 35km from the Spanish capital.

The university moved to its current home in 1836, around 5km north of Madrid's city centre. El Central was originally meant to be a multi-use site, until the national rugby team played here in 1954. More recently, the federation's chief exec

has said that in order for the game to grow, the national team needs to move. One can imagine his frustration when it was reported that 15,000 people packed into El Central to see Spain try and qualify for the 2023 Rugby World Cup.

The decision to move may have been accelerated had Los Leones not been disqualified from competing in the 2019 and 2023 World Cups. Indeed, Spain has become the ongoing soap opera of international rugby because this was the second time the country had been kicked out for fielding an ineligible player.

The 2023 version revolved around a picture of South African-born prop Gavin Van den Berg taken at a wedding in his homeland from 2019. This got into the hands of the Romanian Rugby Federation who then presented it to World Rugby. The picture was taken two weeks before Van den Berg had supposedly left Spain, according to the dates in his passport, and his club, Alcobendas, stood accused of falsifying documents. So, Los Leones lost their place in France. And who replaced them? Romania, of course.

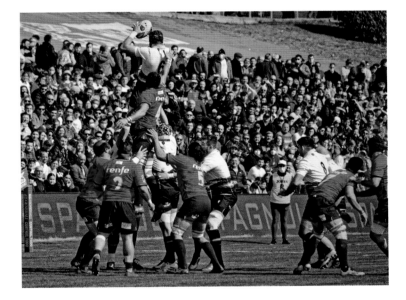

OPPOSITE: The ground is set in the university campus. Complutense de Madrid is one of the world's oldest universities.

ABOVE RIGHT: Spain take on Romania in February 2022 in an ultimately unsuccessful bid to qualify for France 23.

RIGHT: The stadium has an Old World feel, as it should, having been built in 1943.

Estadio Padre Ernesto Martearena

Salta, Argentina

Our Lady of Fatima Parish is around an hour's walk from Estadio Padre Ernesto Martearena Stadium. It was at this church that Father Ernesto served parishioners from 1983 to 2001. He was an extraordinary figure within his community in the city, a man who led projects to improve both public health and the environment.

He wanted to improve the areas that didn't have access to healthcare and played a key role in helping eradicate diseases such as polio, measles, and smallpox within those communities. He also established community kitchens and founded the NGO Programas Sociales Comunitarios in 1993.

All of this makes the circumstances behind how and why he was murdered, on 8 October 2001, so shocking. A few days earlier, Father Ernesto had been filmed by his godson, Javier Alanis Colauste, taking money out of a cash machine. Colauste had noted the pin code and then colluded with Marcelo Castillo, who was one of the altar boys at Our Lady of Fatima, to rob Ernesto of his bank card.

What followed was an act of senseless brutality, as Ernesto was repeatedly stabbed and his body was set on fire in an attempt by the young men to dispose of any evidence. Earlier that year, the Estadio Salta hosted its first matches, having been built to host FIFA Under 20s Football World Championship.

Soon after his death, the stadium was given a new title to ensure his name would live on, not just within Salta but that the wider world would hear about his achievements and his legacy. The ground was designed by Buenos Aires-based architectural firm MSGSSV, which has worked on several famous stadiums, including La Bombonera for Boca Juniors.

The ground itself is rather more functional than remarkable but has been the scene for some of the greatest performances by Argentina's rugby team, famously beating England 24-22 in 2009 and South Africa by 26-24 in 2016.

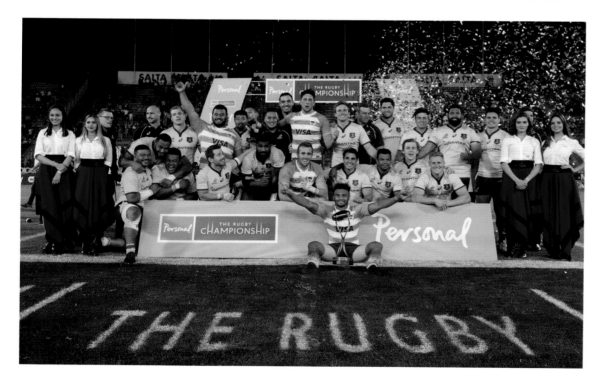

OPPOSITE: The Estadio Padre Ernesto Martearena is an unremarkable structure named after a remarkable man, whose lack of connection with rugby amply demonstrates the esteem he was held in by the local community.

LEFT: The Wallabies celebrate with the cup after a Rugby Championship victory against Argentina at the Padre Ernesto Martearena Stadium on 6 October 2018.

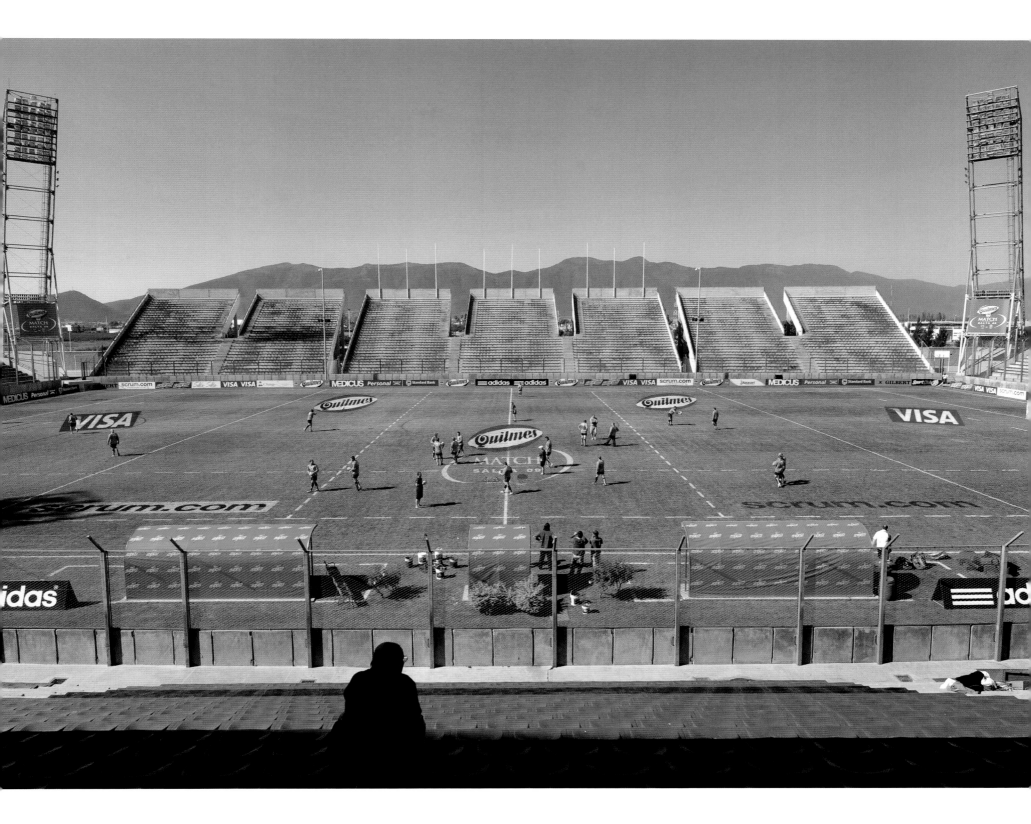

Forsyth Barr Stadium

Dunedin, New Zealand

Team: Otago Highlanders

Before the Forsyth Barr Stadium, there was Carisbrook, sometimes known as the House of Pain. Carisbrook was a ground famous for its intimidating atmosphere. All that structurally remains of its 108-year history is the Neville Street Turnstile – a Category I historic building, which means it is protected.

The Forsyth Barr Stadium, sometimes referred to as the Glasshouse, was built ahead of the 2011 Rugby World Cup in New Zealand. It bills itself as 'the only fully roofed natural turf stadium in the world'.

Although Carisbrook was past its sell-by date, not everyone was in favour of the new ground, largely because of the cost, which came in at NZ $224 million. One of the concerns was that the new ground would only be used on limited occasions. There was a Stop the Stadium march through Dunedin, but the council carried on regardless. Not only was the new venue delivered on time and on budget but is also, in the words of architects Populous, a 'true hybrid', meaning it is both a sports stadium and an entertainment arena.

The roof is much more than just a design feature. It means that a constant temperature can be maintained to allow the grass to grow but also keeps out the elements, including rain (of which there is a good supply in Dunedin), hail or snow, which prevents the pitch from becoming a bog.

In 2016, *Popular Mechanics* magazine named it among the 'World's 20 Most Impressive Stadiums', coming in at ninth, with Munich's Allianz Arena at number one. The ground was in regular use until the pandemic, which suddenly meant that 380 events were cancelled, almost overnight.

Much to the owners' relief, Forsyth Barr, a financial services company founded in Dunedin, renewed its sponsorship for another 10 years in October 2020. The stadium is home to Super Rugby team Otago Highlanders and the Otago Rugby Union. Being a multi-purpose venue, it also hosted matches at the 2023 Women's FIFA World Cup.

OPPOSITE: The Glasshouse keeps at bay the typical 167 days (45%) of rain expected in Dunedin.

BELOW LEFT: The stadium dominates its dockside location.

BELOW: The British & Irish Lions took on the Otago Highlanders at Forsyth Barr in 2017.

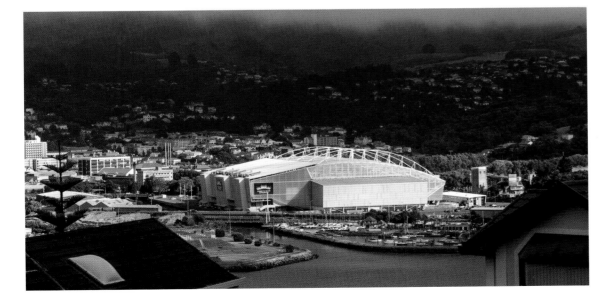

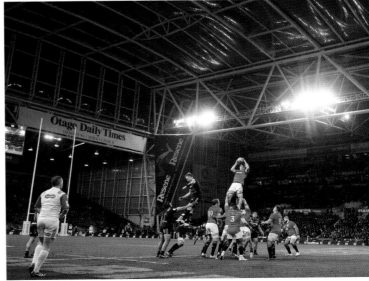

The Greenyards

Melrose, Scotland

Team: Melrose RFC

A year after rugby turned professional in 1995 there were 76 nations affiliated to what used to be the International Rugby Board and is now World Rugby. As of 2023, that figure has risen to 130. The growth of the sport as a global game is obviously to be welcomed, albeit with complications, such as the ability for richer nations to poach the best players from the smaller territories – i.e. the Pacific Islands.

One of the key reasons for that growth is the popularity of Rugby Sevens, the history of which can be traced back to a Scottish village a few miles from the border with England. In 1883, the first Melrose Sevens was held here, making it the world's oldest rugby tournament.

The exact details of why Ned Haig, an apprentice butcher and rugby player, suggested playing a different version of the game remains somewhat unclear, but what is known is that the club was looking for ideas to raise money and Haig suggested staging a sports day that would include a tournament. There wouldn't have been enough time to play 15-a-side matches running to 80 minutes. So, apparently, an idea was born to reduce the teams to seven-a-side and make each match 15 minutes long.

OPPOSITE: A little piece of rugby paradise at the foot of the Eildon Hills.

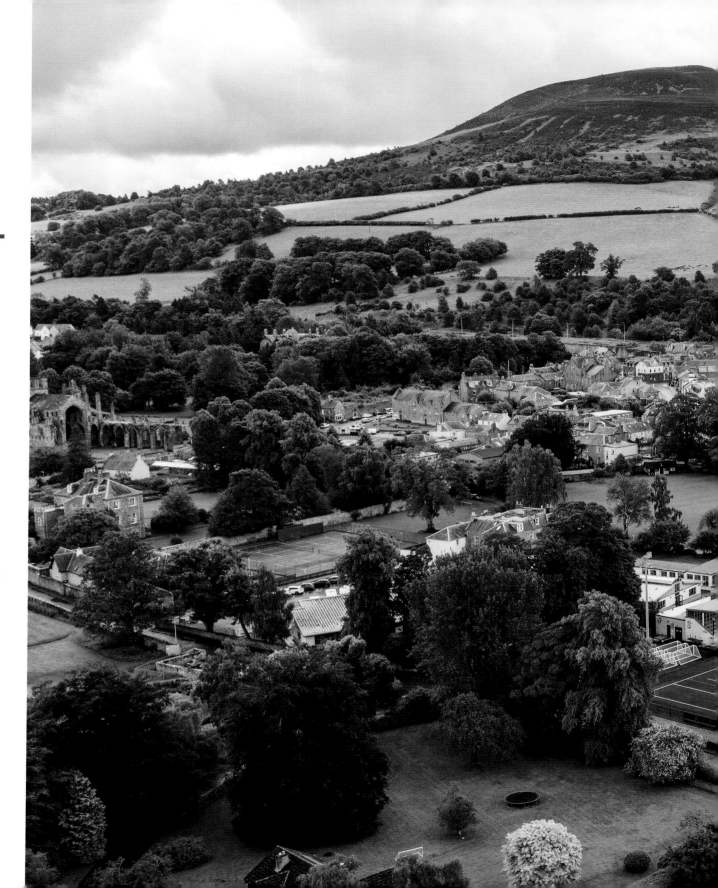

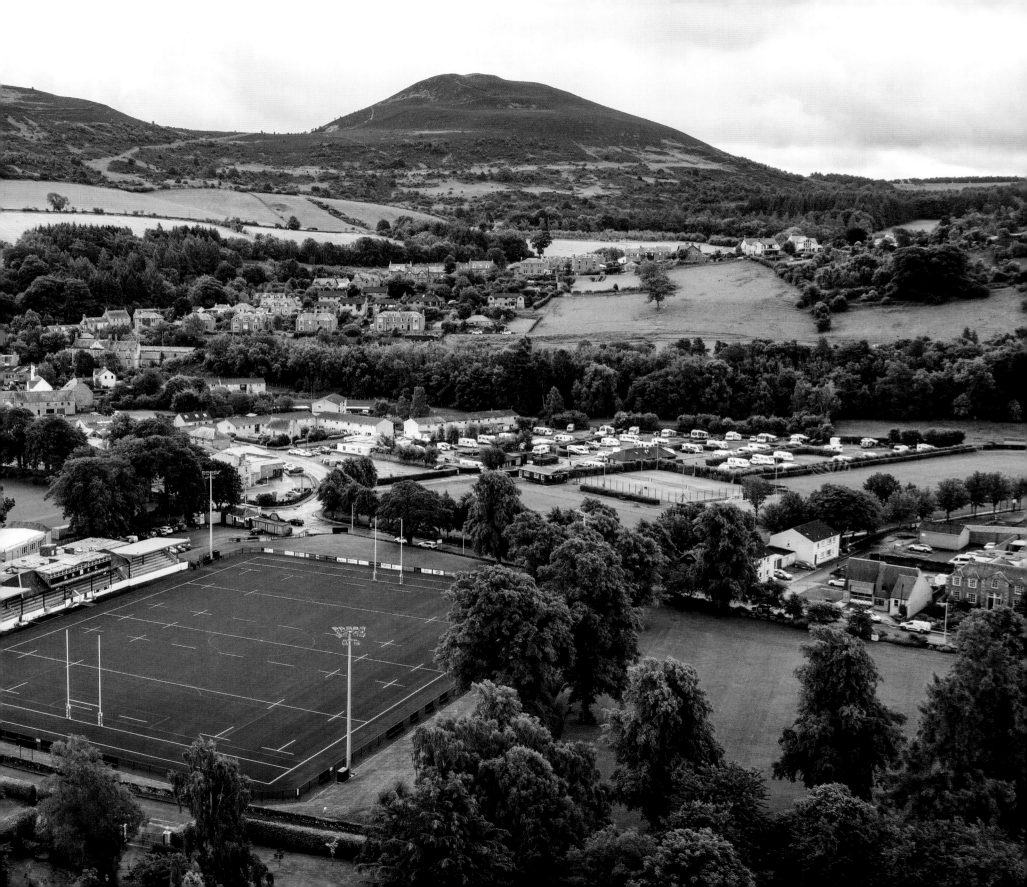

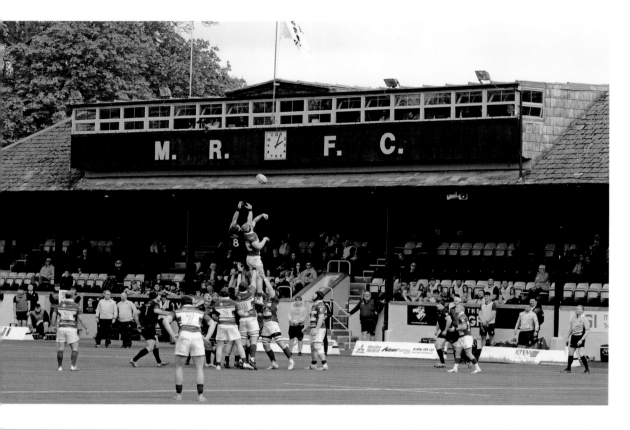

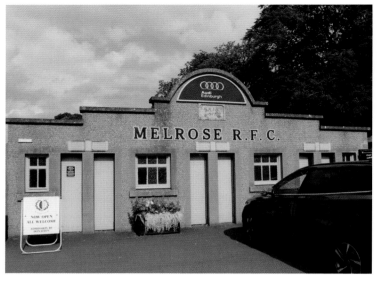

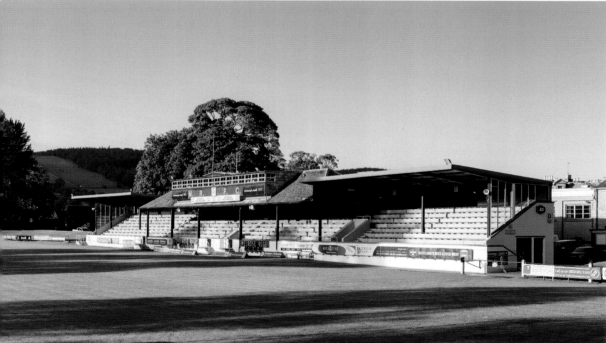

The format soon caught on across the border region both in Scotland and in the north of England and is the game's great modern success story, as Sevens rugby is now an Olympic event. Just as the sport can trace its roots back to Rugby School, the Hong Kong Sevens, Singapore Sevens, Dubai Sevens and even the Battleship Sevens (see page 26) came about because of Ned Haig's revision of the main game. The Melrose Sevens attracts teams from around the world and when they arrive here they find themselves competing in one of the most beautiful places to play rugby in the British Isles, with the triple peaks of the Eildon Hills looming in the distance.

The Main Stand, which is the only permanent stand, includes a press box that was built into the roof in the 1930s, but the club has ambitious plans. In 2019 a new 3G pitch was installed. Traditionalists, understandably, will always bemoan the loss of a turf pitch, but the club will say the trade-off is that more teams, especially young boys' and girls' teams, can use the pitch. There are also plans for a new main stand. Michael Laird Associates, who have recently completed phase 1 of the Edinburgh Accies' elegant new sports facility on the site of the first

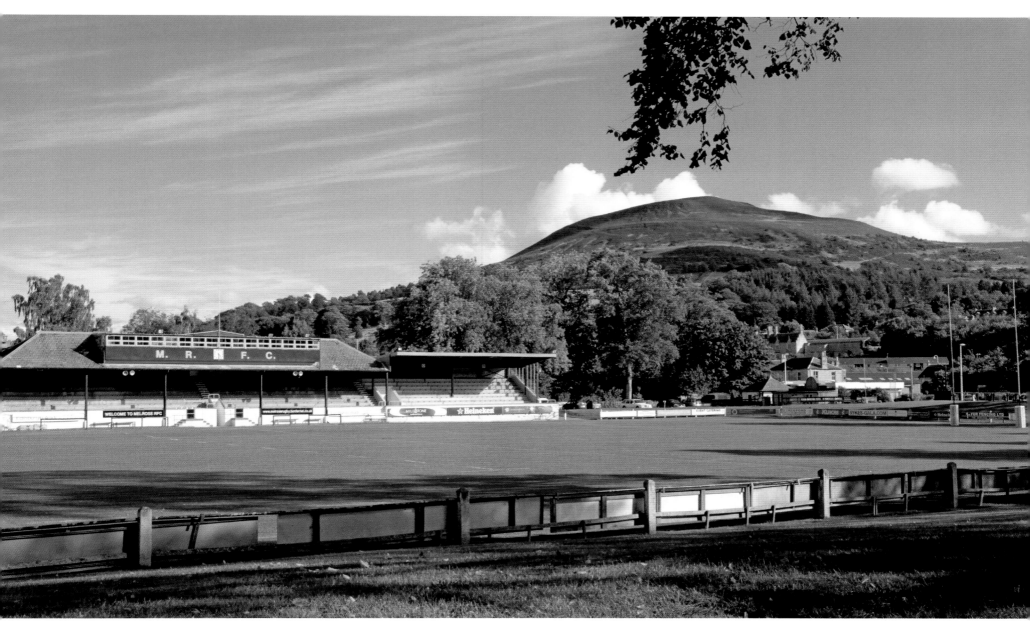

international rugby match between Scotland and England in 1871, have created proposals and concepts for a 21st-century Greenyards. The long-term vision is that the ground will become one of the venues for the World Rugby Sevens jamboree in 2033 when the sport will celebrate its 150th birthday.

ABOVE: Radical change has been proposed for this historic ground, which is always the cue for heated debate.

OPPOSITE TOP LEFT: Southern Knights (Melrose) take on Watsonians at the Greenyards as part of the FOSROC Super6 series launched in November 2019 featuring six franchise teams, with part-time professional players and full-time coaches.

OPPOSITE BOTTOM: Melrose is one of the few club grounds to have its own press box.

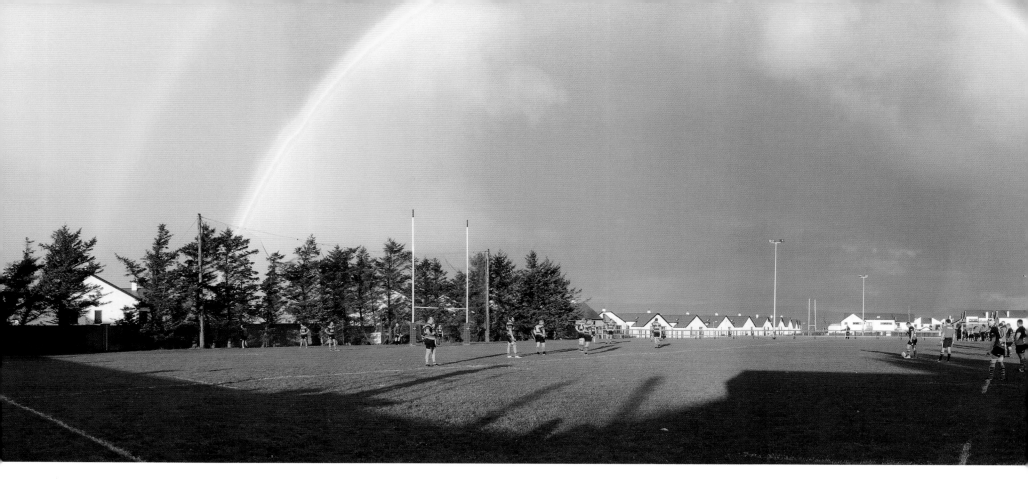

Hamilton Park

Strandhill, Sligo, Ireland

Team: Sligo RFC

In Irish mythology, buried at the top of Knocknarea Mountain is the megalithic tomb of the 'Warrior Queen Maeve of Connacht', also known as Queen Maeve's Grave.

Knocknarea scales up to around 320 metres at its peak, and if you look north on a clear day you can see Donegal Bay and past Strandhill to Coney Island. Although there are several Coney Islands dotted around Ireland and several interpretations of how the New York version got its name, it is said that when Sligo-born Peter

O'Connor sailed into New York in the late 18th century, he saw a peninsula at the end of Long Island that reminded him of his mother country and the rest is... etc.

Sligo is one of Ireland's oldest rugby clubs, and was founded in 1890. The ground gets its name from the father-in-law of former club president George Draper, who sadly passed away, surrounded by his club-mates, on a return trip to watch Ireland play at Lansdowne Road.

And the importance of family ties extends to the clubhouse, which is named after George Hamlet,

the son of George T. Hamlet, who was capped 30 times for Ireland, including eight occasions as captain, and who served as President of the Irish Rugby Football Union in 1926/27.

Given that football (or soccer to avoid confusion in Ireland, where there are three footballs) is the sport that dominates in Sligo town, coupled with the strength of Gaelic Football throughout the rest of the county, it is a testament to how well the club is run that it not only continues to grow its membership but also has eight minis, or juvenile teams, along with ten youth teams – boys and girls.

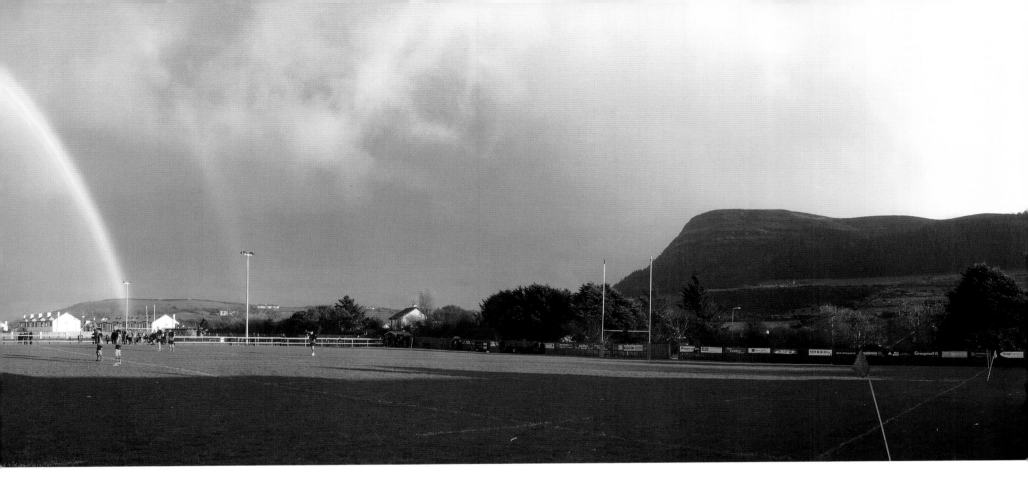

Up until 2016, the club would have struggled to accommodate 21 club teams. The weather has a habit of causing havoc at Hamilton Park, and the grass pitch would often take a battering from the elements. So, a new 3G playing surface was installed which, combined with the main pitch and second pitch, allow for a busy schedule of matches and training.

All of which means that if you visit one of the most scenic parts of Ireland, there's a fair chance you can also see a match at one of the most scenic grounds. And pay your respects to Queen Maeve.

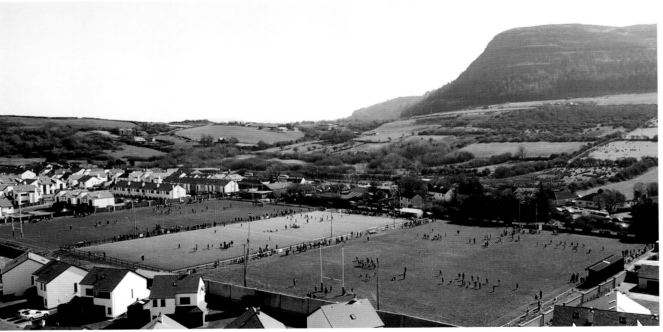

ABOVE AND RIGHT: Knocknarea Mountain looms over the pitches at Hamilton Park

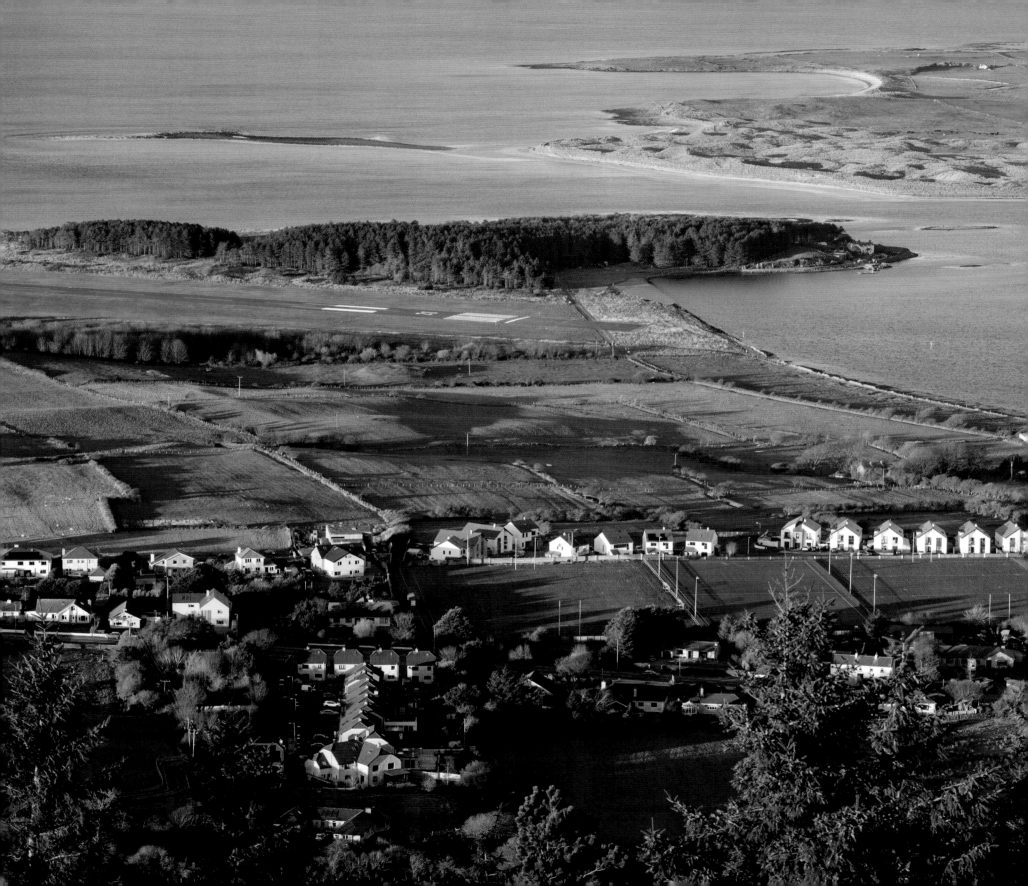

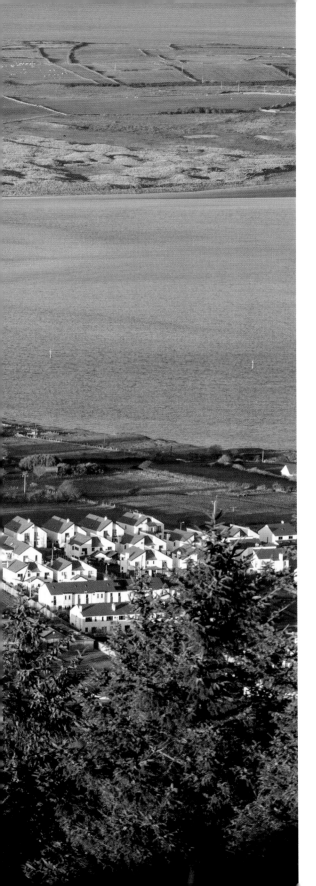

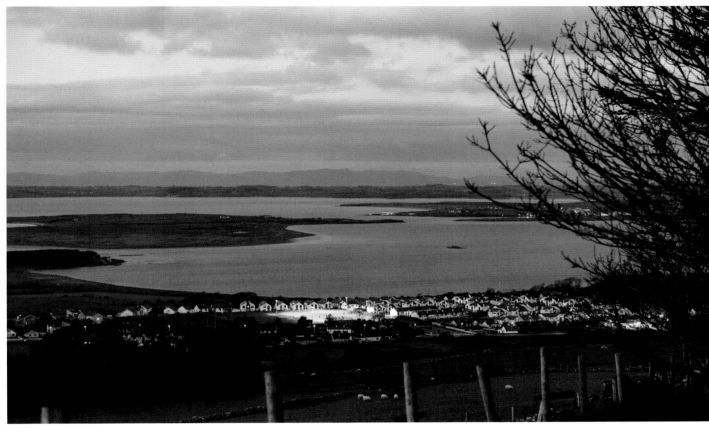

RIGHT: Knocknarea as viewed from the First XV pitch.

OPPOSITE AND ABOVE: Hamilton Park as photographed from Knocknarea by Conor Doherty, who finally ventured up the mountain in 2023 following a spell of frost followed by prolonged spells of rain, but was perfectly placed just as the floodlights came on. Coney Island is visible beyond, with Sligo Airport runway to the left.

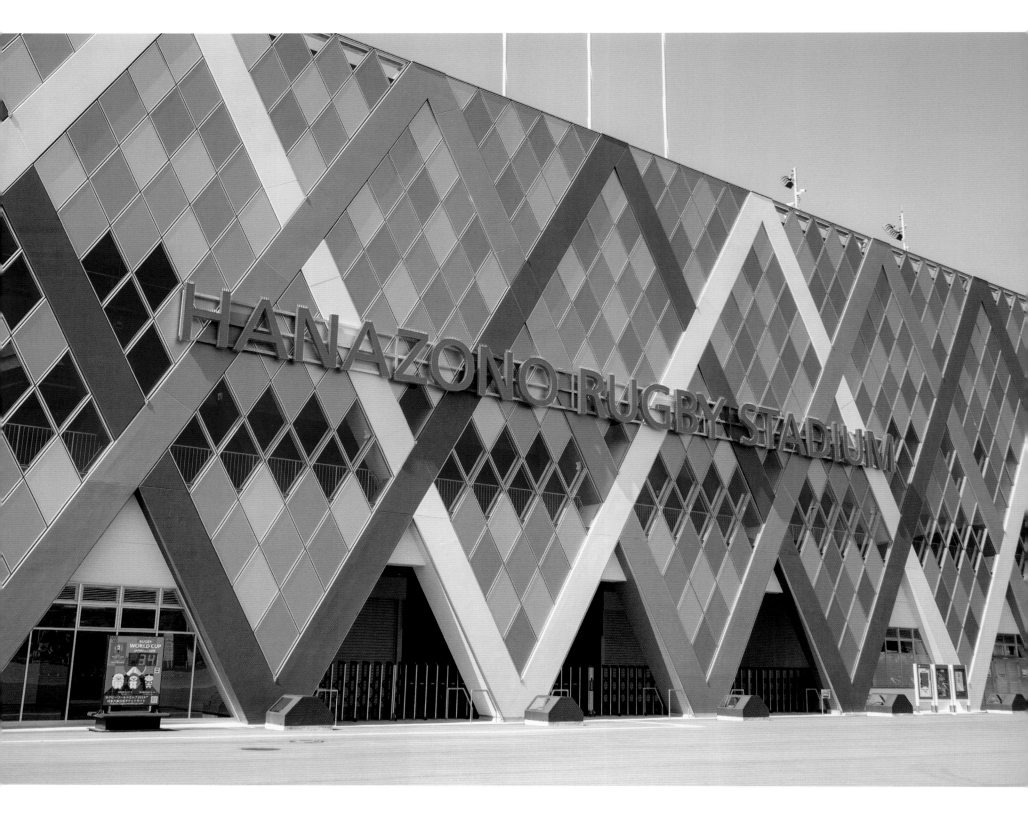

Hanazono Rugby Stadium

Osaka, Japan

Team: Hanazono Kintetsu Liners

Of all the venues that hosted games at the 2019 Rugby World Cup in Japan, Hanazono was the first to be specifically built to host rugby.

In October 1928, Prince Chichibu (see Chichibunomiya Stadium on page 34), was travelling on a train run by Osaka Electric Orbit Company, when he saw a vast expanse of empty land next to the railway line. 'Rugby is becoming popular these days,' he noted, 'so why don't you build a stadium around here? You could increase both passengers and revenues.' Or words to that effect.

Within two months, the Company decided to build what would become Asia's first rugby stadium, situated on the outskirts of Osaka. It was apparently modelled on Twickenham and, depending on which version you believe, the capacity was anything from 12,000 to 30,000.

During World War II, the metal roof covering the main stand was handed over to the government as part of the country's Metal Recovery Act, which later became part of a strategy to rebuild the nation after the conflict, owing to scarcity of materials and commodities in Japan.

Oxford University has played here on several occasions and provided the opposition for a match against Japan's national team (known as the Cherry Blossoms) to celebrate when the ground was renovated and reopened in 1992.

When it was announced that Japan would be hosting the 2019 Rugby World Cup, it provided the impetus and money to create a modern rugby stadium. Work began in 2017, and for the exterior, Japanese architectural firm Azusa Sekkei created a 'Scrum Screen', a diamond-shaped, lattice façade that is meant to represent players interlocking for a scrum, but also represents a motif in Japanese culture and design. The ground, which now has a capacity of 26,000, would go on to host four World Cup matches.

Inside, the stadium celebrates not only the history of this ground but also the part it has played in the history of rugby in Japan since opening in 1929. Throughout that time it has been the home of Hanazono Kintetsu Liners, who play in League One of Japanese Rugby.

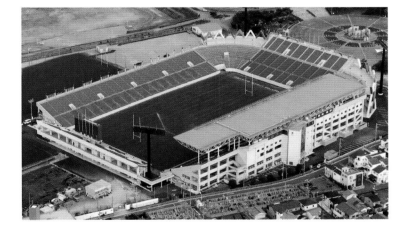

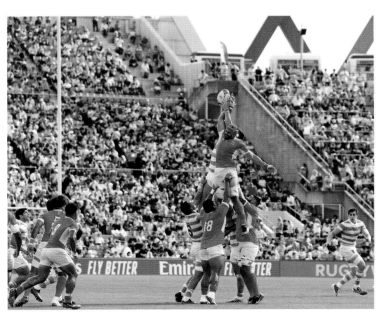

OPPOSITE: The distinctive 'Scrum Screen' lattice façade of the rugby-dedicated stadium.

ABOVE RIGHT: Hanazono was the setting in 2006 for Japan winger Daisuke Ohata to break David Campese's record for most tries scored in rugby Test matches.

RIGHT: Argentina take on Tonga in Pool C of the 2019 Rugby World Cup.

Haven Oval

Terrigal, New South Wales, Australia

Team: Terrigal Trojans

Gosford's Central Coast Stadium may be one of rugby's most scenic venues, but if you come out of that stadium, take a left on the Central Coast highway and keep heading eastward for about eight miles you will eventually arrive at a place that bills itself as 'the most beautiful rugby ground in the world'.

The Haven Oval on Broken Head is home to the Terrigal Trojans. The team was founded in 1975 but nearly folded almost as soon as it had started as the club struggled to put an XV together. So they contacted the local surf club, which was also short on numbers, and together they supported each other. The Trojans' first match took place on 3 May 1975, eight miles down the road on the same site as the Central Coast Stadium, when it was known as Grahame Park.

The Trojans' first official home ground was five miles inland and had none of the aesthetic pleasures provided by Broken Head. That said, when the team moved to the Haven Oval in 1977 it seemed, at first, like somebody had made a terrible mistake. The pitch had no drainage, and the first match was played in heavy rain. Five years (and plenty of irrigation work) had passed before the club secured the use of the disused toilet/laundry block and converted it into a clubhouse on a site shared with a caravan park. Decades of fundraising eventually provided the Trojans with enough dollars to build a new clubhouse that would make the most of its prime position.

The clubhouse, which opened in 2019, is built on a bank and provides a glorious ocean view of the South Pacific. Alternatively, if you want to watch the action from another fantastic (if distant) viewpoint, you can take a walk up the elevated stretch of land behind the pitch known as the Skillion, which at its peak, is about 150 metres (500 feet) above sea level.

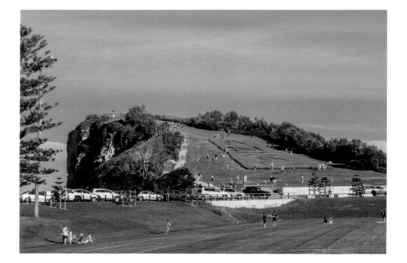

RIGHT: A view of the Skillion from the Oval pitch, in this instance used for a Remembrance Day display.

OPPOSITE AND OVERLEAF: Two aerial views of the Haven Oval pitch. Terrigal is a surfing destination north of Sydney, while Kiama (see page 94) is a similar distance south of Sydney.

BELOW: During the summer months, the Oval is used by the Terrigal Matcham Cricket Club.

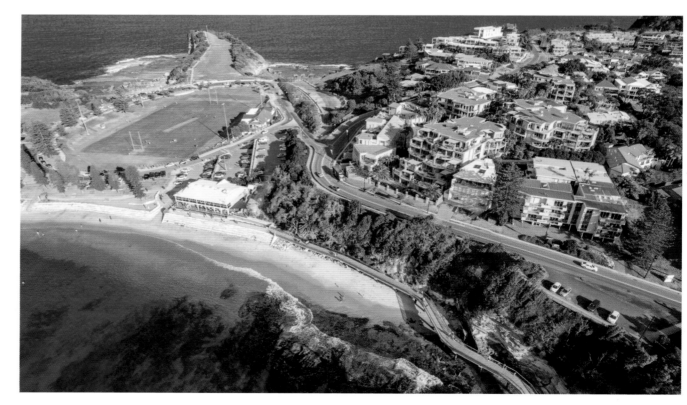

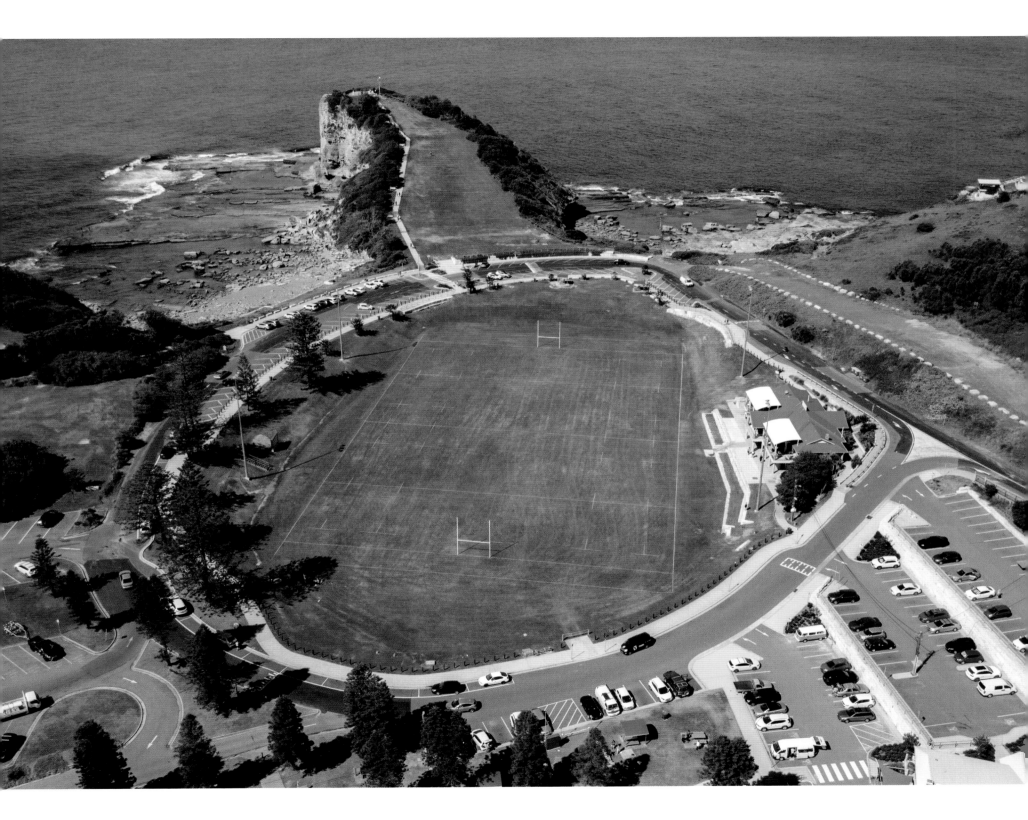

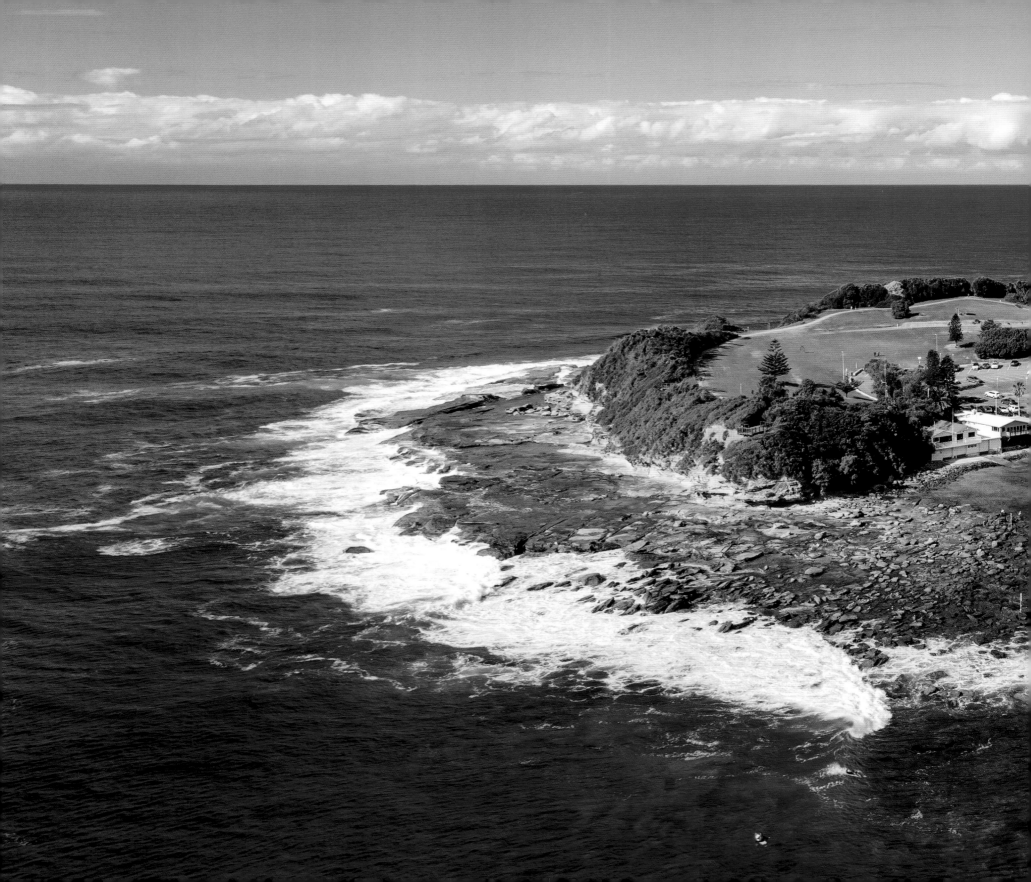

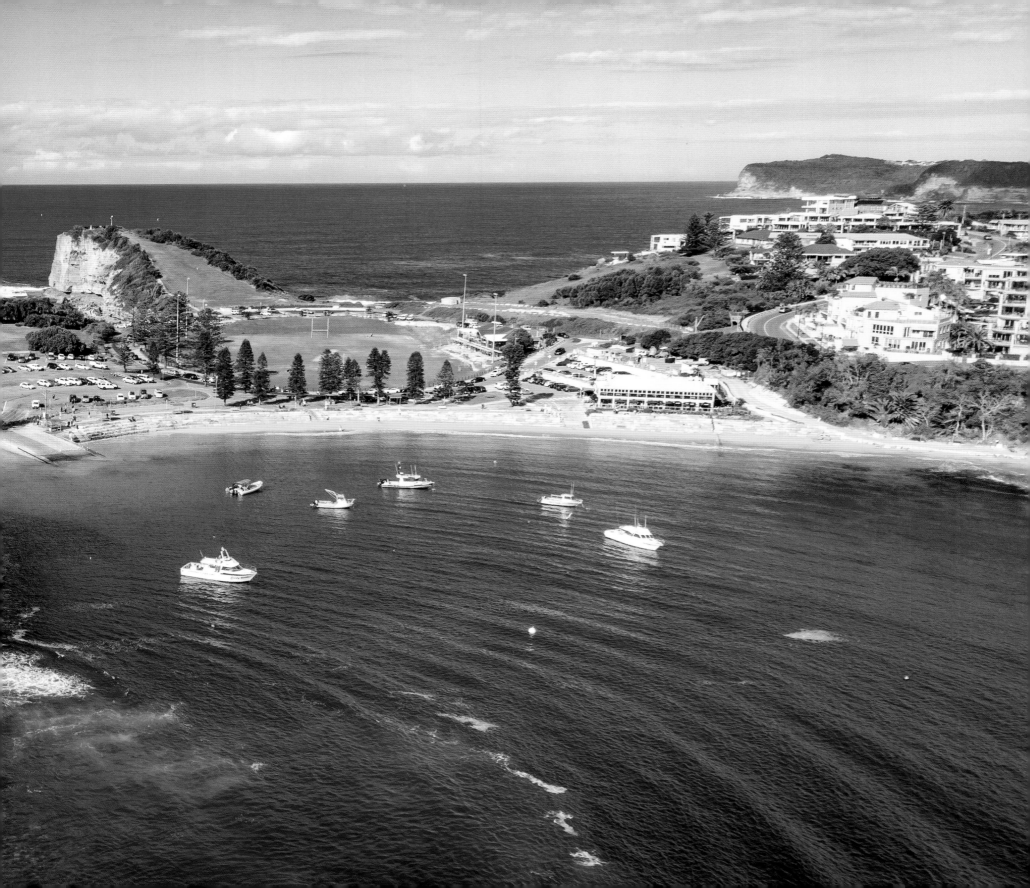

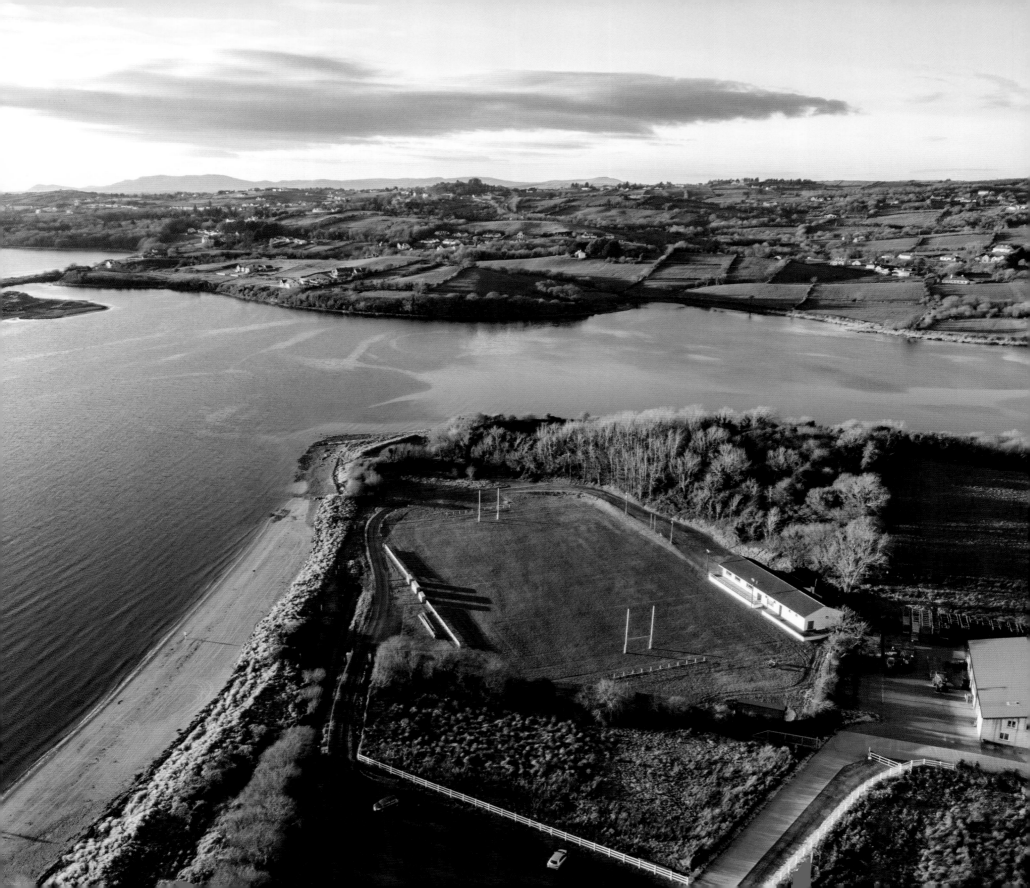

The Holmes

Donegal, Ireland

Team: Donegal Town RFC

County Donegal is home to not one but two of the most stunning sports grounds in the world. The first is Old Killybegs GAA Pitch in Fintra. In March 2022, US sports and business writer Joe Pompliano, who has around 500,000 followers on Twitter, compiled a list of the 50 most beautiful sports grounds, and at number 11 in the charts was Killybegs.

The other one is 20 miles along the coast, and is the 'hidden gem', although perhaps not quite so hidden given the exposure in this book. It's not just the idyllic setting, which we will come to later, that makes Donegal Town RFC remarkable.

The club was founded in 1973 following an informal meeting in a room at the local cinema. The four founders, Roy Irwin, Charlie McGinty, Jack Ramsey and Alrick Thompson, decided to start a rugby team in a part of the world that was dominated by Gaelic football. It was very much a DIY affair – the rugby club's home ground was a grazing field and the 'clubhouse' was a hotel bar.

Soon, Donegal Town, who today play in Ulster Provincial Rugby North, came to represent something more substantial. 'The Troubles' of the 1970s was a violent and bloody conflict that claimed thousands of lives and ripped apart communities that became divided on sectarian lines. In this time, the team would often venture from southern to Northern Ireland to play matches, breaking down religious, social and sporting barriers, helping to popularise the sport along the way.

Having been a nomadic outfit, hopping from ground to ground, the team secured a permanent home in 1980, by purchasing land next to Holmes Beach which overlooks Donegal Bay. Perhaps the reason the ground hasn't been enjoyed by a wider audience is that it is tucked away from the main tourist traps.

The photographer who took these wonderful shots is Conor Doherty. He explains: 'You've got mountains right next to the sea, the forest, lakes, and they're all very close together here. You're within 10 minutes of all these different environments. There's this kind of "signposted beauty" but often those sights become very busy.

'Little places, like where you'll find the Donegal Town pitch, where you're turning off the main road for just five minutes, are not somewhere that people would usually go. There's just incredible beauty to this coast that is largely unseen. Hopefully, shots like this help people to appreciate what a stunning place it is.'

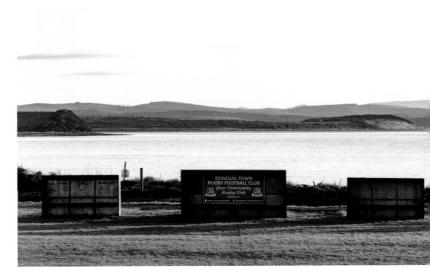

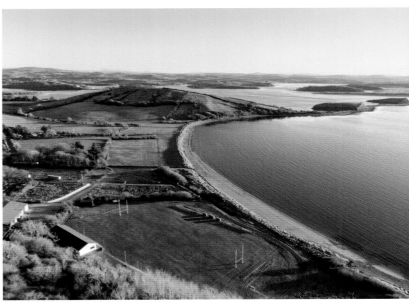

ABOVE RIGHT AND RIGHT: Looking past the rugby ground towards the islands at the entrance to Donegal Bay.

OPPOSITE AND OVERLEAF: Not only is Donegal Town Firsts' pitch a contender for the World's Most Beautiful Rugby Ground, the Seconds' pitch runs it pretty close.

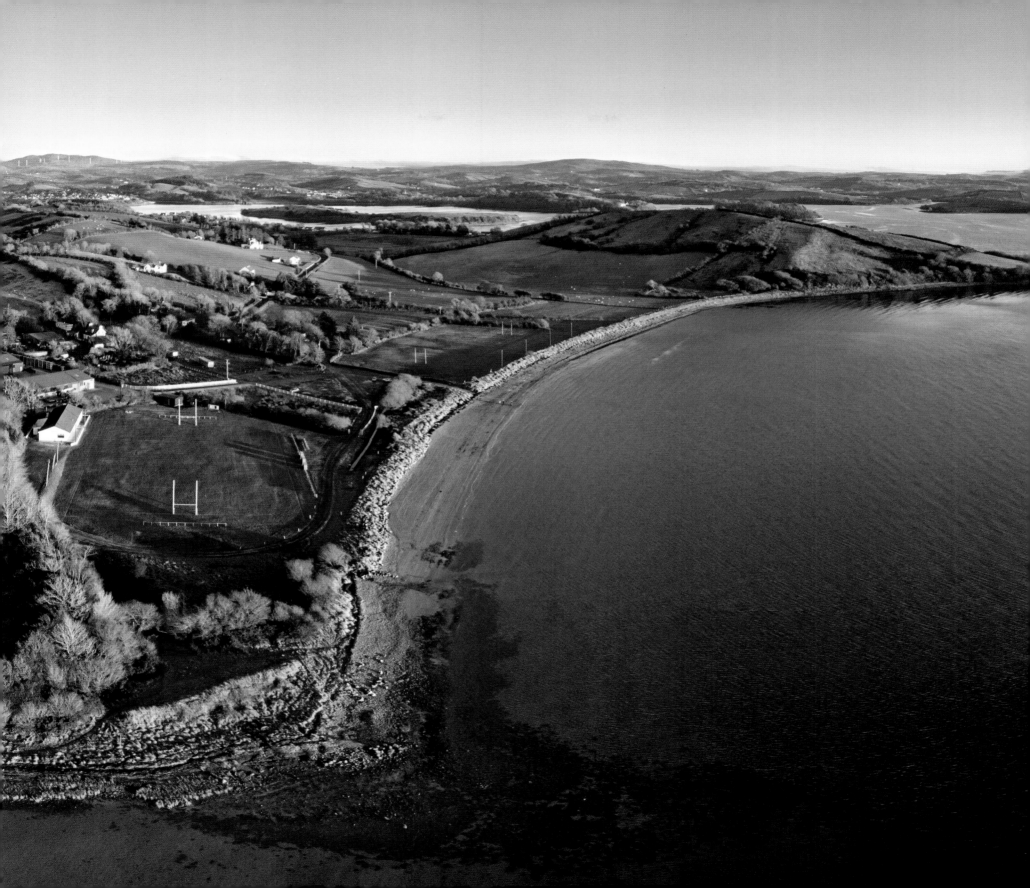

Hong Kong Stadium

So Kon Po, Hong Kong, China

Hong Kong endured one of the strictest lockdowns of any territory during the pandemic. The frenzied financial district was suddenly reduced to one of the most isolated cities in the world. This land of opportunity, which had experienced population growth every year dating back to 1961, declined for the first time in 2020.

So, when the Hong Kong Rugby Sevens tournament returned to the stadium in November 2022 following a three-year hiatus, it represented something far bigger than the event. It was a country reminding itself what life used to be like.

The Hong Kong Rugby Sevens is the biggest event on the HSBC world jamboree – this is also the only ground to have staged the Rugby Sevens World Cup on two occasions.

Sevens Saturday is the big event, and the atmosphere in the South Stand can be pitched somewhere between an England one-day cricket international, a US college football game and the World Darts Championships. It is the one area of the ground that serves alcohol, and most of the stand is in fancy dress. The first drinks are downed shortly after 8am; by lunchtime it is Hong Kong's biggest party zone. Although it's probably not advisable to turn up dressed as Winnie the Pooh...

The stadium is approaching its 30th birthday, and while the structure has stood the test of time, for much of that time it was a Premiership-standard stadium with a National League-standard pitch. In 2015, $100 million was spent on finally trying to rectify the problem and, like many modern stadiums, the pitch is now a mix of turf and synthetics. There have also been issues with sound quality and noise pollution and it is about to be downsized, to a 10,000-capacity arena.

The construction of the Kai Tak Sports Park, which will include a 50,000-capacity stadium, will immediately make it Hong Kong's premier ground, and it is set to become the new home of Rugby Sevens from 2024. For some rugby fans, but, more specifically all party animals, the test of whether the Kai Tak is a success or failure will be if it can replicate the organised chaos of the South Stand of the Hong Kong Stadium on Sevens Saturday.

OPPOSITE: Party Sevens – a view from the fun-loving South Stand with spectators equipped for a downpour.

BELOW: Sombrero-wearers outnumber the Marilyns in 2019, the last tournament before lockdown.

BOTTOM: The Hong Kong event has firmly established itself as the world's leading Sevens tournament.

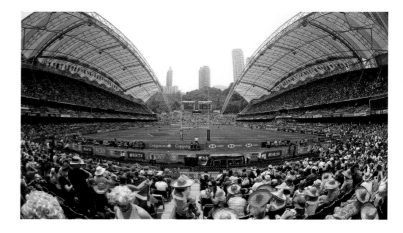

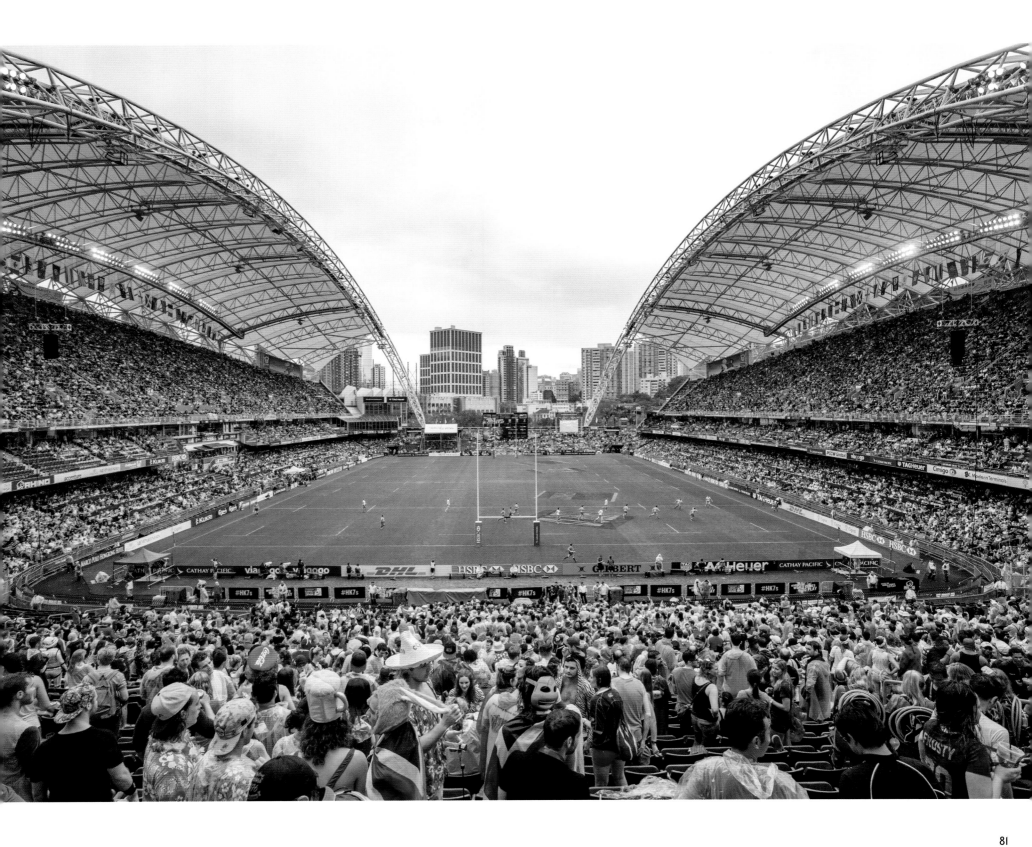

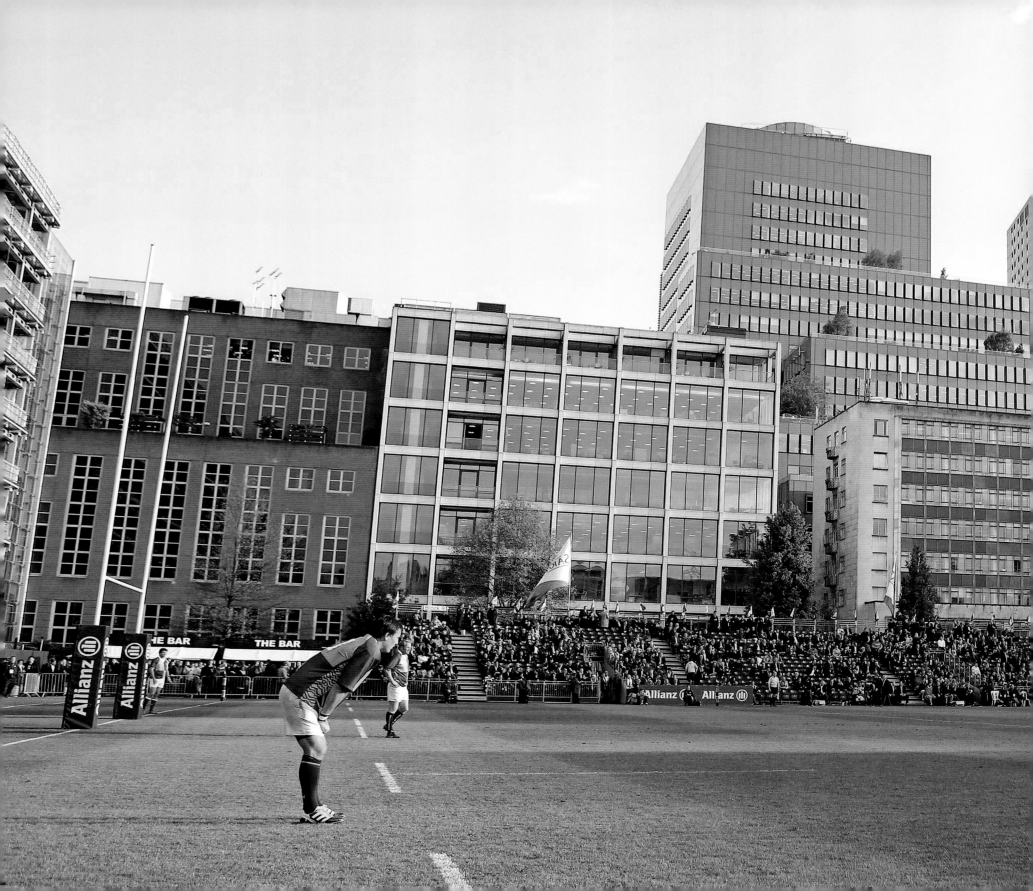

Honourable Artillery Grounds

London, England

Team: Honourable Artillery Company RFC

'One of my favourite things is arriving at the ground early, getting changed, waiting to greet the opposition as they're coming in, and then watching the expressions on their faces as they walk through the gates.' Andy Hughes is the Honourable Artillery Company rugby club's joint captain. Some 15 years after making his debut here, the joy he gets from simply turning up to play is palpable. It's easy to see why.

LEFT: Saracens take on a South African Barbarians side in the heart of the city.

BELOW: Four slightly embarrassed men forced to do a photocall outside the HAC headquarters in June 2022 with the Gallagher Premiership Trophy: Mark McCall of Saracens, Steve Borthwick of Leicester, Chris Boyd of Northampton and Tabai Matson of Harlequins.

HAC RFC is tucked away between the hipster heartland/tech hub that is London's Old Street and some of England's most prestigious and oldest legal firms. It is the capital's most centrally located rugby ground, and it is some location. The six-acre site is home to the Honourable Artillery Company, Britain's oldest regiment that was founded by Henry VIII in 1537 and has been based in London EC1 since 1641.

A report from 1995 in *Rugby World* observed that, 'if you covered the ground with an inch of gold the ground would still be worth more.' You could probably add another inch or three since then, but because of the HAC's charitable status, it means the land is protected from being sold off by the government.

The site is still primarily used 'for military exercise and training and for the better defence of the realm'. Hughes adds, 'It is still one of the few places in Central London that could immediately go into lockdown at a time of emergency.'

Back in 2005, the attention of the world's media was squarely focused on HAC. In the wake of the London 7/7 bombings, the playing field was converted into the site of a temporary mortuary for the 52 victims. However, thousands of people walk past the HAC grounds every day and

only a handful may know that it is home to an immaculate rugby pitch.

'There are guys who have worked in the city for 10 years, and they still really have no idea this exists,' says Hughes. 'They will have noticed what looks like a small castle on the City Road and thought, "well, that's interesting", and carried on walking.'

The rugby team was originally made up of servicemen, but by the 1970s it became harder to put a team together. It was around this time that the club was opened up to civilians. That said, most of the current side which won London North West Division 2 in 2022 and plays its rugby in Regional Anglia 2, has some sort of military connection.

Hughes adds, 'And you'll find that most of the team work in and around the city, although they're not all the stereotypical sort of city boy. We've got guys who are musicians, teachers, charity workers ... one of the strengths of the club is that it's a real mixed bag of professions and backgrounds.'

It is also one of the few places where the civilians will dine in the same mess hall as the servicemen. As Hughes succinctly says, 'There are so many things that happen here, but don't and couldn't happen anywhere else.'

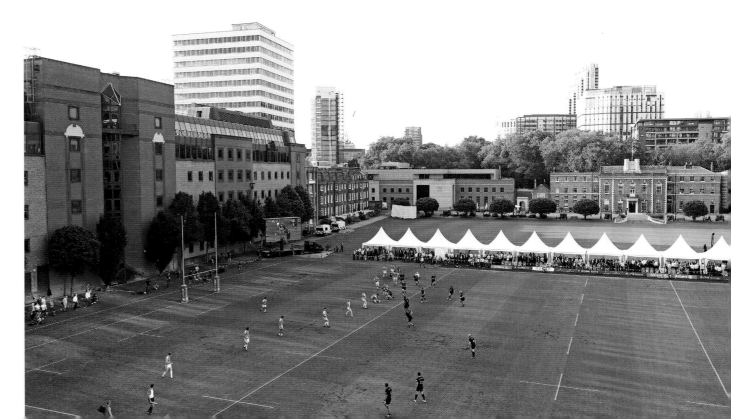

OPPOSITE: An aerial view of the HAC grounds looking towards the Shard and the City of London in 2013.

ABOVE RIGHT: The HAC brought along one of their pieces to fire after the anthems at a Six Nations match at Twickenham.

RIGHT: Looking down on the Saracens vs Ospreys friendly at the Honourable Artillery Company in August 2018.

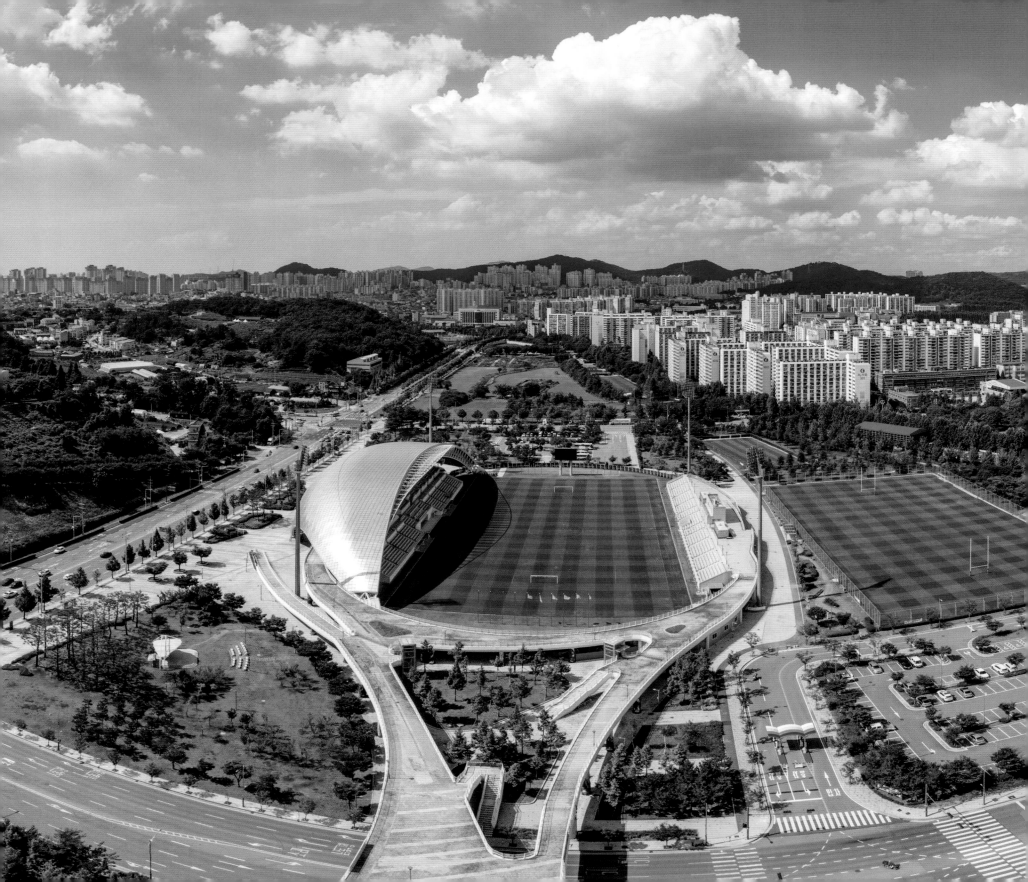

Incheon Namdong Asiad Rugby Field

Incheon, South Korea

When South Korea hosted the Olympic Games in 1988, President Roh Tae-Woo campaigned for rugby to be included for the first time since 1924. Roh played rugby in his youth, and the nation enjoyed some success in the 1980s, winning the Asian Championships on three occasions. Exactly how close he was to succeeding is open to interpretation but he remains the country's most famous rugby fan and player.

Tae-Woo was the country's first democratically elected prime minister, but on the spectrum of political leaders who played the sport, he is closer to Idi Amin than Che Guevara. On the eve of the Games, students burned an effigy of Tae-Woo and accused the government of using the event to legitimise a repressive regime – sportswashing is far from a new concept.

Tae-Woo was, however, adept at international diplomacy and navigated problems that could have overshadowed, or even destroyed, the Games. It marked a key moment in history for the country, both culturally but also as an emerging force in sport. His departure from office in 1993, followed by three years in prison for corruption, meant rugby was no longer on the list of personal interests for a South Korean president.

Progress on the rugby ground stalled until 2014. The Asiad Rugby Field was built to host several events, including rugby, at the Asian Games, the second biggest sporting event on the planet after the Summer Olympics. In total well over $1.5 billion was spent on building new venues across the host city, Incheon, including a domed indoor arena and the rugby field, which are connected by pedestrian walkways built above main roads that lead into the city centre.

The rugby field's capacity is just over 5,000, and although it is fanciful to think the South Korean team will become a force in the game, they only lost by 21-23 against Hong Kong in the final of the 2022 Asian Championship, which also, sadly, meant being eliminated from the World Cup qualifying process.

OPPOSITE: Incheon's stadium as viewed from above the domed indoor arena.

BELOW LEFT: Members of Japan's Brave Blossoms national rugby team acknowledge the crowd after beating South Korea 47-29 in their Asia Rugby Championship game in 2017.

BELOW: The stadium set up for a match between Japan Women and Uzbekistan Women at the Asian Games.

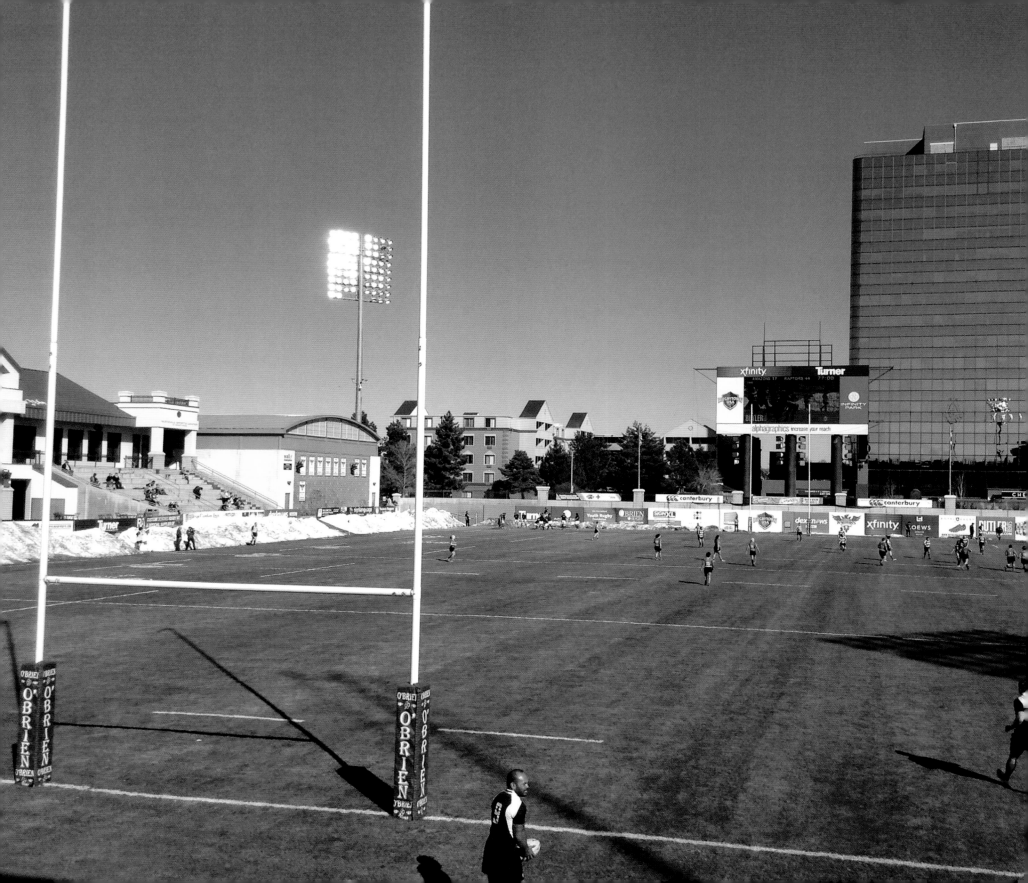

Infinity Park

Glendale, USA

Welcome to RugbyTown, USA. Mike Dunafon is the Mayor of RugbyTown, aka Glendale, Colorado, on the outskirts of Denver. At one time Dunafon – a man for whom the expression 'bit of a character' could have been invented – had an NFL contract with Denver Broncos, only to tear both hamstrings and be dropped from training camp. So, he sold his house, bought a boat, and sailed to the Caribbean, to carve out a career as a musician and stand-up comedian.

During that time, he first became exposed to rugby and played for the British Virgin Islands RFC. He returned to America, became a coach, also went into politics, and was elected Mayor of Glendale in 2012. Two years later he stood for Governor of Colorado, where he campaigned to legalise cannabis and received public support from Snoop Dogg.

He also wrote a paper called 'The Game of Life' in which he put forward the case for rugby as a sport that can build a community. It was the foundation of his pitch to convince the city council that it was worth spending millions in public funds to redevelop Infinity Park, an underused space in the centre of Glendale, and transform it into RugbyTown, USA.

Infinity Park is now a 5,000-capacity, purpose-built rugby ground. It is also home to a sports centre, an event centre, a public park, and the world's only high-altitude rugby training centre – although one could argue demand for such a facility might be somewhat limited outside of Denver unless you're preparing to play South Africa.

In 2019, Infinity Park hosted the HSBC Women's Rugby World Sevens, and Dunafon will be eager to see RugbyTown feature in some capacity during the Rugby World Cup in 2031, possibly as a training camp. RugbyTown is also home to the XO (crossover) Academy, designed to bring in the best talent that didn't quite make it in other pro sports – the obvious one being American Football – and provide the foundation for a US rugby team.

Dunafon's passion for the sport and significant commitment to promoting it has prompted US Rugby Foundation Executive Director Brian Vizardo to say that the 'biggest impact on rugby in America is the development of RugbyTown USA in Glendale, Colorado.'

OPPOSITE AND TOP RIGHT: Cleared snow lines the side of the pitch at Infinity Park, which is situated 1,609 metres, or 5,280 feet, above sea level.

ABOVE RIGHT: Glendale hosts regular Sevens competitions.

RIGHT: Military members from all US armed services remember fallen comrades before competing in the 2018 Armed Forces Rugby Sevens Championship at Infinity Park.

José Amalfitani Stadium

Buenos Aires, Argentina

Team: Jaguares

The eponymous José Amalfitani was a 'jack of all trades' that included a brief stint as an actor as well as being a sports journalist, football club president and construction manager. In 1940 he bought a plot that was effectively swamp land and said words to the effect of 'we'll build a stadium on this swamp', prompting other property developers to question his sanity.

That land was drained and, much like the Alaskan Rugby Ground (see page 16), Amalfitani convinced all the local contractors to use whatever leftover materials they had from any construction project to fill the site, although he paid the workers with the guarantee of tickets to see Velez Sarsfield, the football team which still plays here.

In 1943, Jose Amalfitani Stadium Mk.1 opened. Four years later the wooden stands were taken down to be replaced with a stadium made of concrete. Although it took 10 years to finance and construct, when the new ground was inaugurated in 1957 it was one of the finest in South America.

The last significant change to the stadium occurred in 1978 ahead of Argentina hosting the FIFA World Cup, when a clandestine detention centre was built a few kilometres away, and imprisoned anyone spotted in or around the stadium who were known to be opponents of Argentina's military junta.

The fact that very little has changed since 1957 is actually the stadium's star attraction. The mixture of terracing and seats generates an atmosphere unlike any other international venue. It wasn't until 1986 that the Pumas started playing here, and although the team still continues to play across the country, this is the de facto home of the national rugby team.

Around the same time, Velez Sarsfield was about to fall on hard times. The ground and club was saved from oblivion by a football hooligan who was famously caught on camera trading blows with an English supporter in Mexico during the World Cup in 1986. Raul Gamez later became the football team's deputy president and helped steer it towards stability and trophies.

More recently, the ground has become better known worldwide as a rugby stadium following the formation of Jaguares in 2015, which became the first Argentine outfit to compete in The Rugby Championship against the best clubs in the southern hemisphere - part of Argentina's ongoing push towards the top of world rugby.

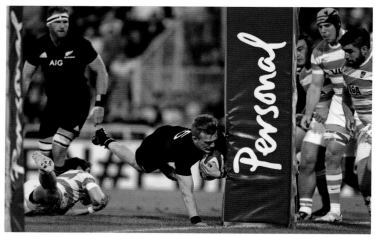

TOP: New Zealand celebrate in September 2018 having beaten the Pumas to claim the Rugby Championship.

ABOVE: The All Blacks' Damian McKenzie dives to score near the base of the post at José Amalfitani in 2017. Tries can no longer be scored against the post protector.

OPPOSITE: Steeply angled grandstands are typical of South American stadia.

Kamaishi City Stadium

Kamaishi, Japan

Team: Kamaishi Seawaves

Kamaishi has been described as a town built on 'fishing, metal and rugby'. The Kamaishi Seawaves won Japan's National Championship every season from 1979 to 1985.

But Kamaishi is best known for the events of 11 March 2011, when an earthquake off the coast of Eastern Japan caused a tsunami that ripped through the town, taking the lives of more than 1,000 people from a population of 35,000. That earthquake also triggered the Fukushima nuclear power plant disaster.

The extraordinary footage from that day shows just how quickly the wave engulfed and destroyed Kamaishi. Residents and workers either try to flee in desperation or look from elevated vantage points in the hills above the town, as the town was reduced to the resemblance of an enormous rubbish dump once the waters had receded.

One of those vantage points is where 570 schoolchildren escaped, helping each other to get out of range of the waves. Their story became known as 'The Kamaishi Miracle'. In fact, they had three years of training in the event of a tsunami and were far better prepared for how to react to the situation than their elders.

As part of a plan to rebuild the city, the municipal government announced in 2014 that Kamaishi would bid to stage matches at the Rugby World Cup in 2019. The Kamaishi Recovery Memorial Stadium was the only ground purpose-built for that tournament.

The decision wasn't met with total approval. Some questioned whether the money could be better spent on housing. But having a set timeframe in which to build the stadium, and the infrastructure around it, gave fresh impetus behind rebuilding the town.

The stadium is steeped in symbolism and put the region back in the spotlight for all the right reasons. The children who survived the tsunami, quite understandably, had mixed emotions about the stadium, not least because it was built on the site of the two schools they once attended. Yet the decision to stage World Cup matches in Kamaishi was a resounding success.

RIGHT: A ceremony before the Rugby World Cup Pool D match between Fiji and Uruguay on 25 September 2019.

LEFT: A junior high school student waves a fisherman's flag at the same event.

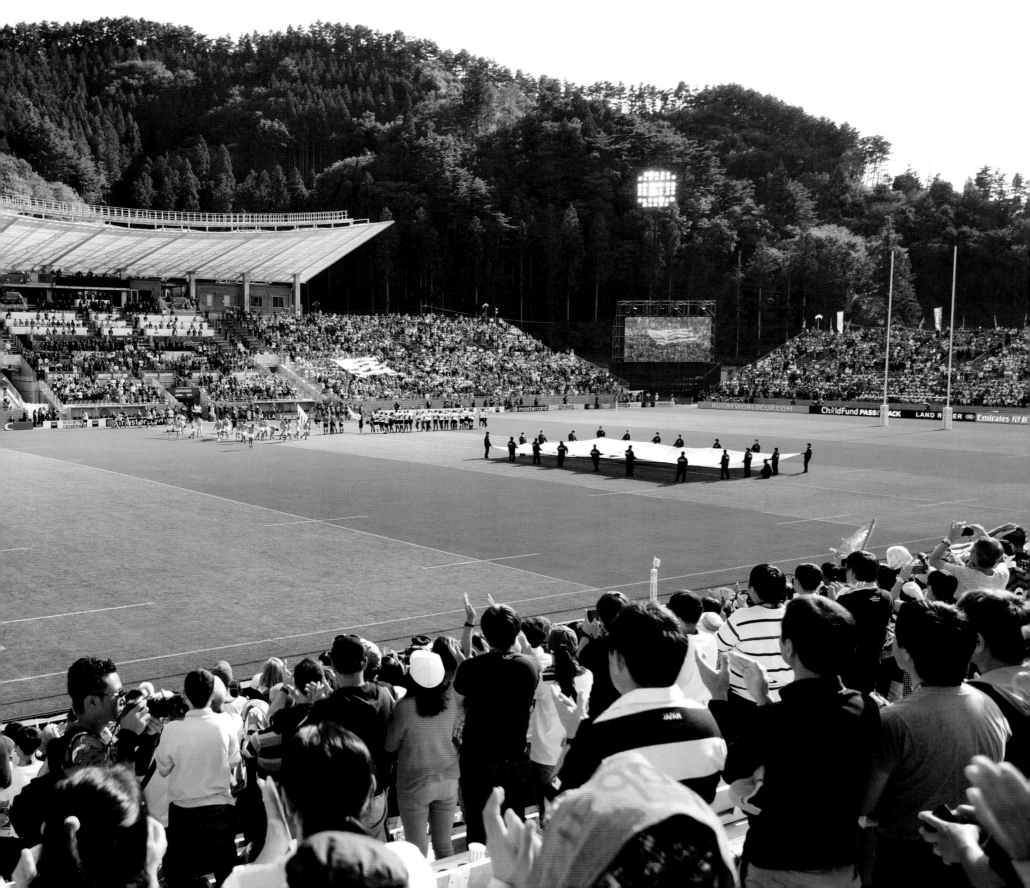

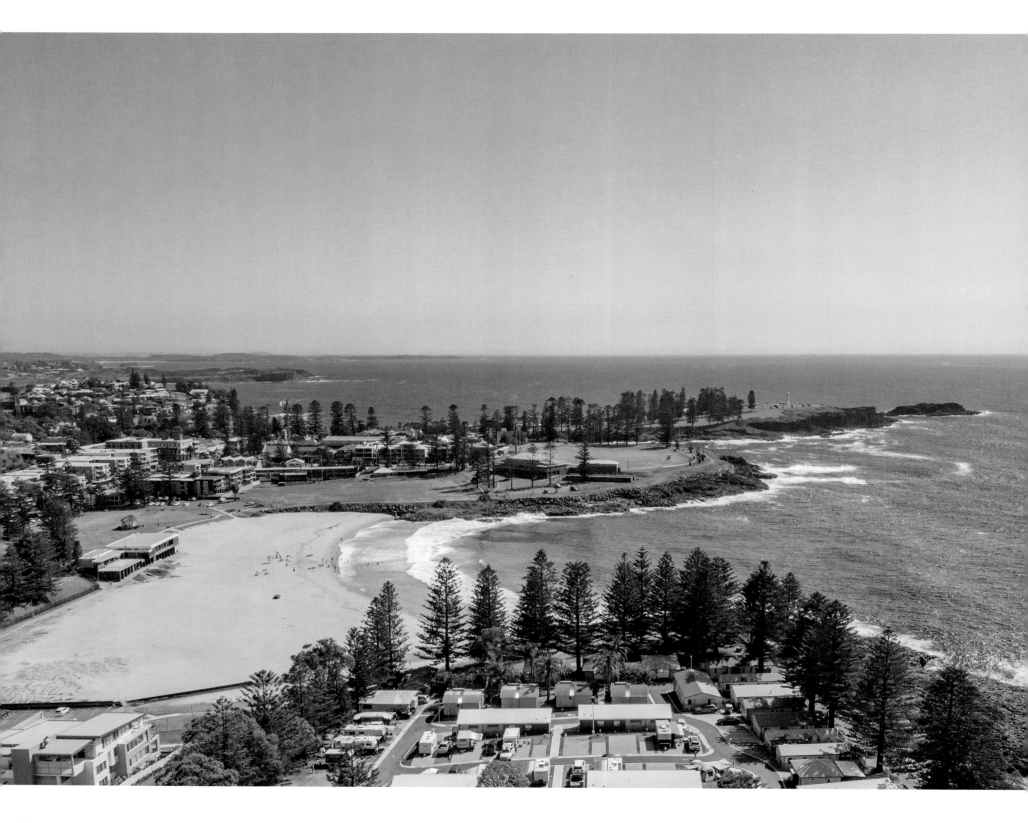

Kiama Rugby Club

New South Wales, Australia

Team: Kiama RFC

Kiama is a coastal resort about 120km south of Sydney in New South Wales. There are many reasons to visit: the sand, the surfing and Kiama's famous blowhole where the Pacific surf erupts through a hole carved in the rock. There is also Kiama Rugby Football Club established on the promontory above Kiama Surf Beach and home to the annual Kiama Sevens tournament. As settings go for a rugby pitch, you could rummage around in a superlatives box and pick out almost any one to describe Kiama.

The club was first established in 1893, lapsed between world wars, and was re-established in 1961 in the Illawarra District Rugby of New South Wales. Wallaby Scott Fava came through the Kiama RFC junior ranks to play for his country in 2005 and other internationals include Jim Miller, Brian Weir, Geoff Shaw, Gary Grey and James Grant.

The main pitch isn't exclusively used for rugby; it also doubles as the Kiama Showground and in 1997 the club was able to build a pavilion overlooking the Showground and out to the Pacific Ocean. It's a suitable venue to host the highpoint of the club's year, the Kiama Rugby Sevens tournament. First started in 1973 with eight teams, The Kiama Sevens has grown into the largest club Sevens tournament in Australia and celebrated it's 50th anniversary in February 2023.

Organiser and club president Mark Bryant was interviewed by journalist Stu Walmsley for Rugby Australia in 2019. While Kiama hosted 54 teams in the 1990s, the tournament now has a different policy for international and invitational sides. 'One of the big things we put in place about four years ago was no international sides,' Bryant says. 'They're fantastic rugby players, the crowds love it and I had some arguments with the life members, but we couldn't fill the other spots. We made a conscious decision to only have club sides.'

The format is now 44 Rugby Australia-registered clubs split into four men's and two women's divisions.

It's a sporting and social event not to be missed, and returning teams have their own little rituals, which for the Grenfell Panthers includes 'kidnapping' the tournament director as they leave town on Sunday night. 'They usually let me go at Jamberoo pub, but one year the wife had to pick me up from Robertson (43km away) – I've been warned I'm making my own way home next time,' says Bryant.

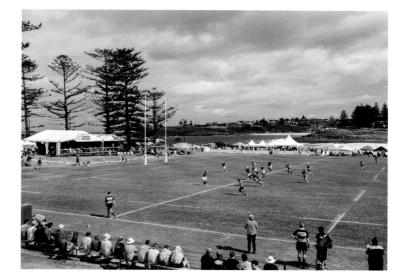

OPPOSITE: Looking across to the two pitches used by Kiama; the showground pitch and clubhouse are on the right.

ABOVE RIGHT: Perfect conditions on the showground pitch for the 2019 Kiama Sevens.

RIGHT: The famous Kiama Blowhole.

Kingsholm

Gloucester, England

Team: Gloucester Rugby

Peter Wilby is a political writer and former columnist for the much-loved-but-now-defunct *Observer Sports Monthly* magazine. In 2004, he wrote a piece about rugby fans in the West of England, claiming they weren't the most enlightened group of people. This prompted a flood of emails and letters telling Wilby he was out of order. Or something along those lines...

So, *The Observer* decided to send him to Kingsholm, to spend an afternoon watching a match in The Shed, the most famous stand in English club rugby. It is sometimes described as the closest thing the sport of rugby has to The Kop at Anfield but has more in common with the Kippax at Manchester City's former ground, Maine Road, because it runs along the length of the pitch. The Shed holds 3,000 fans, which may not sound like much but the low, sloping roof means they sound a whole lot noisier, and it is still an all-standing terrace.

The Cherry Red and Whites were founded in 1873 and played their first matches on a patch of land on the wonderfully-named Castle Grim estate, that would eventually become the site of Kingsholm. They moved the following year but returned in 1891. Kingsholm was also briefly home to England's rugby team before moving to Twickenham.

Much like Bath, Gloucester is a rugby heartland city. But unlike their West Country rivals, Gloucester is a working-class rugby club, and Gloucester is largely a rural county (the

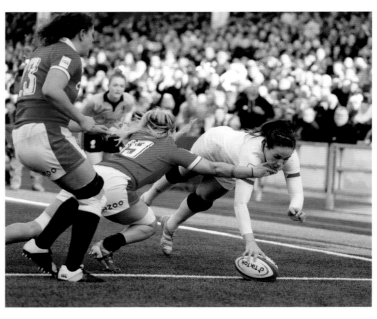

ABOVE: Like Bath, Gloucester is a rugby city, neither having a football team in the top tiers.

TOP RIGHT: On match days, the pubs around the ground are rammed before kick-off.

RIGHT: Emily Scarratt dives over the line for England against Wales in a women's international held at Kingsholm in 2021.

OPPOSITE: Gloucester invested in a 3G artificial pitch, which was installed over the summer of 2021.

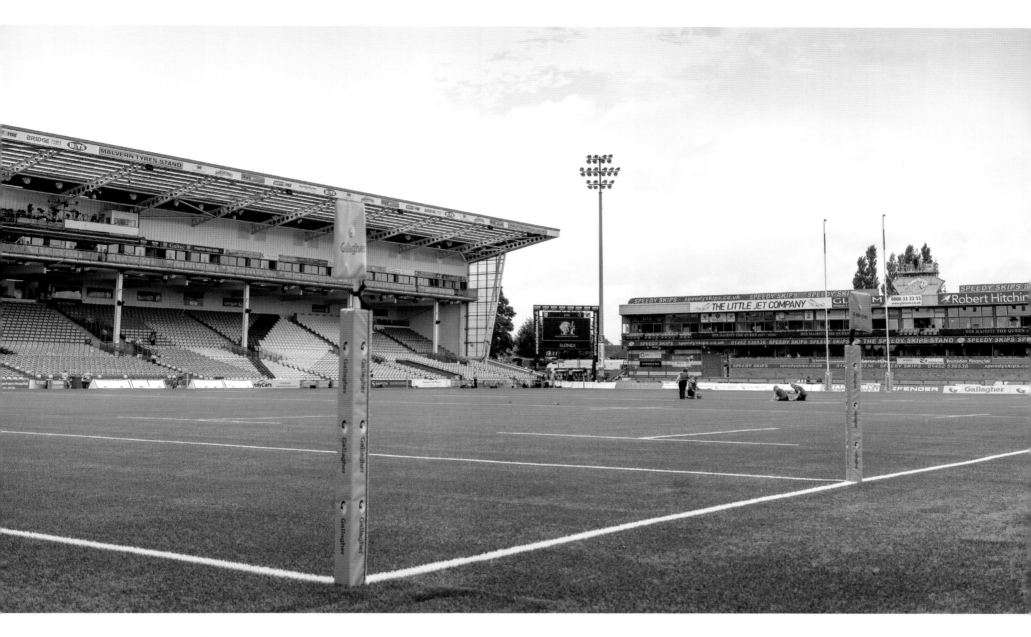

club gained a reputation in the 1970s for an agricultural approach to the game).

In recent years every other part of Kingsholm has been redeveloped, including the South Stand which was built in 1932 and grew from a capacity of 1,800 to 7,500 in 2007. During the demolition of the original stand, a treasure trove of memorabilia was unearthed and would have

been chucked away were it not for one of the builders alerting the club. Many of the artefacts that were salvaged from a skip remain on display at the club.

As for Wilby, he revised his view of Gloucester's most vocal supporters, aka the Shed Heads, with this pay-off, recording that 'Oh, bugger off' was the worst language he heard in two visits.

Kings Park

Durban, South Africa

Team: The Sharks

Around 200 yards from Kings Park is the Moses Mabhida Stadium, which was built for the 2010 FIFA World Cup. Even though both grounds have similar capacities, Moses Mabhida dwarfs its neighbour and also boasts an arch that spans 340 metres, designed to represent South Africa coming together as a nation after apartheid was abolished in the 90s.

The neighbouring soccer stadium had been demolished in 2006 to make way for Moses Mabhida, which hosted seven World Cup matches. The local government also anticipated that the new showpiece ground, which cost around £750 million to build, would also stage rugby matches after it had been used for the tournament.

Kings Park, however, is still the home of the Super XV and Champions Cup team the Sharks, and getting the club to sign a 50-year lease on Kings Park (also in 2006) wasn't the smartest piece of forward planning by the local government.

Even as recently as Summer 2022, the club had to deny reports that it would be moving to Moses Mabhida and re-stated its commitment to a deal that will keep the Sharks at their current home until the end of that lease, meaning that rugby will have been played on this site dating back to 1891.

The ground is so called because a railway platform was built close by with a special siding reserved for whenever monarchs visited Durban. In 1958, a new stadium opened on the site of Kings Park with a capacity of just 12,000. It immediately became clear this was far too small. By the 1970s, temporary stands helped to increase the capacity to 44,000, but that makeshift solution put Kings Park's status as an international Test venue under threat.

In 1984, a new cantilever grandstand was built, complete with offices, suites, media facilities and changing rooms. Further upgrades were made ahead of South Africa hosting the Rugby World Cup in 1995, and the hosts beat France here to reach the final.

More recently, Kings Park opened the Small Zone, which is unique to any rugby ground in the world. Traditionalists may be appalled at the concept, which was named after South African Rugby World Cup winner James Small, who wanted to attract more families to the sport. The area features a crèche, a sand pit, and even two water slides. And as kids hurtle down the slides into the pool, they even get to see Moses Mabhida's arch in the distance.

OPPOSITE: Looking down on Kings Park from the neighbouring Moses Mabhida, which has a funicular railway taking tourists over the arch.

BELOW LEFT: The Sharks residency on the site is longer than most clubs in the northern hemisphere.

BELOW: An aerial view of the two stadiums and the railway line that helped name the smaller of the two.

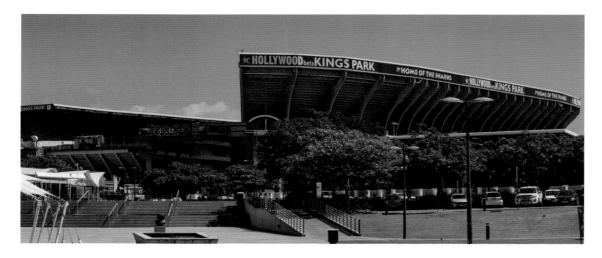

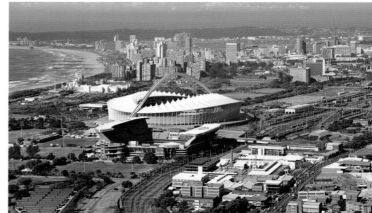

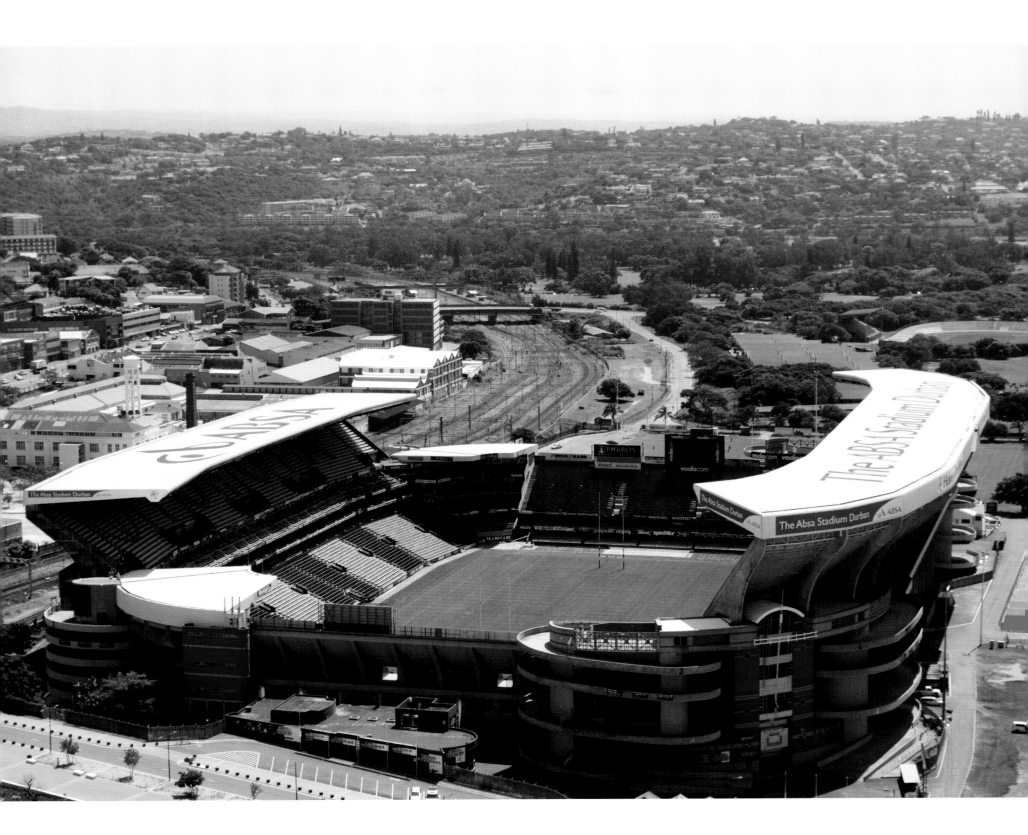

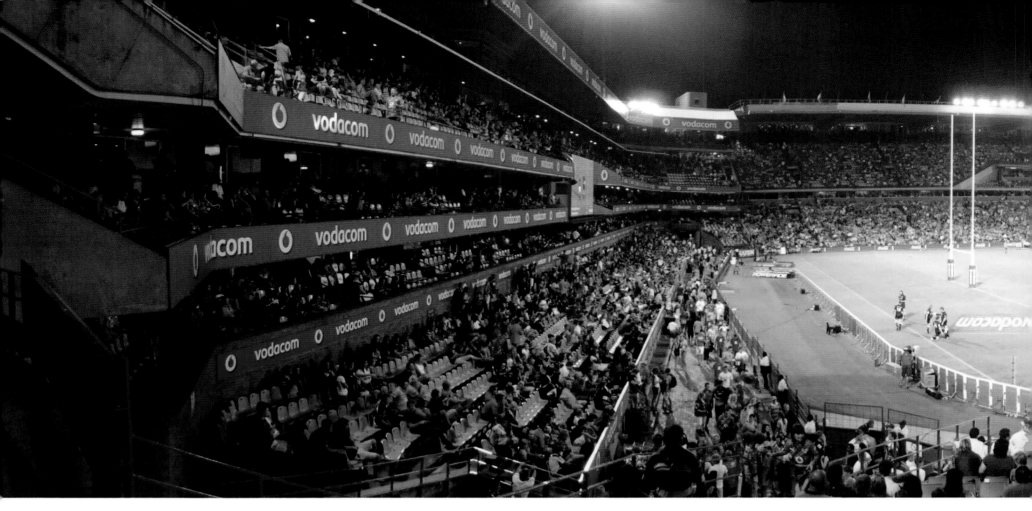

Loftus Versfeld

Pretoria, South Africa

Team: Vodacom Blue Bulls

Robert Owen Loftus Versfeld's last act was to attend a rugby match. On 4 May 1932, he died of a heart attack while watching a Currie Cup contest between Transvaal and Free State.

Soon after his passing, it was decided that the Eastern Sports Ground in Pretoria should be renamed in his honour, an honour thoroughly deserved as Versfeld had given so much of his life to the game.

In 1888, he had moved to Pretoria and founded what would eventually become the Pretoria Rugby Club (the oldest team in Transvaal). He would also be a key figure behind starting Eastern Province Rugby Union, which got its own ground in 1906. Versfeld even took it upon himself to import kikuyu grass from Kenya so that Transvaal could have its own grass rugby fields and would make pitches more playable.

In 1923, the first concrete stand was erected holding just 2,000 spectators. Five years later, the All Blacks played here against the

Springboks, and profits from the match resulted in the much-welcome construction of changing rooms and toilets.

The 1970s and 80s saw the ground go through a transformation that started with the construction of the Eastern Pavilion and ended in 1984 with the opening of the Northern Pavilion. Various sponsorship deals resulted in the stadium's name changing over the years, often inexplicably dropping the surname from the title, until Vodacom saw sense in 2005 and rightly reinstated Versfeld.

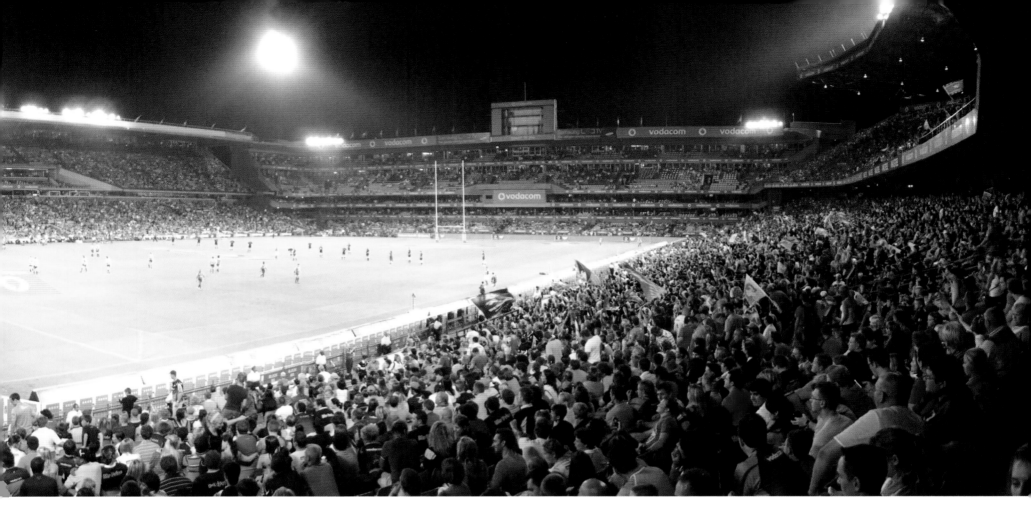

The 1995 Rugby World Cup and the 2010 FIFA World Cup also led to further upgrades to the stadium. The next significant addition to the ground will be a museum in the North Pavilion, named after another Pretorian rugby legend, Frik du Preez. Du Preez won 35 caps for South Africa and is one of the all-time great second row forwards. He was chosen by fans as the Springboks' Player of the Century – a testament to his enduring legacy given he finished his Test career in 1971, 24 years before South Africa won the World Cup.

Loftus Versfeld is also famous for hosting the biggest boxing match ever held in the country. In 1979 South African Gerrie Coetzee fought John Tate for the vacant WBA World Heavyweight title, which had been relinquished by Muhammad Ali. It was the first time an African had fought for the Heavyweight crown, and around 80,000 spectators saw Coetzee lose on points. He eventually won the title in 1983.

TOP: Teams line up before kick-off in a Super Rugby match between the Bulls and the Sharks.

RIGHT: Filled to capacity the ground can hold 51,762.

Mangatainoka Rugby Ground

Mangatainoka, New Zealand

'He built it and they did come,' said the headline in the *Sydney Morning Herald* on 29 January 2011. Some 40 years previously, Mangatainoka Rugby Club closed, seemingly for good. All that remained was a quaint but dilapidated wooden grandstand built in 1908.

Farmer Neil Symonds bought the land on which the rugby club had stood, which happened to be next door to the TUI Brewery. Symonds and TUI's commercial manager, Nick Rogers, talked about restoring Mangatainoka's small wooden grandstand and bringing the national game back to this rural town with a population of around 1,800.

They raised NZ $60,000, hired a few decent carpenters, and Mangatainoka Rugby Club reopened in 2008. All Black legend Colin Meads was the guest of honour to celebrate the club's 100th anniversary, which was commemorated with a veterans game.

Rogers wanted to take it a step further by hosting a Super Rugby match. Eventually, he managed to bring the Hurricanes to play a pre-season game in 2010, which became a huge community event attracting around 10,000 visitors. Symonds had wondered if he would live to see it happen. By the time the

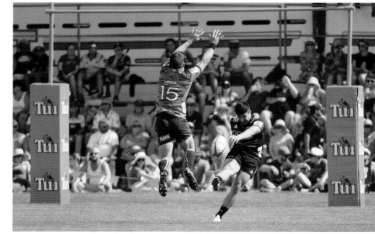

second Super Rugby pre-season game was played here in 2011, he had been through 39 sessions of radiotherapy for prostate cancer.

In 2013, Rogers decided to take the pre-season match on the road as part of his 'crusade' to promote grassroots rugby before returning to Mangatainoka five years later. However, rugby in Mangatainoka was put on hold again after the grandstand was set alight by a teenage arsonist

in 2020 for no other reason than he could. Over a hundred years of history destroyed within a matter of minutes. 'It's sad for the community,' said Rogers. 'This was our icon. It was something to hold on to, it was a piece of history that was ours.'

OPPOSITE FAR LEFT: The beloved old wooden grandstand.

ABOVE: Rugby fans watch from 'the sheep truck stadium' during the original Hurricanes vs Blues game of 2010. The TUI Brewery is to the left of the posts.

OPPOSITE: Jackson Garden-Bachop of the Hurricanes clears the ball while Michael Collins of the Blues tries to block during the Super Rugby pre-season match between the Hurricanes and Blues at Mangatainoka on 9 February 2019.

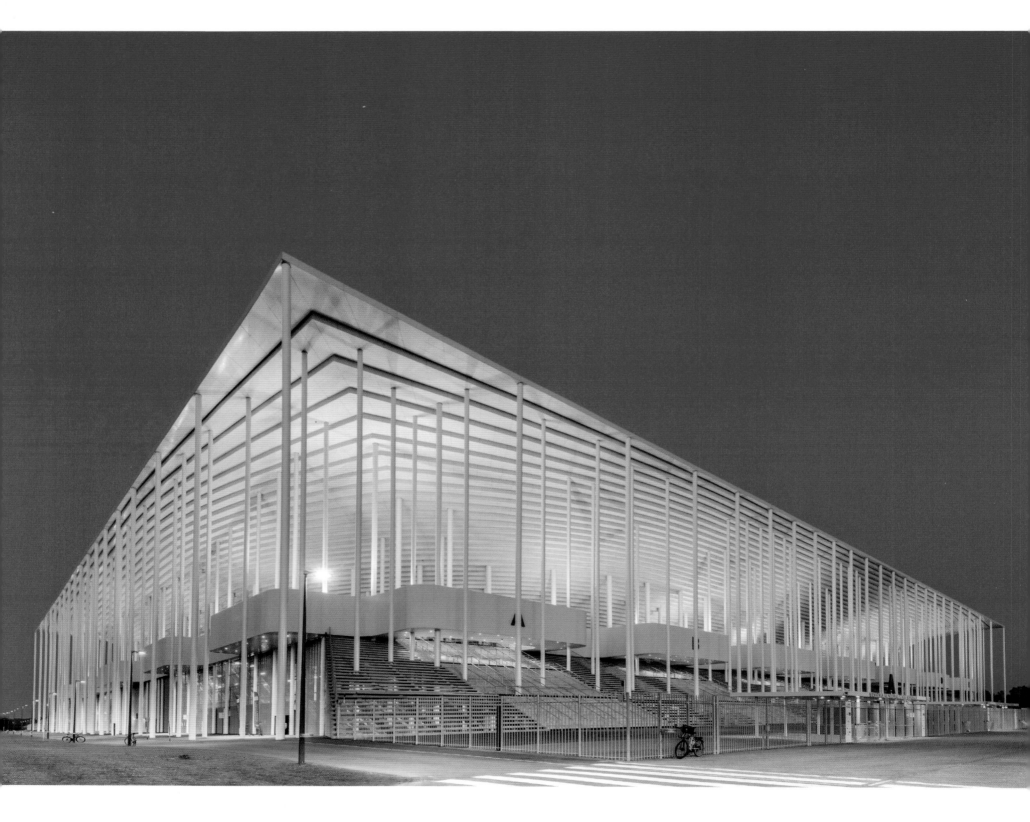

Matmut Atlantique

Bordeaux, France

Herzog & de Meuron is the Swiss architectural firm responsible for some of the world's most famous stadiums, including the Allianz Arena in Munich and the National Stadium in Beijing, aka the Bird's Nest. The company was also commissioned to design for a new ground in Portsmouth in 2007 that never got beyond the CGI stage but is worth googling for the outlandish idea backed by a club facing financial meltdown.

When the firm's most recent, completed stadium opened in 2015, it prompted Washington-based writer Kriston Capps to lament, 'This stadium, this gorgeous artful building, is nowhere near Washington, D.C. It's the Nouveau Stade de Bordeaux, a whole ocean away, in Bordeaux, France. What went wrong, D.C.? Why can't we have nice things?' Capps added, 'At a glance, it looks like a juiced-up John F. Kennedy Center for the Performing Arts.'

Now known as Matmut Atlantique after the naming rights were bought by an insurance company, the stadium features an exterior unlike any other in the world, let alone Washington. It gives the impression of 'lightness' – a huge structure seemingly propped up by 900 thin white columns inspired by the pine trees found in Landes Forest, south of Bordeaux.

Among the first matches to be played here were the French Top 14 rugby semi-finals, as well as a football match between Bordeaux and Nantes, which prompted questions about the safety of the structure, and forced the stadium management to respond, saying, it's 'a metallic stadium, and when people start jumping in rhythmical fashion, you can feel vibrations, it's normal.'

Inside it almost feels like an entirely different ground – a bowl inside a square.

The architects also enhanced the atmosphere by adding a layer of acoustic panels, and included retractable seats at each end that can be removed for the extra yards required to stage a rugby match, so spectators are kept as close to the action as possible irrespective of which team is playing.

This all looks and sounds awesome to the outsider looking in, but it replaced the more centrally located Stade Chaban-Delmas – an Art Deco-inspired arena that opened in 1938 – and the move to a new home six miles from the city centre has coincided with a steep decline in fortunes for the resident football team, Girondins de Bordeaux.

The ground is rarely even half full for domestic football matches, and has arguably enjoyed more success as a rugby venue. Prior to hosting five Rugby World Cup matches in 2023, the record attendance was set when Stade Toulousain met La Rochelle for a Top 14 tie in 2019, pulling in 42,071 fans.

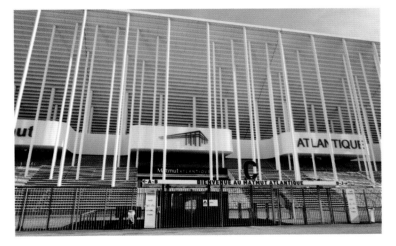

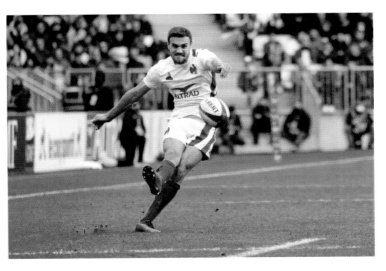

OPPOSITE: The stadium started off in life as Nouveau Stade de Bordeaux. Opened in 2015, its first significant rugby matches were the semi-finals of the Top 14 championship.

ABOVE RIGHT: Two views of the striking architecture that will be on display as it hosts games in the 2023 World Cup.

RIGHT: France's Melvyn Jaminet converts a try in a 2021 autumn international against Georgia.

Mbombela Stadium

Nelspruit, South Africa

Team: Pumas

When people think about sport and corruption, they probably won't immediately think of the 2010 World Cup in South Africa. Yet even as the tournament started, and commentators were talking about it being a watershed moment not just for a nation but also for the continent, the murky story of how the stadiums were built was becoming clearer, prompting speculation about the lengths that people would go to cover up a crooked tendering process.

At the centre of this growing scandal was Mbombela Stadium, which generated lots of attention and acclaim when it opened in 2010, because of the black and white zebra-inspired seating plan, and also because of the 18 pillars that hold up the roof and meant it became known as the Giraffe Stadium. 'What happened was as the design evolved, the roof supports just naturally started to sort of take the shape of a giraffe,' said architect Mike Bell. 'We obviously then tailored it a little bit so it does look like a giraffe.'

Out of all the grounds built for the tournament it was the one that came in closest to its original budget. Other venues saw costs deliberately inflated. And whereas some of those other grounds turned into money pits and struggled to find regular tenants, Mbombela is home to two clubs, including 2022 Currie Cup winners the

Pumas. It has also held a number of international rugby matches.

Before its inauguration, at least three people with connections to Mbombela were killed, and a further three died from suspected poisoning. They included local politician and whistleblower Jimmy Mohlala. Mayor and former political prisoner Lassy Chiwayo was also vocal in his criticism of how construction contracts were won, and received a death threat but lived to tell the tale. Yet the police said none of these deaths were connected to the stadium. Go figure.

There were also accusations that the corruption surrounding the stadium became endemic. A deal struck with the local community to buy the land on which the ground was built, was also said to be crooked – key documents relating to that deal went missing. Promises to improve impoverished local communities were broken and it has taken years to see tangible benefits for the people who gave up their land to make the Giraffe Stadium happen.

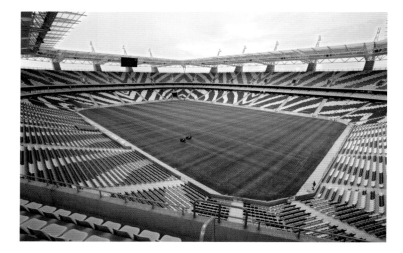

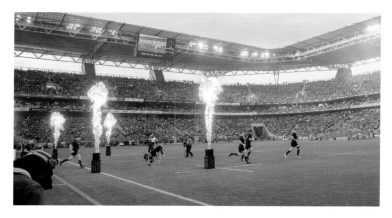

TOP: Continuing the African wildlife theme inside the stadium, the seating gets a zebra effect.

ABOVE: The All Blacks take to the field at a packed Mbombela Stadium in August 2022 for a Springboks Test match.

OPPOSITE: There's no denying that the stadium has a significant giraffe feel and would be the perfect setting for a Lions game.

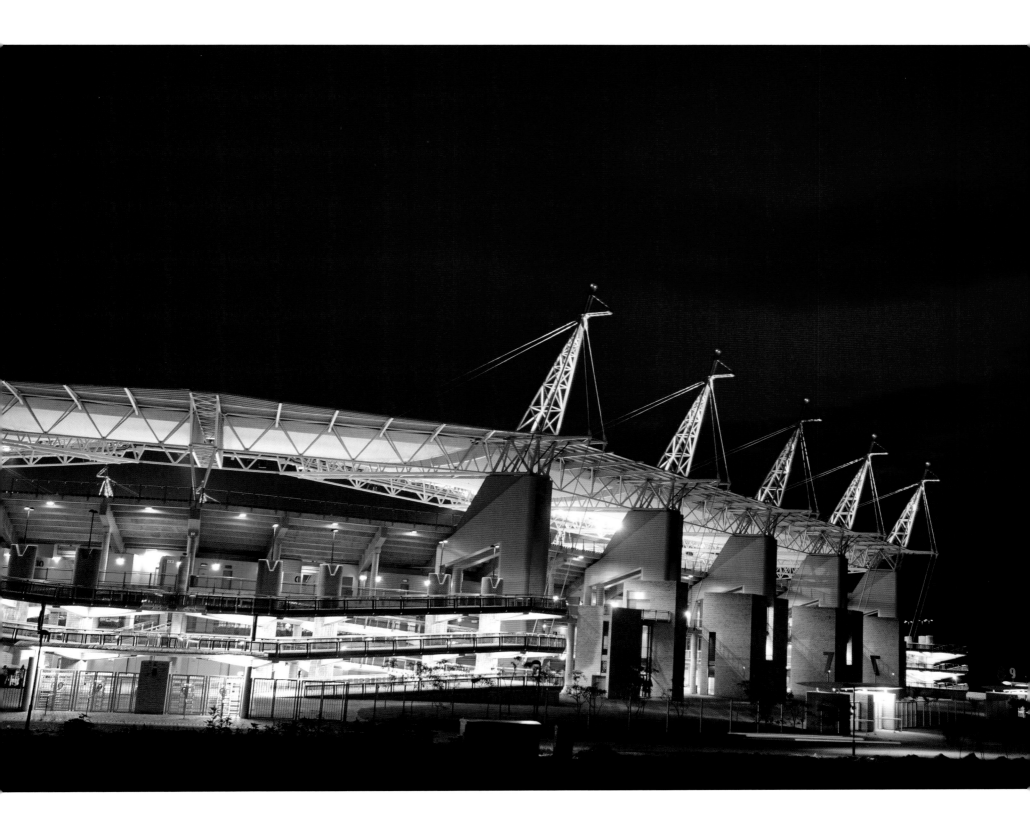

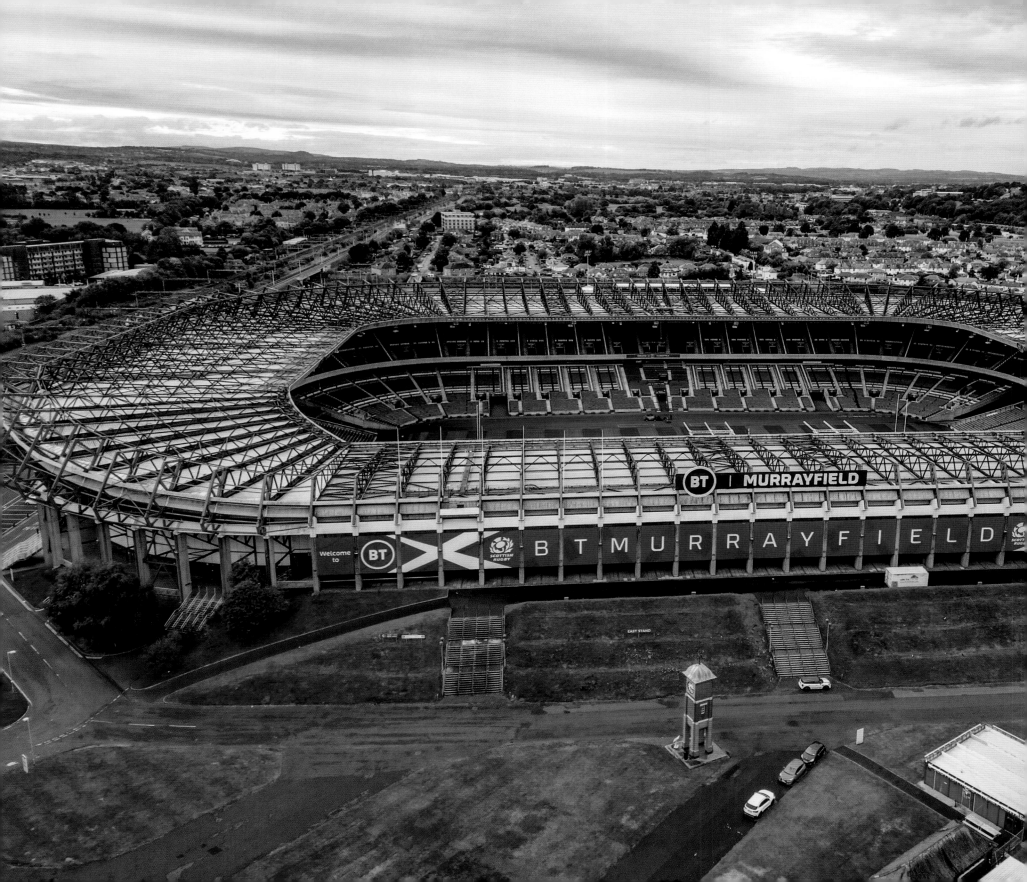

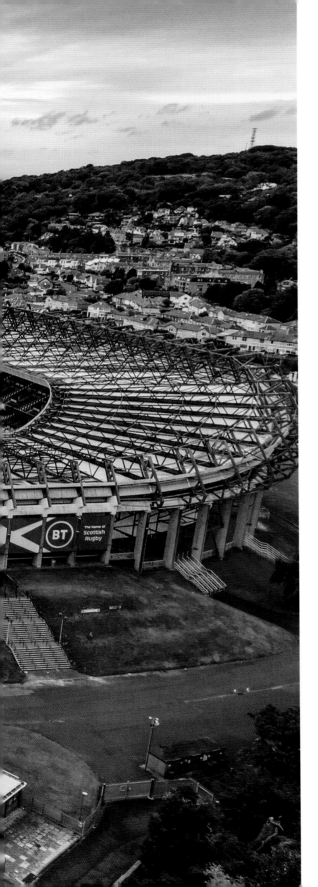

Murrayfield

Edinburgh, Scotland

The Scottish Rugby Union couldn't have wished for a better opening night in its new HQ at Murrayfield. England provided the opposition for the first match held here in 1925 and not only did Scotland beat the 'auld enemy' but victory also secured a first Grand Slam – a feat that has only been repeated twice by the Scots in 1984 and 1990.

That 1990 campaign also finished with a clash here against England and was the first time two teams had gone into the last match both chasing the Grand Slam. The occasion is vividly recalled in *The Grudge*, a book by Tom English, that gives a reader a sense of what it was like to be involved, along with a wider context of the relationship between the two nations, and includes this quote from England captain Will Carling: 'If you'd told me a week before that I'd have Margaret Thatcher, the poll tax, Butcher Cumberland and Bannockburn thrown at me, I'd have told you that you were on drugs.'

Scotland walked slowly, and deliberately so, onto the pitch that day, led by captain David Sole, to try and spook the opposition. It had the desired effect. Scotland defied the odds, beating England 13–7 and all the superlatives wouldn't do justice to the intensity of it all.

When the SRU decided to purchase the 19 acres of land from the Edinburgh Polo Club back in the 1920s, it was to build a ground that could meet the demand of Scots wanting to see their team play. And Murrayfield became capable of

accommodating massive crowds – 104,000 turned up to see Scotland defeat Wales on 1 March 1975, and is still a record for a European rugby union match.

However, the SRU was fortunate that the match passed without any serious incidents. Back then, Murrayfield had terraces on three sides of the ground, and anyone could turn up and pay on the day. When pushed to give an official figure, SRU secretary John Law simply offered a curt

OPPOSITE: An aerial view of the stadium with the 1929 clock tower in the foreground.

BELOW: The victorious Scots team of 2022 – their victory over the 'auld enemy' in the Six Nations was one of the final nails in Eddie Jones' England managerial coffin.

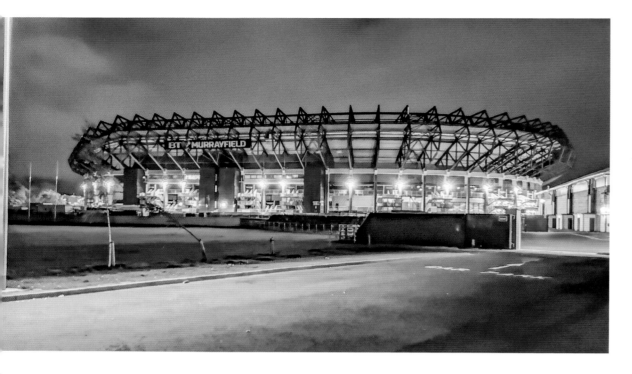

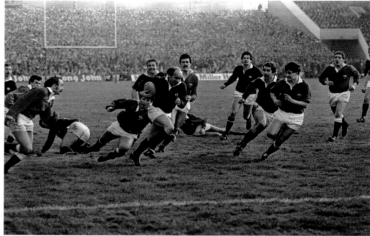

TOP: Jim Renwick sprints for the line through the Welsh defence and the long grass at the old, terraced Murrayfield.

ABOVE: The inspirational Doddie Weir presents the match ball at a Scotland vs All Blacks match at Murrayfield in 2017. For those of a certain age it is impossible not to hear commentator Bill McLaren's voice exclaiming, 'and it's taken on by Doddie Weir!'.

LEFT: The war memorial outside the ground. In the Great War 31 Scottish rugby players lost their lives.

OPPOSITE: In 2016 Scottish Rugby revealed plans to build a hotel, with up to 200 rooms, on the land adjacent to the main entrance to the stadium.

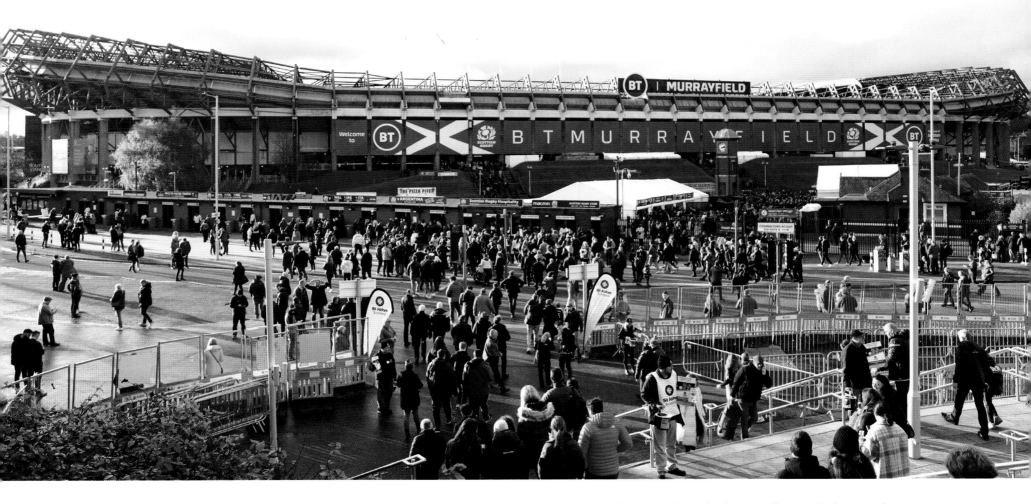

response: 'That's our business,' he said. The police made it their business and insisted future matches would be all-ticket.

Following the Taylor Report into the Hillsborough Disaster of 1989, every major ground in the UK would become an all-seater stadium. By 1994 the new Murrayfield was taking shape. The upper tier of the West Stand still provides a view of the Edinburgh skyline featuring the Castle, and Arthur's Seat.

Having sorted out the stadium, the next challenge was to tackle the infrastructure.

When Dominic McKay, the chief operating officer of the SRU, unveiled a plan in 2018 to build a compact, 8,000-capacity stadium backing onto Murrayfield, which is now the home of Edinburgh Rugby, one of the key factors for building a new ground on this site was, 'a flood defence system around the site, which was never there before. That gives us the confidence to make an investment.'

That system was built after the city experienced what Edinburgh council leader, Donald Anderson, described as the worst floods to hit the city for a century, back in 2000.

The water breached the stadium and left parts of it submerged. The weather can still play havoc with playing conditions, especially when the wind gets in and swirls around the arena.

But if there was a list of things every rugby fan should do before they die, then towards the top must be going to Murrayfield and experiencing that moment when the bagpipes stop playing and all you can hear is the crowd singing *Flower of Scotland*.

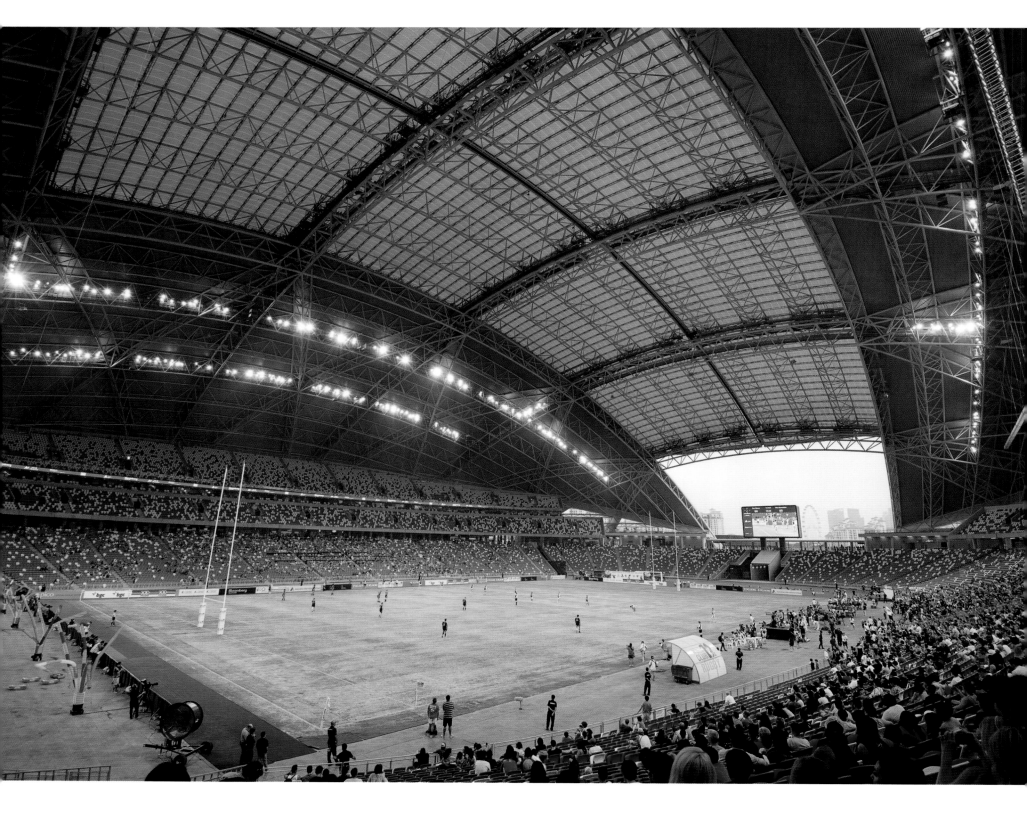

National Stadium

Kallang, Singapore

One of the many ongoing debates around the FIFA World Cup held in Qatar is whether it could truly claim to be a sustainable event, with seven of the eight new stadiums being constructed with a built-in aircon system. There were a lot of questionable claims raised around 'carbon offsetting'. In short, carbon offsetting often means 'we can continue to do bad stuff here because we're planting thousands of trees somewhere else.'

This leads us to the National Stadium in Singapore, home of the HSBC Singapore Rugby Sevens. After the previous national stadium closed in 2007, it was announced that a new one would be built on the same site. This would become part of a far bigger project to create a sports and entertainment hub that would revitalise an underused part of Singapore by the River Kallang.

Having been slated to open in 2011, the project would take far longer than planned because of the global financial crisis in 2008. By the time it hosted its first game in 2014, the stadium had achieved a world record by having the largest dome, which spans 1,017 feet, or 310 metres. In the same year the Singapore Sports Hub won 'Sports Building of the Year' at the World Architecture Festival.

Eight retractable seating modules allow it to host rugby, football and cricket matches as well as track and field events. The process of going from rugby pitch to athletics track takes around 48 hours. The dome is necessary because Singapore only really has one climate, which is hot and humid, and when it rains it seriously pours.

It takes just 20 minutes for the retractable dome to cover 95% of the seats, and the insulated metal roof reflects the sunlight to reduce heat gain and keep out solar radiation. Even so, it can still get pretty warm inside. So, the stadium has a 'bowl-cooling' system that pumps out air at 23 degrees from underneath the seats. The system is programmed to only operate in areas where there are spectators and it is partially powered by solar panels. Unlike Qatar, the Singapore cooling system has never faced much scrutiny; however, architectural firm Arup says it has a zero carbon impact on the environment.

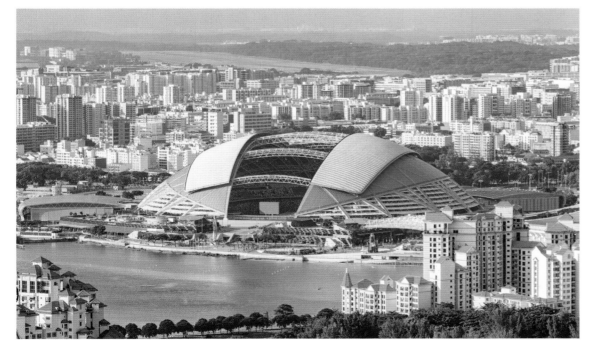

OPPOSITE: The dome set up for Sevens rugby.

LEFT: From afar, Singapore's National Stadium has been likened to a Samurai helmet.

BELOW: New Zealand take on Australia at the 2019 HSBC Singapore Sevens.

Newlands Stadium

Cape Town, South Africa

What is the tipping point between preserving history and clinging on to the past? At the time of writing, this is the question that faces Cape Town's government on the future of Newlands, which used to be the home of South African rugby. Club officials had denied reports that this grand old stadium's days were on borrowed time, only later to admit those reports were, indeed, true. Newlands was put on the market in March, 2022.

A few months later, former Springbok captain Wynand Claassen submitted an application to have Newlands declared a 'heritage site' and later spoke about a plan to turn the ground into a museum of rugby. Whether that plan is viable is another matter.

Newlands has quite a heritage as the second oldest international rugby ground in the world, after Lansdowne Road/Aviva Stadium. Back in 1883 T. B. Herald was a local magistrate who became secretary of the Western Province Rugby Football Union (WPRFU). Herald wanted Western Province to share the Newlands Cricket Ground, which opened in 1888, a matter of yards from the station. Herald's offer was knocked back, but in 1894 the WPRFU bought a plot of land just up the road from the cricket ground for £2,500. The first permanent stand was built in 1919 and by the 1970s, Newlands became the only major stadium in the country that was owned and run by South Africa Rugby. This also coincided with a series of upgrades to facilities, including more private boxes and seats, which continued through to South Africa hosting the Rugby World Cup in 1995.

The beginning of the end for Newlands came when South Africa won the bid to host the 2010 FIFA World Cup. At first it was thought this would provide an opportunity to modernise the ground, but typically FIFA insisted that new arenas had to be built, including the DHL (formerly Greenpoint) Stadium, which is within walking distance of Cape Town's city centre.

In 2015, a new plan would have seen Newland's capacity reduced to 35,000 with the North Stand adapted to host a retail/residential complex. Despite overwhelming support, the WPRFU's executive committee turned it down. Two years later, an agreement was signed that would see the WPRFU move to Greenpoint. In 2021, it was announced the DHL Stadium would become the new home of DHL Western Province and DHL Stormers. During that four-year period, a series of plans to sell off Newlands were mooted by unpopular WPRFU President Zelt Marais that never came off. In June 2022, Marais was suspended by SA Rugby for a year, by which time the WPRFU was in administration. Come what may, Newlands' place in rugby history is assured. This ground hosted the first game of that 1995 World Cup, the first major sporting event held in South Africa following the end of apartheid. South Africa beat defending world champions Australia 27-18 before the hosts went on to lift the Webb Ellis Trophy. It was also the scene of Jonah Lomu's finest game, scoring four tries in the semi-final against England.

OPPOSITE: The fate of Newlands is a lesson in what can happen when countries win bids to hold major sporting events.

BELOW: An aerial photo shows just how close Newlands rugby stadium is to the cricket ground.

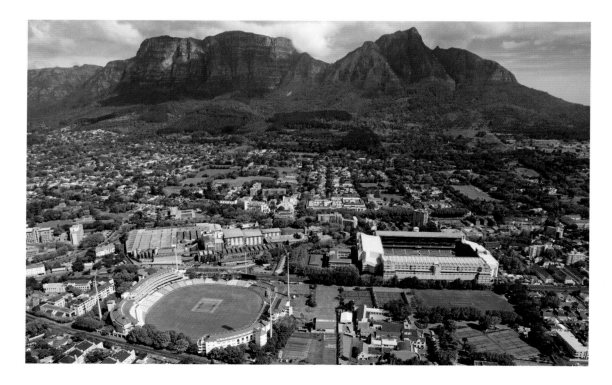

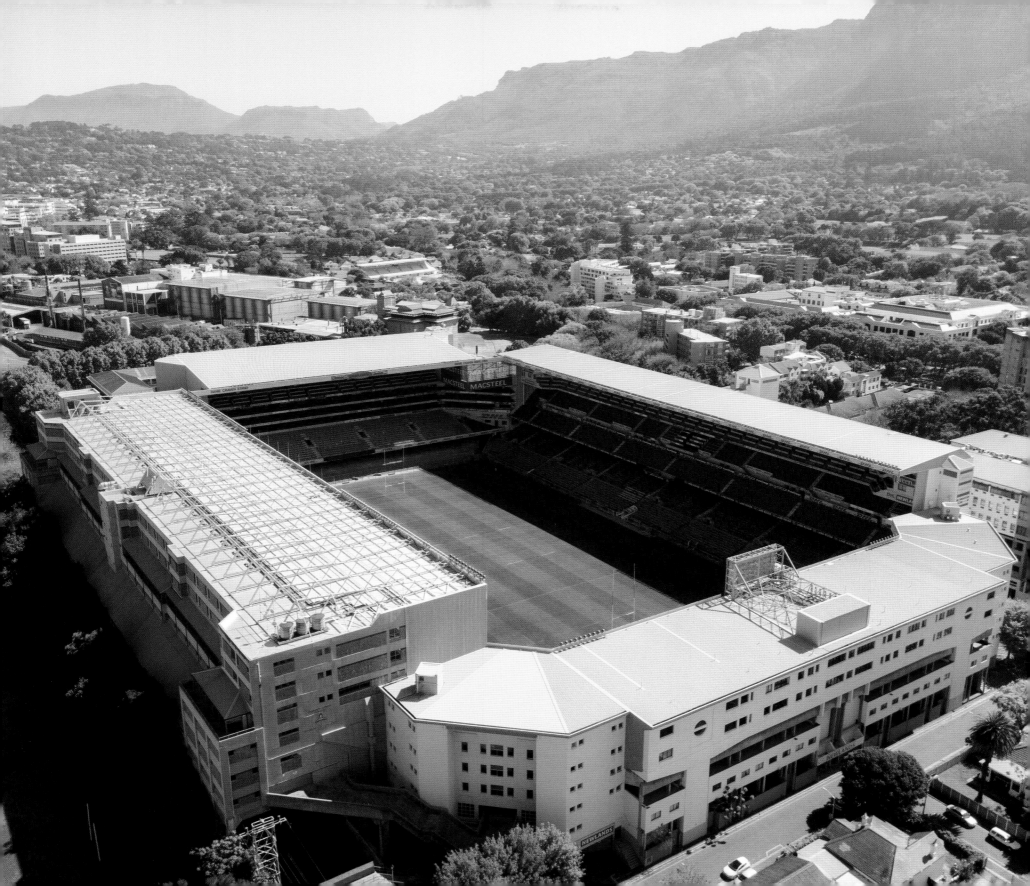

Optus Stadium

Perth, Australia

Team: Queensland Reds

The Prix Versailles bills itself as the World Architectural and Design Awards. Since 2017 it has honoured the best new buildings that opened the previous year. In 2019, a new category was added to the Prix Versailles, one for Sports, and the first winner was the Optus Stadium in Perth, chosen ahead of the Hangzhou Sports Park in China and Louis Armstrong Stadium in New York.

The award is a marketing man's dream and prompted numerous articles to call it the 'most beautiful stadium in the world' (or at least the most beautiful one that opened in 2018). That said, the Optus was a worthy winner, although it wouldn't have been built had the Government of Western Australia heeded the advice of a task force which recommended building a new stadium seven kilometres away, next door to the old Subiaco Oval in East Perth.

A new ground also represented a chance to regenerate a site in the Burswood Peninsula that was once a rubbish dump. The stadium was being built on sandy marshland, so it had to be constructed in four quadrants to allow for land that will shift over time. It was also a chance to rethink Perth's transport links in a city that wants to promote a strong green agenda. The combined number of spectators who get to the stadium either by public transport or by walking is well over 90%. And the bronze exterior was designed to reflect Western Australia's geology.

Inside, having an oval playing area means the capacity and pitch dimensions can be adjusted for cricket, rugby, football or Aussie Rules, and the ground has been used for a host of rugby internationals. Originally known as Perth Stadium, the grand opening happened, as promised, in 2018, but the cost, as so often happens with major construction projects, was larger than the original figure. That said, there's going over budget and then there's going AUS $900m over budget!

When a new government was installed in 2017, it decided that the project needed to recoup some of the huge overspend and sold the naming rights to the second biggest telecoms company in Australia, hence the Optus Stadium.

BELOW LEFT: The Optus has hosted regular Wallabies vs All Blacks games in the Bledisloe Cup.

BELOW: Looking over the Optus to the Matagarup Bridge and downtown Perth.

BOTTOM AND OPPOSITE: The bronze cladding on the exterior is a nod to Western Australia's rich geology.

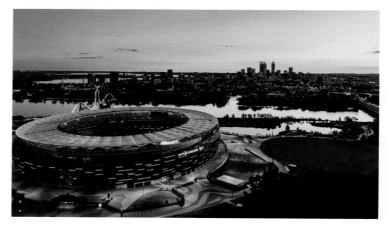

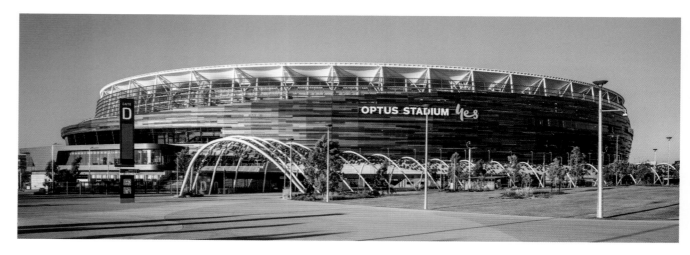

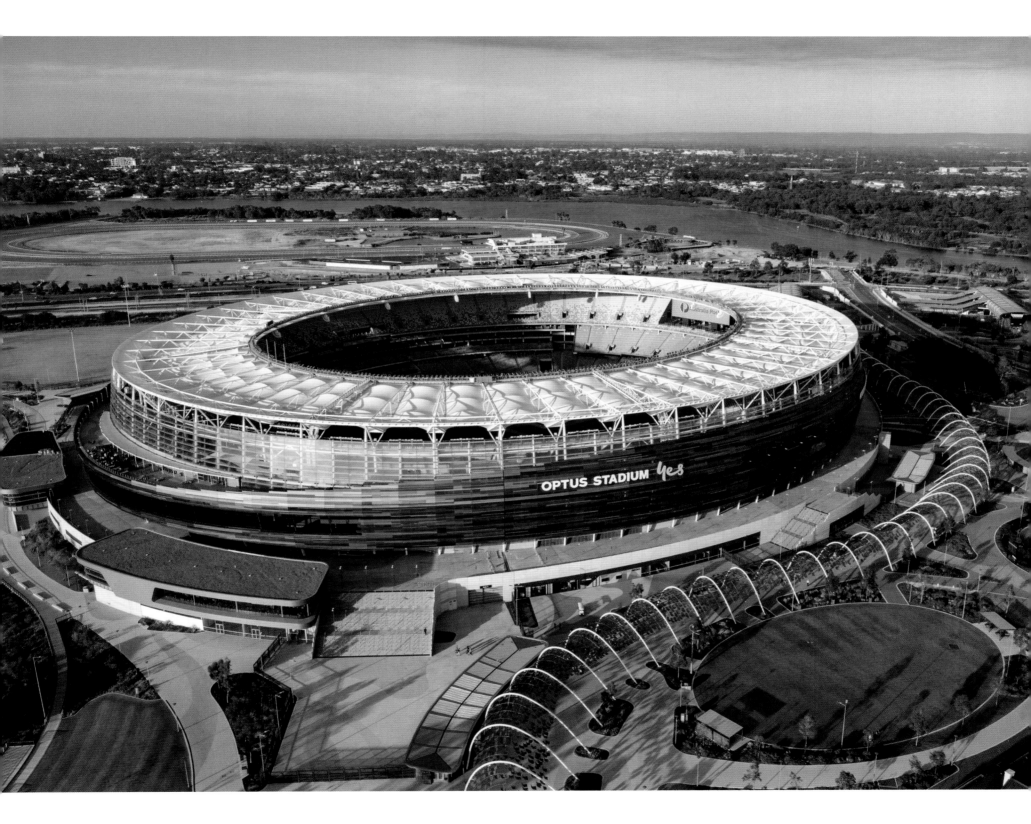

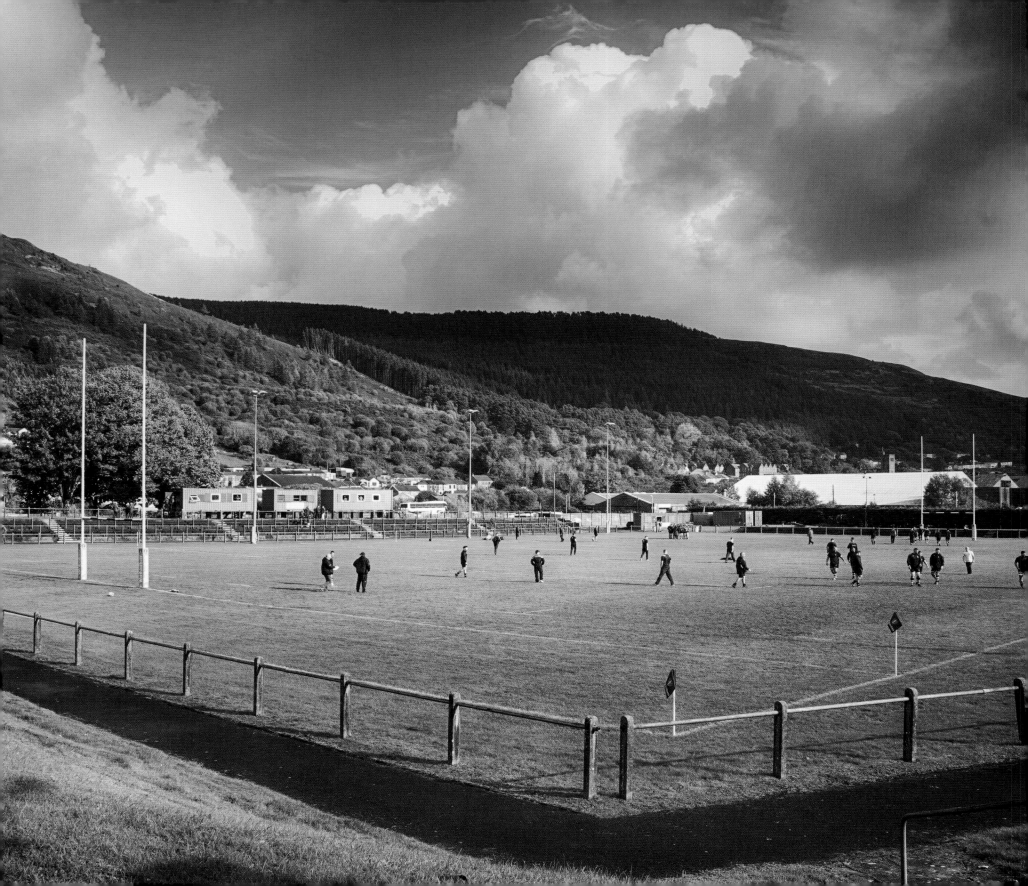

The Oval

Treorchy, Wales

Team: Treorchy Zebras

Treorchy RFC was founded in 1886 and played at seven different locations throughout the town before settling on the Oval, with the first game being played there in January 1924.

The rise and fall of Treorchy Zebras is one of rugby's more extraordinary stories. In 1992, the team was languishing at the wrong end of Welsh rugby's Third Division. Within three years they had finished third in the top flight, competing with, and beating the biggest clubs in the country.

During that heyday of the 1990s the ground not only entertained the likes of Cardiff, Swansea and Llanelli but also overseas teams including Canterbury (NZ), the Bulls (formerly Northern Transvaal), and Fiji. Part of Treorchy's story was captured in *The Dream* - a six-part series broadcast on BBC Wales in 1994 that followed the club's pursuit of promotion into the First Division – a forerunner of Amazon's *All or Nothing* sports docuseries.

The point where they went from also-rans to contenders came when coach Clive Jones approached Treorchy's former tight-head prop Phil Davies to install some commercial savvy into the club. Davies could see the direction of travel and told Jones it was only a matter of *when* the game would turn professional, not *if*.

Davies set out the sort of plan that is second nature to every club now, around marketing, attracting sponsors, and raising its profile. All the while the Zebras had created a mystique around their team and its ground in the Rhondda Fawr Valley. *The Dream* revealed the reality of being a small amateur club in an age before the Internet. When rugby did indeed turn professional in 1995, Treorchy simply couldn't compete with the big boys.

The Oval remains a place of beauty. It typifies the stereotype of what a rugby ground in the Valleys should look like – a natural amphitheatre, with the Bwlch mountain for a backdrop. When the weather is not kind it can be a difficult place to perform, and when the sun shines you couldn't choose a better place to visit and play.

Even though no small-town club will scale those heights again – creating regional teams has seen to that – the Treorchy story puts one in mind of the old saying, 'It's better to be a lion for a day than a sheep all your life.' Or, in this case, a Zebra.

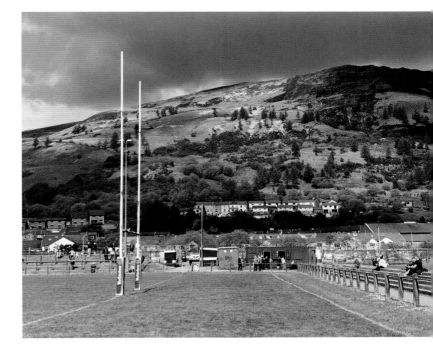

ABOVE RIGHT: Treorchy's ground is located in a natural amphitheatre in the Rhondda Fawr.

OPPOSITE: Founded in 1886, over the years 18 Treorchy players have represented Wales, including the first Home Nations Championship.

RIGHT: Treorchy's compact grandstand.

Parc des Princes

Paris, France

Rugby fans of a certain vintage have a tendency to get a bit misty-eyed at the mention of the former home of French rugby. It immediately conjures up names like Rives, Sella, Lagisquet and Blanco along with stories of the brilliance, often mixed with moments of outright brutality, that came with French teams of the 1980s.

The stadium as we know it was built in 1972 and designed by Roger Taillibert, who was one of those architects that could be described as 'Marmite'. He is best known for the Olympic Stadium in Montreal that still divides opinion between either being the work of a visionary genius or an ill-conceived white elephant. In his defence, construction was fraught with complications beyond his control.

In an interview with daily newspaper *Le Berry Républicain* shortly before he died in 2019, Taillibert said of the stadium that resides in southwest Paris, 'The old Parc-des-Princes had 29,000 spaces with poles, scrap metal, it was a scary thing! General de Gaulle had asked me for a stadium with a minimum of 50,000 seats, without posts, so that all the spectators could see the pitch perfectly. Today, I often go to matches and I must say that there is an atmosphere that you cannot find elsewhere. I am very proud of the Parc because it has become a monument of Paris.'

The site was originally a cycling velodrome. It was inaugurated in 1897 by Henri Desgrange, director of *L'Auto*, the sports paper that created

the Tour de France, and the race would finish at the stadium. The cycling track was removed in 1967 to make way for Taillibert's creation which still has that imposing exterior with the ground surrounded by 50 concrete columns in an exoskeleton to support the roof.

The reason why rugby fans bemoan the national team moving to Stade de France is party influenced by location – Parc des Princes is within walking distance (albeit a very long walk) from the Eiffel Tower. Stade de France, by contrast, is on the very outskirts of Paris, in an area with a high crime rate. The stadium still occasionally hosts rugby matches, for both Stade Français' men's and women's teams, but faces an uncertain future.

The city owns Parc des Princes, and its anchor tenant is Paris Saint-Germain football club, which is owned by Qatar Sports Investments. A row broke out in late 2022 between the club and the city, with PSG saying they were 'no longer welcome' after submitting an offer to buy the stadium outright that was turned down. The club's President has threatened to leave and move to Stade de France.

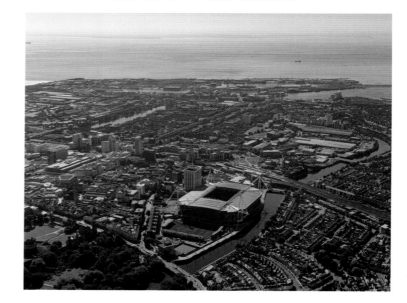

OPPOSITE: Parc des Princes sits across Rue Claude-Farrère from Stade Jean Bouin.

ABOVE RIGHT: Still host to the occasional rugby game, Parc des Princes is losing its magic for the Qatari-owned PSG.

RIGHT: Serge Blanco with the ball in his last game as England knock France out of the 1991 Rugby World Cup at Parc des Princes.

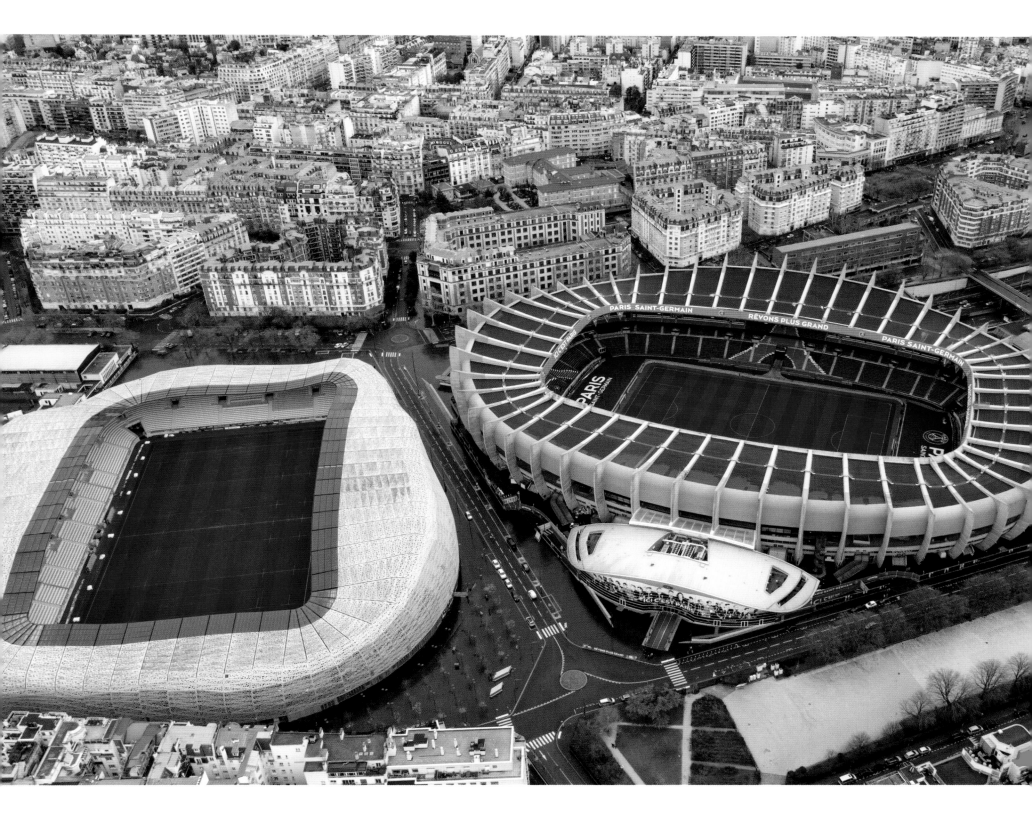

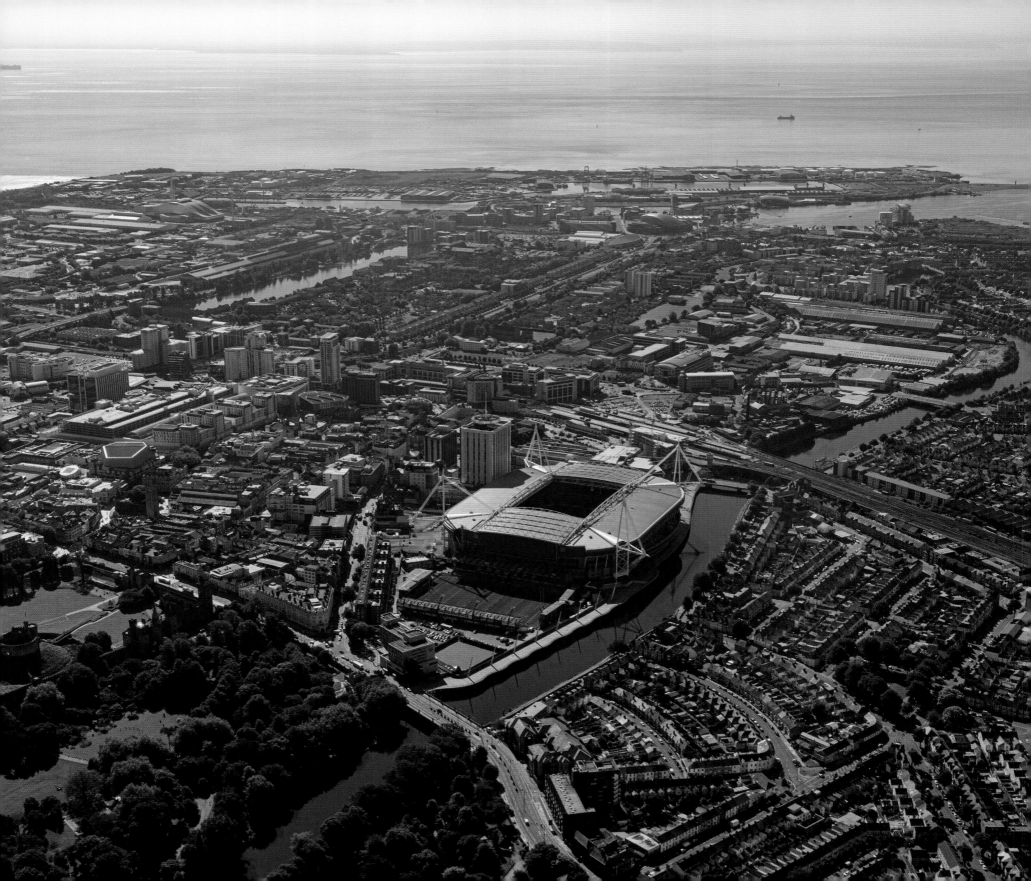

The Principality Stadium

Cardiff, Wales

The national stadium of Wales often tops the polls as the best rugby stadium in the world, and with good reason. Or several good reasons.

Firstly, the capacity is just shy of 74,000 but even from the 'nosebleed' seats you don't feel detached from the action. Secondly, when the roof is closed and the Welsh national anthem is ringing out, it is an event that is certain to stir the soul, whatever your nationality. Thirdly, it is located in Cardiff's city centre – the queues for trains after a game might be long but it's hardly as if Cardiff is lacking in venues for a post-match pint or two. Fourthly, even the opposing teams love playing here.

Because it works on every level, it makes it all the more surprising that the Principality Stadium almost didn't happen. When the Welsh Rugby Union (WRU) decided in 1995 that the National Stadium was no longer fit for purpose and the team needed a bigger venue, the initial plan was to move 20 miles down the road to Bridgend.

But the desire to build a new ground went back to 1958 when the National Stadium (aka Cardiff Arms Park) hosted events for the Commonwealth Games. It was a landmark moment for Cardiff, which had only become the nation's capital city three years earlier, and the event was broadcast around the world. But in the aftermath of hosting the Games, the state of the pitch would become a regular source of grievance, not helped by the fact that Cardiff ranks among the wettest cities in the UK.

The WRU purchased 80 acres of land in Bridgend with a plan to build a new stadium there in 1964, but there were problems with getting to and from the site. Yet, some 30 years later, the Bridgend plan was back on the table and drew support from Cardiff's fire commissioner who said a city centre venue would be a fire risk. Local councillors and the WRU successfully lobbied for the stadium to be built partly on the site of the National Stadium, albeit turning the pitch 90 degrees. The proposal to factor in what would become the first retractable roof at a British stadium was accompanied by footage of a choir getting drenched while attempting to sing on the pitch at the old ground.

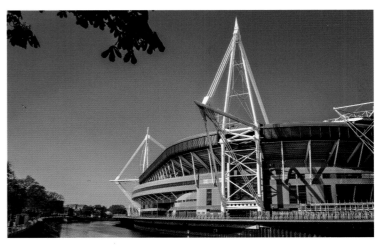

OPPOSITE: The Millennium Stadium was the first large UK stadium to feature a closable roof.

ABOVE RIGHT: In 2015, the Welsh Rugby Union announced a 10-year sponsorship deal with the Principality Building Society for the naming rights.

RIGHT: The Principality Stadium is skirted by the riverside Millennium Walk.

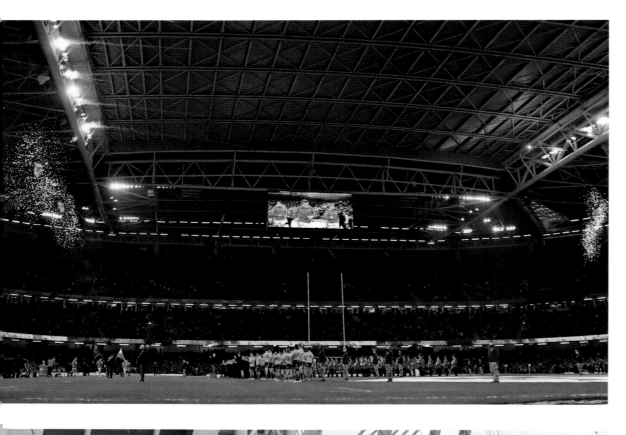

ABOVE: A sense of anticipation builds before the singing of the anthems.

TOP LEFT: A closed roof for the Autumn International series in 2022, Wales vs Australia at the Principality Stadium. Despite opening up a 21-point lead, Wales lost the match 34-39.

LEFT: Fans arrive for the game alongside the River Taff. Ironically, the stadium is situated next to the Temperance District of Cardiff.

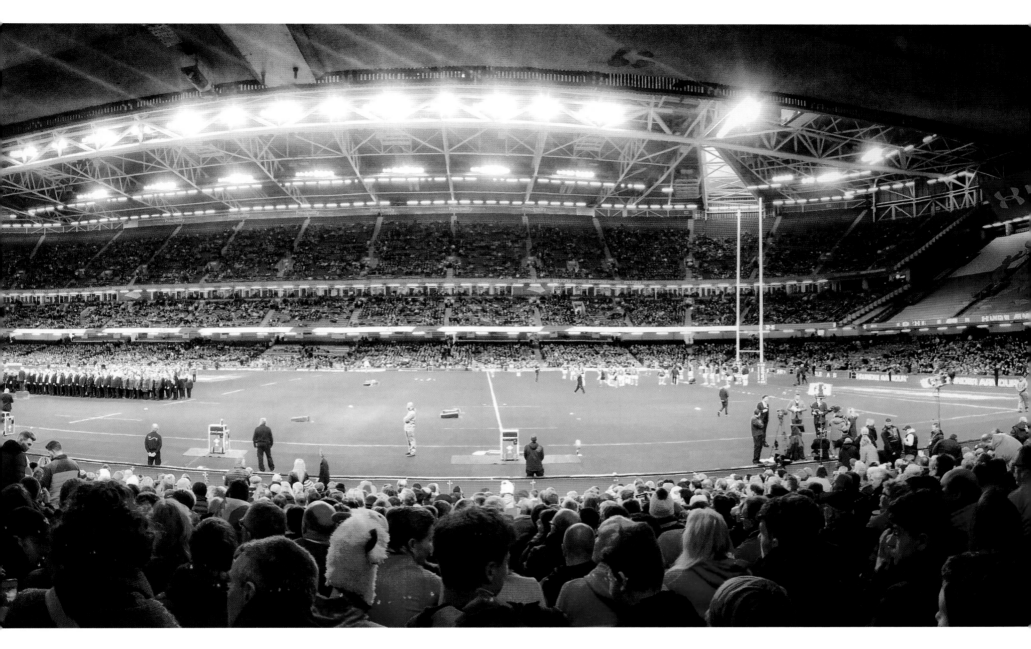

The location of what was initially named the Millennium Stadium and renamed the Principality in 2016 – next to the River Taff – meant that the number of options open to designers was somewhat limited, although it meant they had to stick rigidly to a set plan. Not only was the stadium delivered on time, and within a two-year deadline, but also on budget. Well, sort of.

Construction firm Laing had signed a contract that meant it would foot the bill if the project went over budget, a decision which cost the company £40m. One of the reasons cited is that steel which had been imported from Italy fell off the back of a ship in transit. It is also a rare example of a stadium being built primarily for rugby and then having football added on. Even though it is now 25 years old, the ground doesn't feel dated in any way.

Raeburn Place

Stockbridge, Edinburgh, Scotland

Team: Edinburgh Accies

When Scotland's last captain to win a Grand Slam, David Sole, was asked to speak about Raeburn Place in 2016, his words almost read like an impassioned, pre-match team talk, albeit delivered in a far more measured and sober fashion:

'When you look around you and see the state of Raeburn Place as it is today and you imagine about the possibilities of what it could be in future...you've got to be bold and you've got to have that inspiring vision that you're going to create something really special,' he said.

Positioned next to Inverleith Pond and within walking distance of the Scottish National Gallery of Modern Art, the National Portrait Gallery, and the Royal Botanical Gardens, the ground was looking decidedly out of place with its surroundings. The reason it meant so much to Sole is that Raeburn Place is home to his first club, Edinburgh Academicals, which is the oldest rugby team in Scotland.

Raeburn is also where the first rugby match between Scotland and England was played, in 1871, with Scotland winning by two tries to one. An as-yet-unreleased documentary titled *The Great Game* dramatises the story behind the match with some of the scenes being filmed here. It was a 20-a-side match with each half lasting 50 minutes, and eight members of the Accies played for the Scottish side, including captain Francis Moncreiff.

Eight years later, the first Calcutta Cup match between the Auld Enemies was played here. Raeburn Place is also a significant landmark in the women's game, having hosted the 1994 World Cup Final where England gained revenge over the 1991 champions, USA.

Some 20 years later, though, the ground was barely fit to stage an amateur game, which is when Raeburn Place Foundation was launched – a charity aimed at 'transforming lives through sport and healthy recreation.' The foundation came up with a plan to not only redevelop the site but also make it financially sustainable and hired Scottish architectural firm Mitchell Laird to design the new stand/pavilion/shops. The end result was unveiled in 2022, including a new 2,478-capacity stand and pavilion. On the other side of the stands are commercial units including a garden centre and interiors store, just in case you ever fancy buying a plant, as well as a vase to put it in, and take it to an Edinburgh Accies home game...

OPPOSITE: The elegant new grandstand provides viewing for both main pitches.

BELOW: Games at Raeburn can be admired from the hill on the other side of Inverleith Pond, with a view to distant Edinburgh.

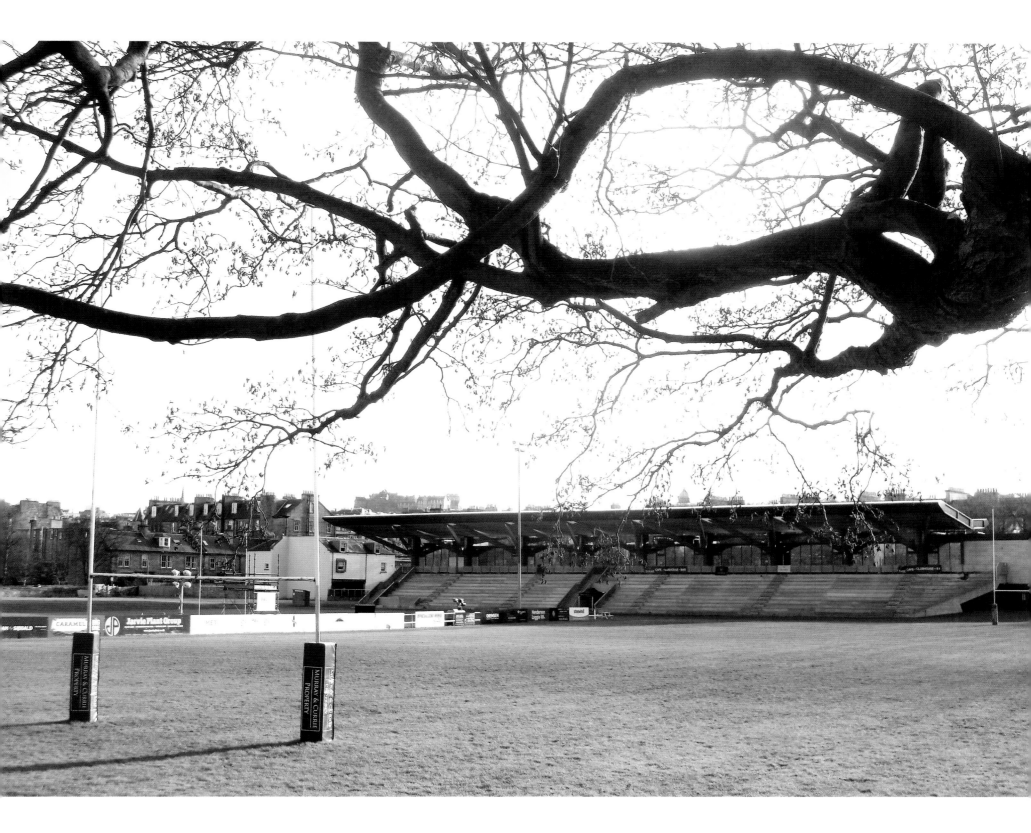

The Recreation Ground

Bath, England

Team: Bath RFC

'A bit of an overpriced shambles but its location in the centre of Bath is like no other,' is how Stuart Barnes, the Bath and England player turned columnist and commentator, once described The Rec.

That location makes The Rec a contender for the best club rugby ground. It is situated next to the River Avon and on the other side of that river, Bath Abbey looms over the city, all of which is shown to best effect during an evening match.

Added to that, Bath is one of a handful of cities in England where rugby dominates the sporting scene, and you get an atmosphere worthy of its surroundings.

Bath Football Club, as it was originally known, moved here in 1894 on land owned by Bath County and Recreation Ground Company Ltd. The Rec originally hosted everything from cricket to lawn tennis to archery and crown green bowls.

Both the North Stand (built in 1927) and the West Stand (built in 1933) were destroyed after being bombed by the Luftwaffe as part of the Baedeker Raids which targeted Britain's historic cities in World War II. Work didn't start on replacement stands until 1953.

Before rugby entered the professional era in 1995, the club was the dominant force in English rugby. Also in that year the team changed its name from Bath to Bath Rugby and secured a 75-year lease on The Rec.

However, the legal technicalities of who really owns the site, and whether that lease was legally sound, along with what can (or cannot) be built there, has been a long, drawn-out saga, and one

RIGHT: Surrounded by Georgian terraces, the Recreation Ground lies on the banks of the River Avon.

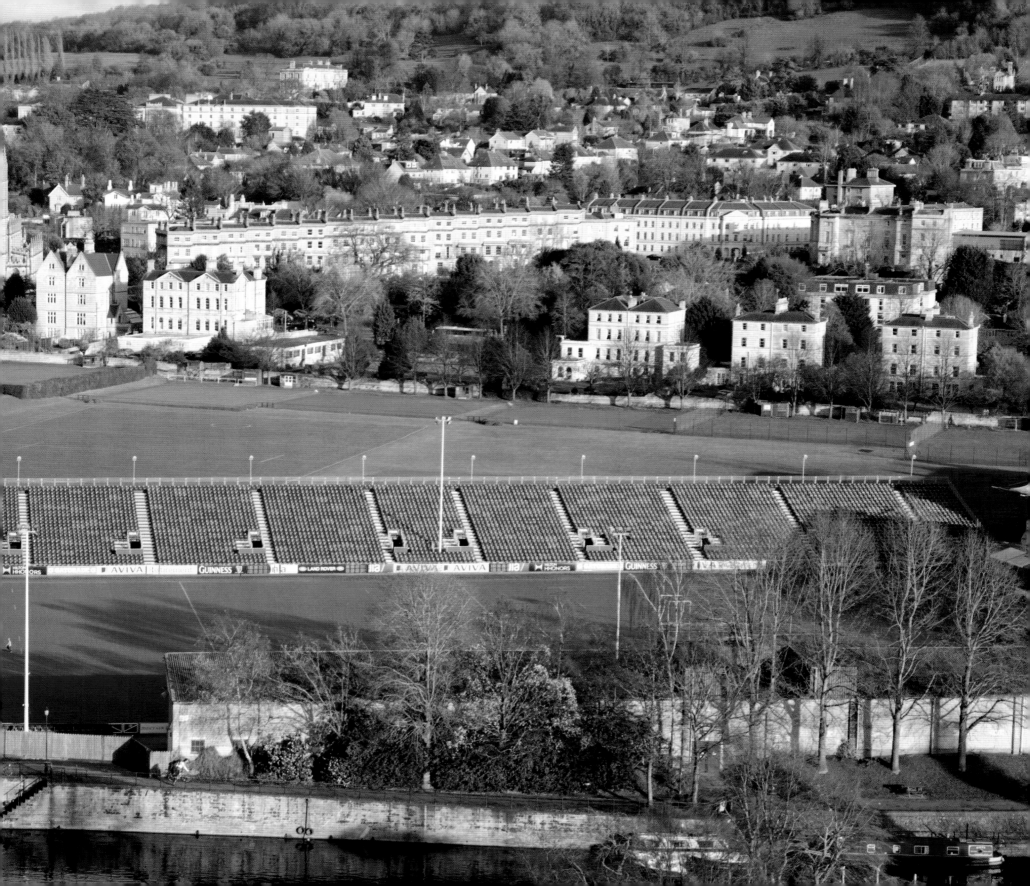

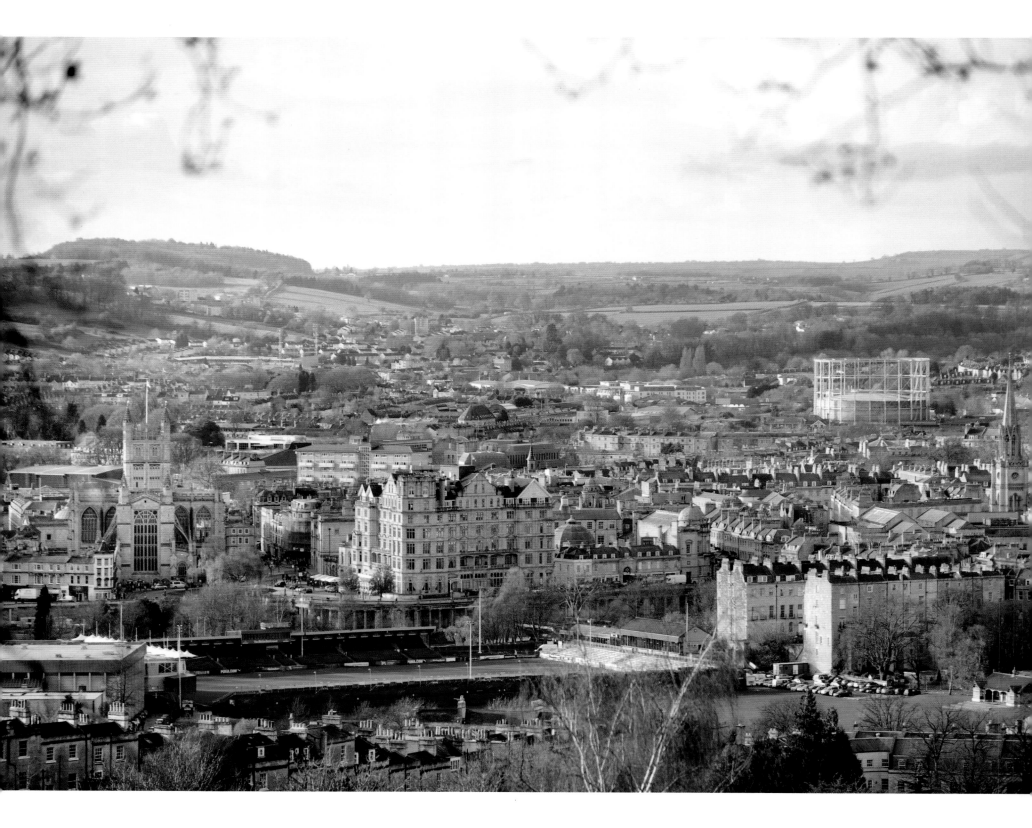

that has gone through the courts. Then there are the simple practicalities of trying to redevelop The Rec.

In 2018, architectural firm Grimshaw was tasked with creating a new, 21st-century version of The Rec, on the same site, and the courts granted permission for Bath to press on with those plans in December 2021. Four months later, a local resident challenged this ruling because redevelopment would have an environmental impact and could threaten the city's World Heritage status.

This happened soon after Liverpool's historic docks were stripped of that same status partly because the site would become home to Everton's new stadium, which was one new development too far for UNESCO.

Bath has been granted the right to keep temporary stands, which have been there for so long, they are 'temporary' in a very loose sense. Something eventually has got to give. But not until 2025, at least.

OPPOSITE: Looking over The Rec towards the heart of the city with Bath Abbey beyond and to the left.

RIGHT: The club have been playing at The Rec since 1894.

BELOW: Casual rugby fans used to be able to get a free view of games from the end of Johnstone Street, but the extension of the stands behind the posts has put paid to that.

BELOW RIGHT: The old turnstile entrances to the park are now Grade II-listed buildings.

Resonac Dome

Oita, Japan

It is a dome of many names. From 2001 it was the Oita Stadium, then the Kyushu Oil Dome, the Oita Bank Dome, the Showa Denko Dome and from January 2023 the Resonac Dome. It was featured prominently in *Big Bigger Biggest*, a series broadcast on the Discovery Channel about the evolution of megastructures ranging from airports to skyscrapers. In 2009, an episode was devoted to domes, and charted a history that began with the Pantheon in Rome (completed in 609 and still the world's biggest unreinforced dome) through to this stadium in Oita, which hosted five matches at the 2019 World Cup.

The episode serves as a good introduction to how you go about building a structure of this nature that has a span of 274 metres (899 feet), as well as the lessons that engineers learned from mistakes made in the past, including the ill-conceived roof at the Montreal Olympic Stadium. A steel skeleton holds the 12,000-tonne roof. Perhaps the most surprising element of the construction process involved the use of paddling pools filled up with water to test the strength of the Teflon-coated membrane that covers the dome and whether it could withstand extreme weather conditions – the Metrodome roof in Minnesota collapsed in 2010 under the weight of heavy snow and ice.

When the episode was broadcast, the Oita Dome was the largest building of its kind in the world but has since been surpassed by Cowboys Stadium in Arlington, Texas, and the National Stadium in Singapore. Yet even though it is over 20 years old, the ground, known as the Big Eye, still looks like something from a magazine predicting what the stadiums of the future will look like.

It is also a multi-purpose venue, which has an athletics track that can be removed and replaced with a tier of retractable seats so spectators in the front rows aren't too far from the action. As spectators discovered during the Rugby World Cup, the stadium is a model of efficiency and cleanliness. The one criticism is that there is very little else within close vicinity of the Big Eye.

Following the World Cup, the Dome also staged the first match played by Japan in almost two years since reaching the quarter-finals, after Covid restrictions were lifted in 2021 and the 'Brave Blossoms' entertained Australia, losing 23-32.

OPPOSITE: The Oita Dome was a stadium ahead of its time when it was opened in 2001.

RIGHT: Two images from the Japan vs Australia Test match as the Wallabies emerged with a 23-32 victory over the 'Brave Blossoms' at the (then) Showa Denko Dome in 2021.

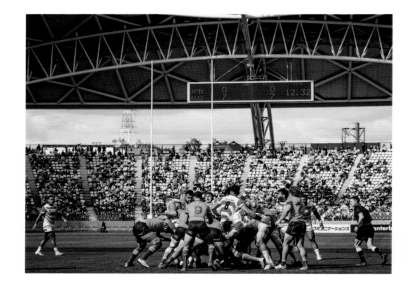

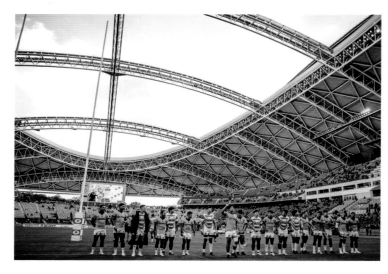

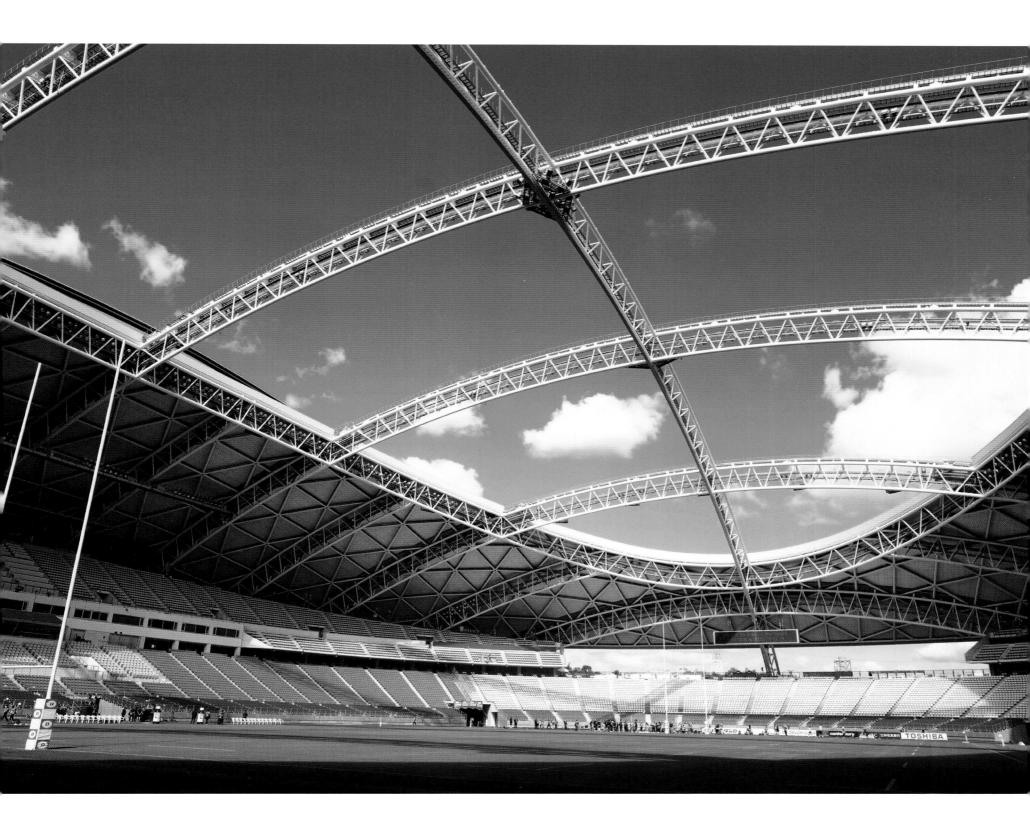

Richmond Athletic Ground

Richmond, Surrey, England

Teams: Richmond RFC, London Scottish RFC

It can be argued that no club has had as much influence on the history of rugby as Richmond RFC. It was one of 21 teams that founded the Rugby Football Union (RFU) at a meeting at the Pall Mall Restaurant in London's Haymarket on 24 January 1871 – effectively the birth date of rugby as we know it.

There were meant to be 23 attendees but Ealing's representative took a detour to the pub and missed his dinner date, while Wasps posted a no-show by turning up in the wrong place, at the wrong time, on the wrong day. The meeting was initiated by Richmond's founder, Edwin G. Ash, who also became the RFU's treasurer, while fellow Richmond official Algernon Rutter was the first RFU president.

The All Blacks played here on their first tour of the UK in 1905. The referee awarded 14 first-half penalties against the visitors, prompting the *Daily Mail* to quote a spectator saying, 'why aren't the New Zealanders allowed to have a man whistle for them, too?' The All Blacks still won 11-0.

And you have the club to thank for the Women's Rugby World Cup. Four Richmond WRFC teammates, led by Mary Dorrington, overcame all sorts of challenges within the game – the International Rugby Board would not recognise the event – coupled with the problems of staging an international tournament on a shoestring budget, to put on the first World Cup in 1991.

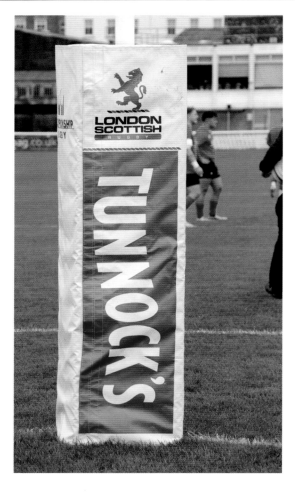

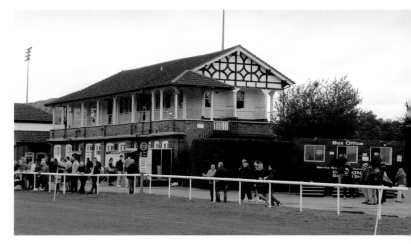

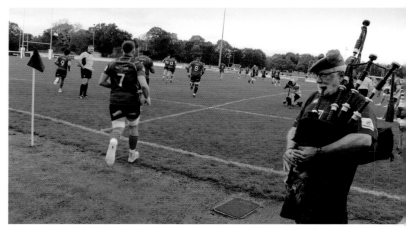

The Athletic Ground has been home to Richmond since 1889 and London Scottish since 1894. The one constant during that time has been the Pavilion, which was built in 1886, resides on an elevated perch with changing rooms underneath, and features plaques that

ABOVE LEFT: One glance at the posts tells you this is a London Scottish home fixture.

ABOVE: A fact reinforced by the skirl o' the pipes when the home team takes to the pitch.

TOP: For London Scottish home games, the dedicated box office is wheeled into place.

commemorate former players who lost their lives in both World Wars I and II.

It is situated on the edge of Old Deer Park, a historic sports complex that also includes a golf club, London Welsh RFC, and the King's Observatory. What it doesn't include is deer, at least not any more. The building was afforded Grade II-listed status in 1997 by English Heritage in recognition of its sporting history. Two years later, both clubs went into administration, victims of the chaos caused by rugby turning professional. Both have come back from the

brink and one hopes they will survive the financial fallout of the pandemic, and that ambitious plans to redevelop the site will see rugby played here for years to come.

ABOVE: London Scottish kick a conversion in their 2022 match with Championship opposition Ealing Trailfinders. The home side matched their local rivals until half-time, but the Trailfinders powered ahead in the second half.

RIGHT: Still in service after 137 years, the 1886 pavilion will be protected in any redevelopment.

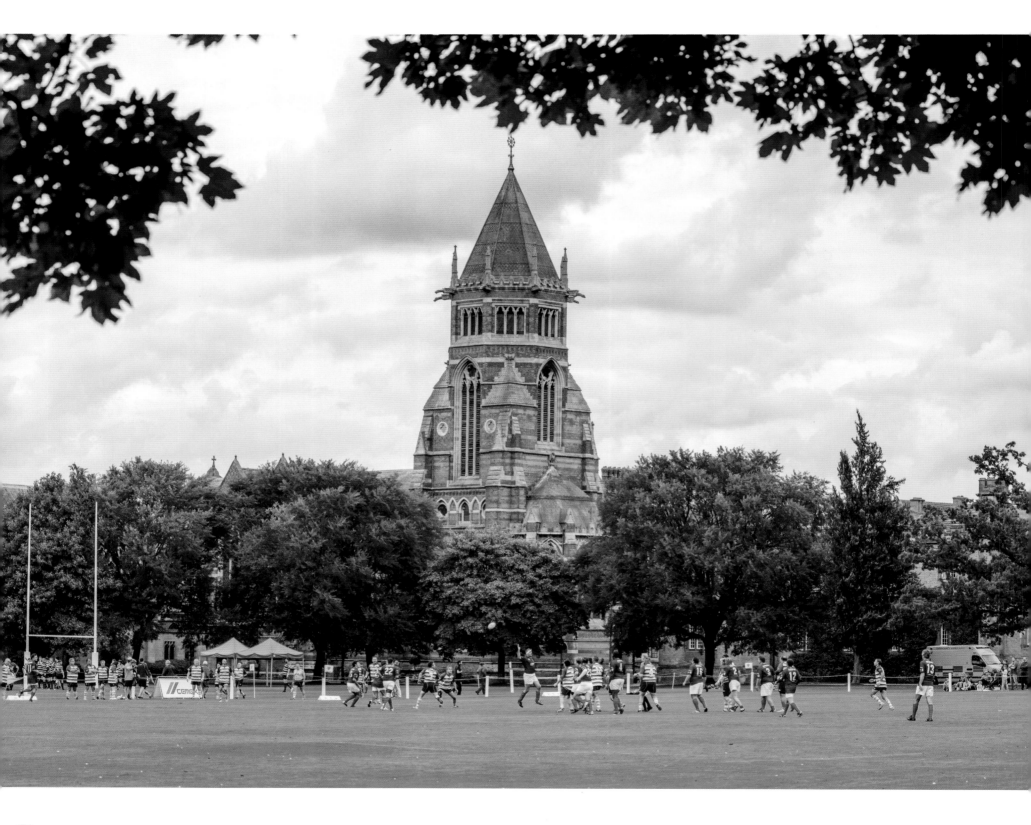

Rugby School

Rugby, Warwickshire, England

Rugby School was established in 1567 with a bequest from Lawrence Sheriff, royal grocer to Elizabeth I, who wanted to provide a free grammar school for local boys. As time went on, the school took in 'non-foundationers', or paid boarders, who eventually became the sole source of pupils admitted to the hallowed halls.

The school is famous for two things: inventing the game of rugby and *Tom Brown's School Days*. The legend of William Webb Ellis, a pupil who picked up a ball during a game of football and ran with it, is part of the sport's folklore. The game that evolved was picked up by other schools and then codified by Messrs Arnold, Shirley and Hutchins at Rugby School in 1845.

Tom Brown's School Days (1857) is a book by Thomas Hughes which sheds light on the English public school system. It contains an account of a game of rugby (and cricket), and the book's popularity helped spread the knowledge of the game both at home and abroad. Tom Brown's School Days was used as an English-language textbook for Japanese high school students between 1868 and 1912, which may account for the nation's adoption of the sport. The Japanese translator omitted the game of cricket in the book as he found it too complicated.

Probably just as important as the Webb Ellis innovation – because balls had been carried during village-to-village football matches from the middle ages – was the invention of the oval-shaped ball. Richard Lindon was a boot and shoemaker with premises opposite the front doors of the Quadrangle of Rugby School. Apart from stitching shoes for the school, there was a constant request for footballs from the boys. The Rugby boys wanted an oval ball to distinguish their game from the bounders playing association football, so Lindon devised an egg-shaped bladder with four stitched panels that would evolve into the modern rugby ball.

For his efforts, in 1861 Richard Lindon was recognised as the principal Foot-Ball Maker to Rugby School, Oxford, Cambridge, and Dublin Universities. He called his creation the Big-Side Match Ball, which was successfully manufactured by both Richard Lindon and, subsequently, his son, Hughes John Lindon, for half a century.

OPPOSITE: The chapel of Rugby School soars over the hallowed turf of the playing fields.

BELOW: Today, the school has a statue to the pupil who put their name on the world sporting map. *Orando Laborando* (to pray, to work) is the school motto.

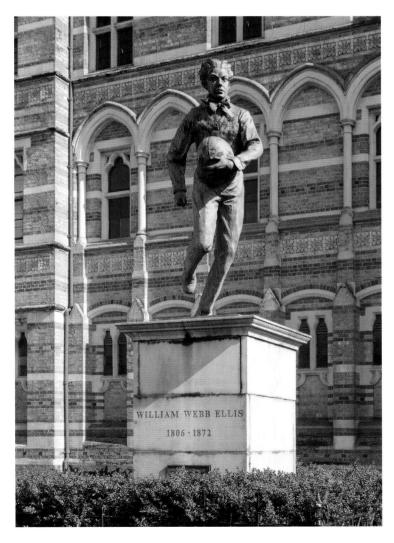

Sam Boyd Stadium

Whitney, USA

When the *Belfast Telegraph*'s Geoff Frazer went to Sam Boyd Stadium on a press trip in 2019 and took in the USA leg of the World Rugby Sevens tournament, he wrote, 'I used to think that watching Ireland play at the Aviva was the best place to watch rugby – after these three days in Vegas, it's definitely time for a rethink.'

When you look at that setting on the outskirts of Las Vegas, and with matches being played in temperatures around the 70°F (21°C) mark, then what's not to like?

From 2010 to 2019 this was the USA home of World Rugby Sevens and it also hosted several Major League Rugby Vegas Weekenders. Before that, it was perhaps best known as the first stadium to have a retractable pitch, known as the Magic Carpet.

It took around an hour to roll up the artificial surface into cylinders and was bought in 1985, in a deal that was part-funded by the Boyd family – one of America's most famous gambling dynasties. Sam's Town is a collection of hotels, casinos, and theme parks founded by the late Sam Boyd, and now run by his son. The huge sign that welcomes you to Sam's Town provided the title for the multimillion-selling second album by The Killers – the bassist could see it from his family home.

After his family moved to Vegas in 1941, Boyd Snr rose through the gambling ranks to run a successful operation away from the main strip, targeting groups of holidaymakers, most notably Hawaiians, who wanted the Vegas experience but couldn't afford Caesars Palace prices. Boyd was once described as a 'straight guy, at a time when many of his peers had a more pliable attitude to rectitude' – a wonderful way of saying that Boyd didn't work for the Mafia and wasn't involved in organised crime.

The stadium that bears Boyd's name is in Whitney (known to some as East Las Vegas), around 6 miles (10km) from the main strip. It looks like it was built in the middle of nowhere and that was pretty much true when the stadium opened in 1971, costing $3.5 million.

Since then, Vegas has grown from a small city with a population of 250,000 to a metropolis approaching 3 million residents. So it was only a matter of time before it got a new mega-sized, mega-expensive ground, and an NFL franchise to go with it.

When the Allegiant Stadium opened in 2020, costing $2.7 billion, it effectively spelled the end for the Sam Boyd Stadium. Frazer can consider himself somewhat fortunate to have seen rugby played there because it shut down in 2020 following the outbreak of Covid 19 and has remained closed ever since.

TOP: The USA Sevens were given all the razzamatazz of an NFL team taking the field.

ABOVE: A wider view of the stadium shows it is firmly set in the Nevada desert.

OPPOSITE: No sign of gridiron markings, or a goalpost with a single support, Sam Boyd was set up for rugby.

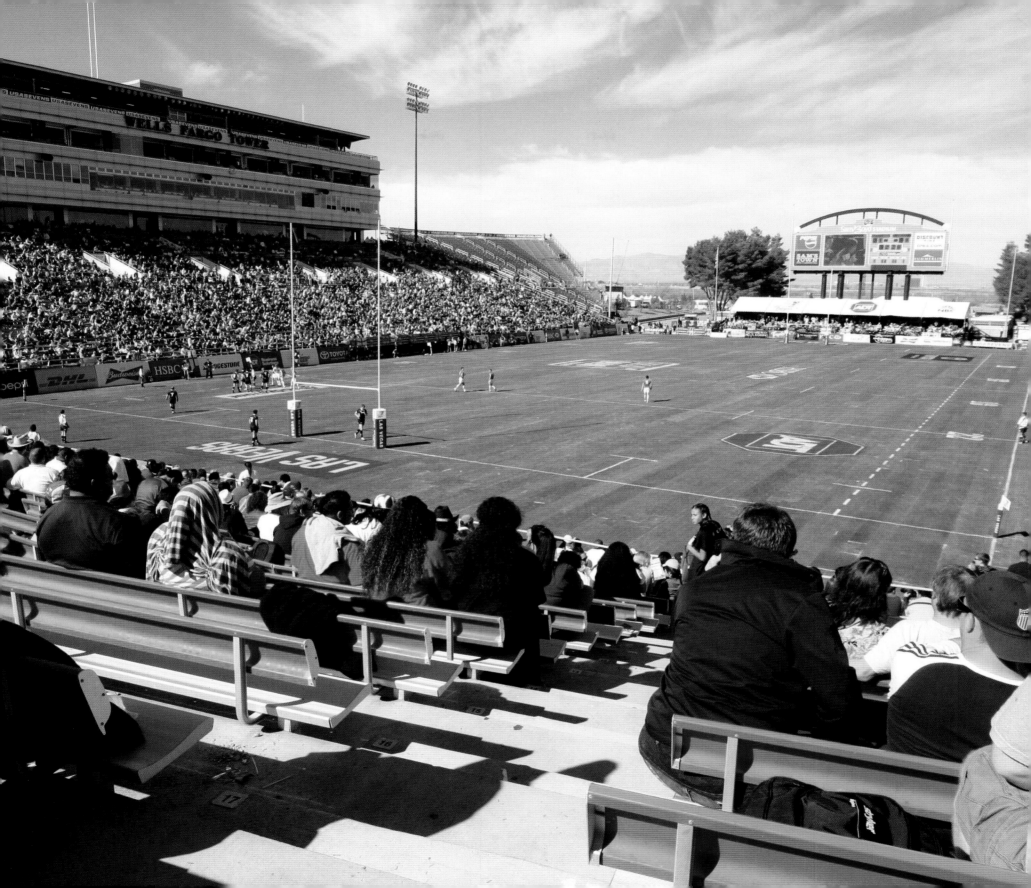

Sardis Road

Pontypridd, Wales

Team: Pontypridd RFC

Sardis Road is also known to the locals as 'Dan's Muckhole' which, admittedly, doesn't make it sound a particularly appealing place to visit. Thankfully, we have the pictures to prove otherwise. The ground acquired the nickname as it was built on the site of the 1875 Pwllgwaun Colliery – a coal dram at the Rhondda end of the ground not only recognises the history behind Sardis Road but is also a tribute to the miners who gave so much to the community.

The colliery's proprietor was Daniel Thomas, who was also a bare-knuckle mountain fighter, boxing under the name of Dai Ponty. Fist-fighting was illegal in Wales, so bouts were staged in the mountains and would often go on until somebody was knocked unconscious. Thomas later found religion and donated much of his wealth to local causes.

The mine shut down in 1948, but it wasn't until 1974 that Pontypridd moved here from their old ground Ynysangharad Park, part of which had become the A470 road. The move coincided with a golden era for the club. Over the next 30 years, Ponty was one of the powerhouses of Welsh rugby, winning titles and trophies and producing a string of international

OPPOSITE: One look at the posts of Sardis Road and you'd be forgiven for thinking you'd arrived at Treorchy Zebras.

BELOW AND BELOW LEFT: 'The Shed' regulars show their appreciation for the home side. 'Proper' rugby grounds have sheds. It's unlikely that modern stadium designers have incorporated a shed in their concept artwork.

BOTTOM: A 3G playing surface allows training on the pitch all year round.

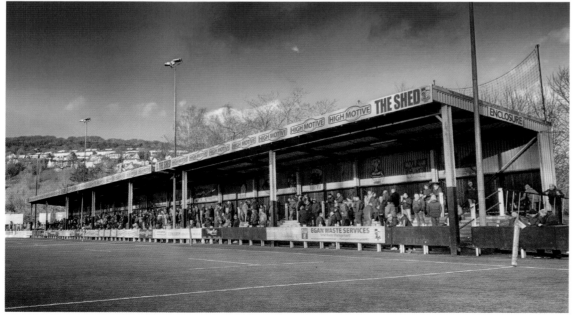

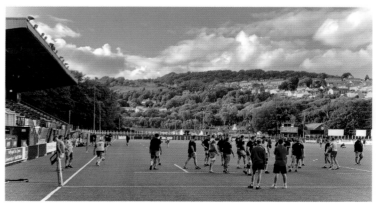

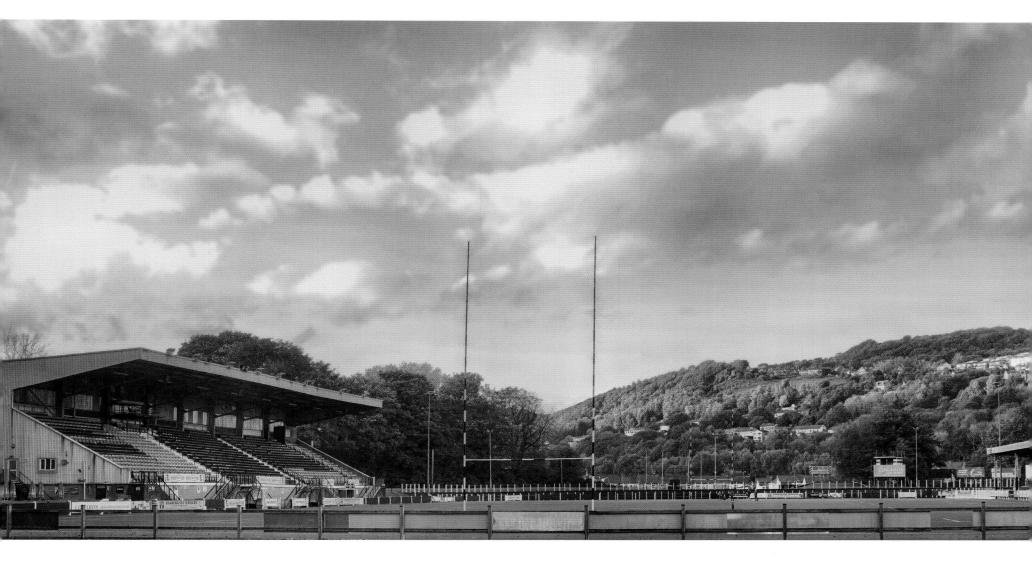

players, including Neil Jenkins. The ground was christened 'The House of Pain' by captain and cult local hero Nigel Bezani, and it was an intimidating place for the opposition to come and play.

During that time 'muckhole' often seemed like an apt description for a pitch that would frequently turn into a quagmire, although the story of a collapsed scrum sinking into the ground is purely a myth … apparently. Eventually, a 3G pitch was installed in 2016.

Kevin Rudge is the photographer who took the shots of all the grounds we've featured from the Valleys, but Pontypridd holds a special place in his affections as it's the team he supports. 'You know, all these modern stadiums are fantastic, but these grassroots grounds have got character,' he says. 'I remember a few seasons ago coming here for a British and Irish Cup game against Bristol. A Bristol fan was walking in with his young son, and I overheard the father say, "now this is a real rugby ground".'

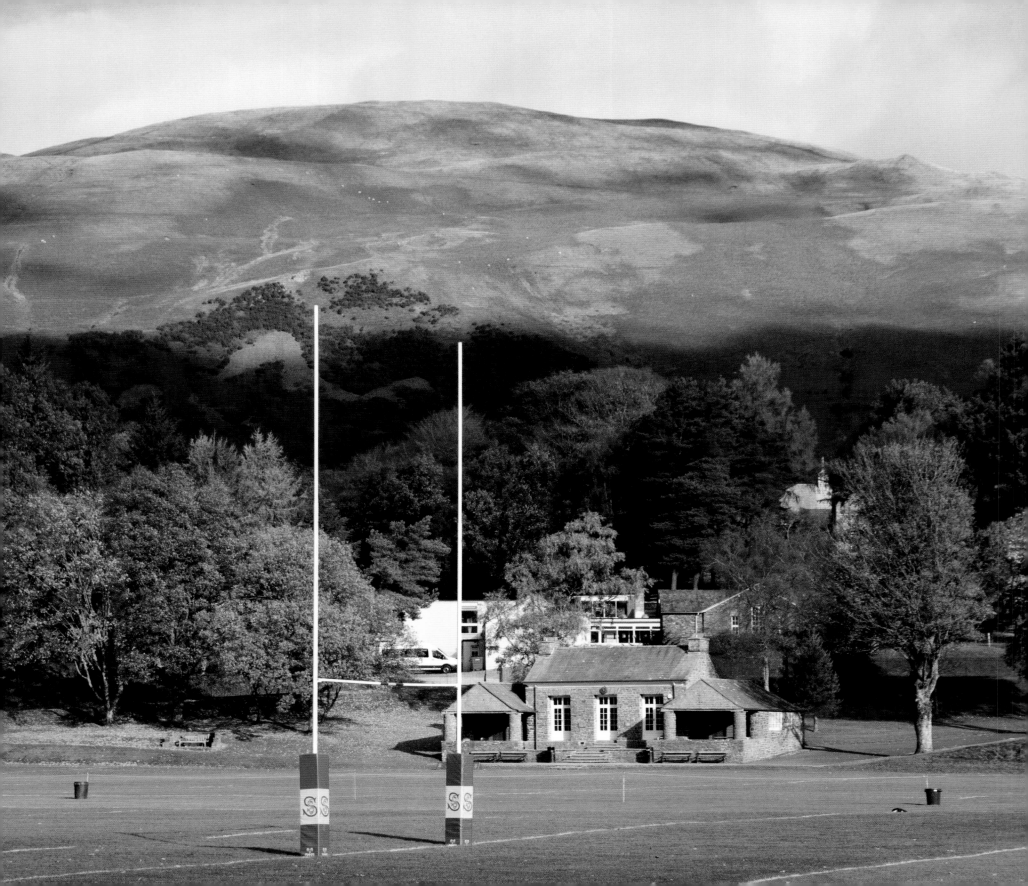

Sedbergh School

Cumbria, England

If you're not familiar with English schools rugby, then Sedbergh may be one of the best teams you probably haven't heard of. Over the years this seat of learning at the tip of the Yorkshire Dales, has been a production line for future internationals including Will Carling, Will Greenwood, Cameron Redpath, Bevan Rodd and rising star Josh Hodge (who may well be a fully fledged star by the time you read this).

'There's no football, there's no anything other than rugby,' Redpath said in an interview with *Rugbypass*, adding that, 'I remember going there for my first ever training day and there were year nines spin passing 25 metres and I couldn't even do that off my left hand at the time let alone my right, they were doing it off both.'

The school prides itself on preaching an attacking style of rugby and has been a regular fixture towards the top of the NextGenXV, aka rugby's world rankings for schools. While Sedbergh boasts a rich history that is etched into the school's panelled oak plaques, it is also looking to the future, as pointed to by the success of alumni Abbie Ward, a member of the England team that finished runner-up in the most recent World Cup. As the school's own website says: 'Girls' sport at Sedbergh is changing. We are no longer playing second fiddle to our impressive rugby boys and with the further introduction of expert coaching, strength and conditioning programmes, extra technical and tactical sessions and links to outside clubs and teams, the standard of girls sport at Sedbergh will only improve further.'

What's more, they get to play their rugby in a village for which the expression 'quintessentially English' could have been invented. This was once home to the 'Festival of Ideas' that would bring together eminent thinkers and philosophers. Sadly, deep-thinkers couldn't work out how to make the event financially viable and it went bust. Since then, the narrow, winding streets have become home to a host of bookshops and it has become England's unofficial 'Book Town'.

It is just a short walk from the village and the school to the Howgill Fells that provide this glorious backdrop. The fells were immortalised by author Alfred Wainwright, who was once dubbed 'the patron saint of walking' and who memorably described this landscape as looking like a herd of sleeping elephants.

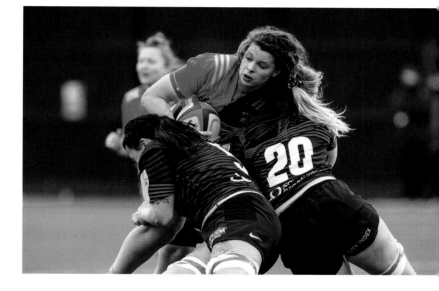

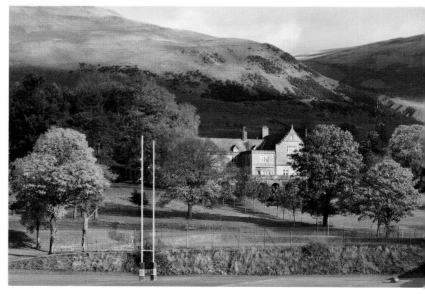

OPPOSITE AND RIGHT: Two views of the Sedbergh rugby pitch set against the Cumbrian Fells.

ABOVE RIGHT: Old Sedberghian Abbie Ward has gone on to star for Harlequins, Bristol Bears and England.

The Sevens Stadium

Dubai, United Arab Emirates

In 2022, sportswashing became one of the biggest global sports stories. In a nutshell, critics say that governments and nation states use sport to create a better image for their country and cover up a multitude of sins.

The 2022 FIFA World Cup in Qatar is viewed as the most obvious recent example of sportswashing, along with the large-scale investment in football teams from oil-rich Gulf States including Qatari-owned Paris Saint-Germain, UAE-owned Manchester City and Saudi Arabian-owned Newcastle United.

The United Arab Emirates was the first of the Gulf states to diversify its economy, and sport has played a central role in that story, from F1 races to golf tournaments, and horse racing to international rugby.

In 2008, the Sevens Stadium opened – a venue purpose-built to host Sevens rugby. It soon became one of the grounds to host the HSBC World Rugby Sevens series. This is also a multi-purpose site that can be converted into a 44,000-capacity venue capable of hosting major concerts, Indian Premier League cricket and pre-season football matches featuring teams across the major European leagues.

In March 2022, a new solar-powered carport was unveiled to accommodate 5,000 vehicles, which is the first time a sports venue has had such a facility. The carport (aka car park) also provides power for 1,042 field lamps, 256 street lamps, 57 water and irrigation pumps, two units of 300-tonne chillers, the Grandstand building, players clubhouse and staff accommodation. Well, if you can't rely on solar power in Dubai... However, those sustainability credentials can get called into question when considering the amount of water required to keep a pitch in tip-top condition in a city which has a desert climate.

OPPOSITE: Dubai is hoping to establish itself as the Sevens destination of the Middle East.

BELOW LEFT: A promotional ball showing the Dubai skyline including the Burj Al Arab and the Burj Khalifa.

BELOW: The Irish women's team control a ruck in their match against Spain during the Dubai Sevens of 2019.

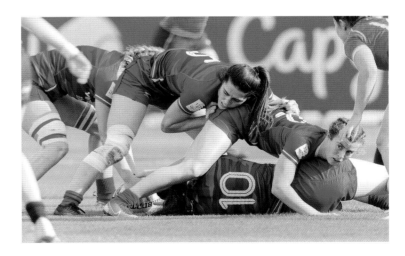

SoFi Stadium

Los Angeles, USA

On 24 May 2021 the SoFi Stadium hosted Major League Rugby as the LA Giltinis took on the Utah Warriors for one of the first events held at the world's most expensive sporting arena.

The choice of venue was by luck rather than design – a scheduling cock-up meant switching the game from regular venue the Los Angeles Coliseum. The Giltinis (named after a 'premium Martini-based cocktail') were co-owned by former Wallabies fly-half Matt Giteau and ex-Aussie wicketkeeper Adam Gilchrist. Having won the MLR title in 2021, the club disappeared in 2022 following a 'violation of league rules' – to this day no further explanation has been forthcoming, possibly for legal reasons. For the supporters, Giltinis vs Warriors made for an impressive spectacle, although there were times when the players looked somewhat confused by the clear gridiron markings designed for the NFL.

SoFi is actually home to two NFL franchises – the LA Chargers and 2022 Superbowl champions the LA Rams. The Rams are owned by Stan Kroenke (who also owns Arsenal FC). Kroenke is so wealthy that he owns a ranch in Texas which is larger than Los Angeles and New York City combined. He is so wealthy that when his vineyard produced $3 million-worth of wine that was not up to his exacting standards, staff were told to pour it down the drain. And so wealthy that he owns the SoFi stadium, which cost $5.8 billion.

It is not just the priciest ground in the world but triple the cost of the next most expensive arena, the Allegiant Stadium in Las Vegas, which begs the obvious question 'why'? The soaring cost of construction was partly attributable to a period of wet weather that saw LA receive more rain in the opening six weeks of 2019 than it had for the whole of 2018.

That said, when you spend $5.8 billion, you do get a bit more than a stadium. The site also covers an indoor arena (the 6,000-capacity YouTube Theatre) a six-acre lake and a 300-piece art collection. In total, the SoFi complex covers 3.1 million square feet. And while the main playing arena has a capacity of 70,000, that can go up to 100,000 when all the other viewing areas around the stadium complex are opened up.

Over 10% of the total cost was recouped when financial services company SoFi (Social Finance) decided to pay $30m every year for 20 years to secure the naming rights. The stadium warrants inclusion in this book not just for a one-off match, but because LA will be one of the host cities when USA stages the Rugby World Cup in 2031 and SoFi will almost certainly be on the list of RWC venues.

BELOW: The SoFi Stadium has been created under the maxim, 'no expense spared'.

OPPOSITE AND BOTTOM: Expect proper posts and correct field markings when the Rugby World Cup shows up in 2031.

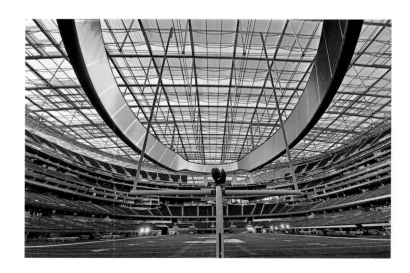

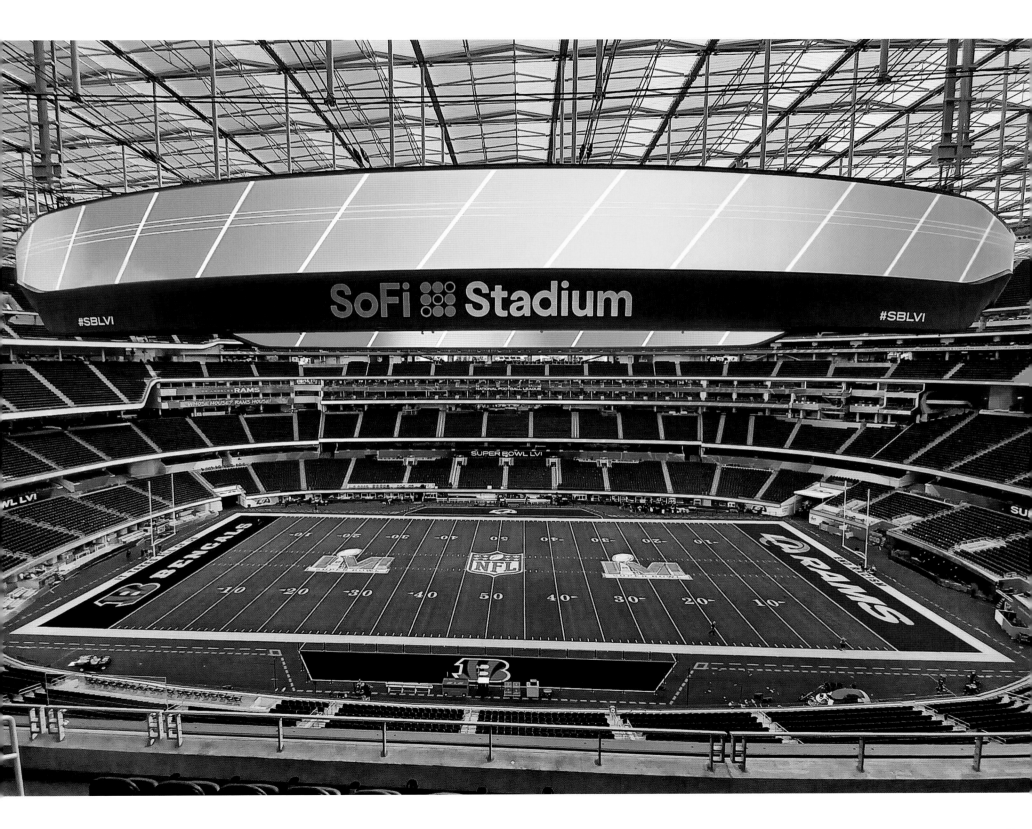

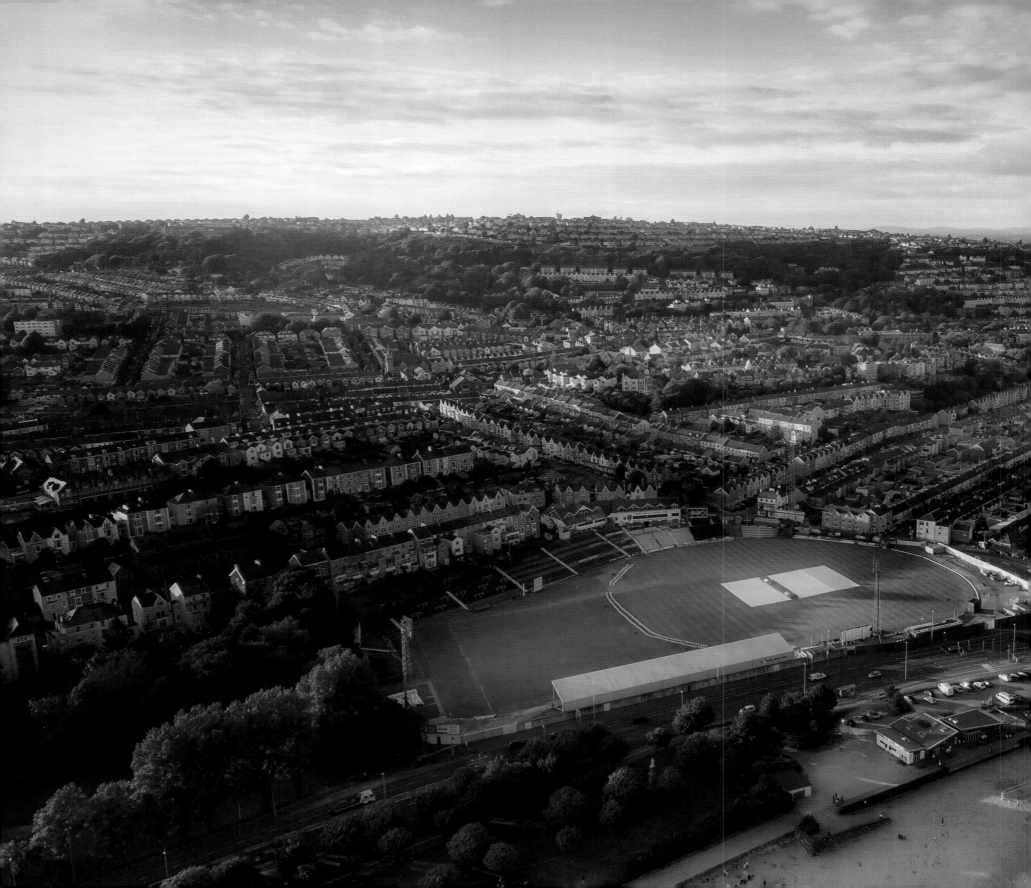

St Helen's Rugby and Cricket Ground

Swansea, Wales

Team: Swansea RFC

Sited close to the shores of Swansea Bay, St Helen's ranks among the most picturesque places to watch sport in the UK, but also boasts one of the most storied histories of any ground in the world.

For starters, there is a plaque outside that reads 'Swansea Rugby Club first ever club side to beat the Southern Hemisphere big three'. In 1935, this was the scene of Swansea becoming the first club side to beat the All Blacks (it was only their second loss in 67 matches across Europe), to add to victories over Australia and South Africa. This is also where the first Five Nations match was played in 1910. Wales won 49-14, beating a French side forced to field a player that one of the selectors randomly found in Paris after another team member had been called up for military service.

St Helen's has a schizophrenic existence – half county cricket ground, half rugby ground (the nearest comparison is probably Bramall Lane, which hosted Yorkshire County Cricket and Sheffield United until 1973). Glamorgan's home ground was the venue in 1964 where Sir Garfield Sobers became the first batsman in first-class cricket to hit six sixes in one over, against spinner Malcolm Nash. Plus there was also the time when the nation's most celebrated poet, Dylan Thomas, won the Swansea Grammar mile race held at St Helen's in 1928 – he always carried a

LEFT: A drone shot of the St Helen's ground with the rugby pitch and grandstands to the left.

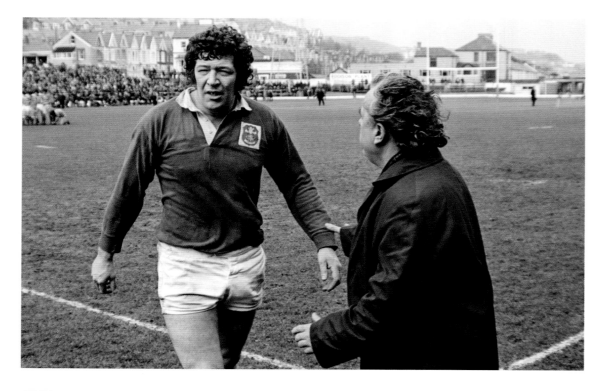

clipping from the local newspaper of his success in the event.

Both Swansea's rugby and cricket teams have co-existed here since 1873 (it was also once home to a cycling track and, very briefly, greyhound racing), and being a dual-purpose venue makes for a decidedly unconventional configuration, especially when you see it from above. The 1920s saw the construction of a new cricket pavilion and rugby grandstand and the Welsh rugby team would divide its home games between the old National Stadium and St Helen's. In 1953 the Welsh Rugby Union felt that the facilities at Swansea had to be improved

LEFT: Llanelli RFC flanker Alan James leaving the pitch in the WRU Cup Semi-Final clash with Bridgend held at St Helen's Rugby and Cricket Ground, March 1975.

BELOW LEFT: The old entry gates adorned with a variety of plaques.

BELOW: Local boy Dylan Thomas' greatest sporting achievement took place at the St Helen's ground.

OPPOSITE: A drone shot looking from St Helen's towards the Mumbles, taken by former Welsh international and now adventure blogger Chris Knight.

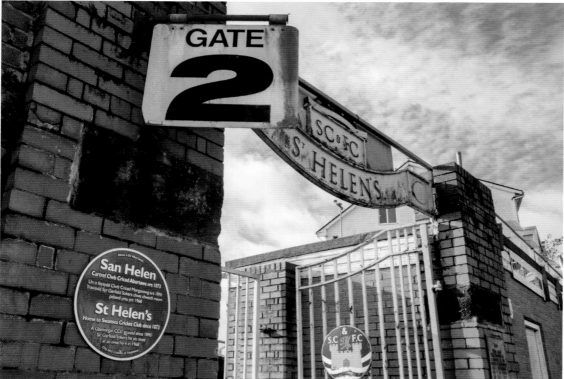

and made the National Stadium its regular home. Swansea erected floodlight pylons in a bid to reverse the decision, but that ship had sailed. Yet the club was still breaking new ground by becoming the first side to tour in communist-ruled Eastern Europe when the team was invited to play three games against Romania. The Romanians toured the UK in 1955 and 1956. On both occasions, they played Swansea; the second match at St Helen's involved three players working with MI5 to help a Romanian player defect from his homeland.

The professional era and the formation of Neath-Swansea Ospreys in 2003, meant that Swansea RFC became the city's second club.

Fears that its future would be under threat as part of a regeneration plan for Swansea proved to be unfounded. Even though the original and much-loved East Stand has gone, what remains is a spectacular view from the members' enclosure over Swansea Bay and the Bristol Channel, with Somerset in the distance.

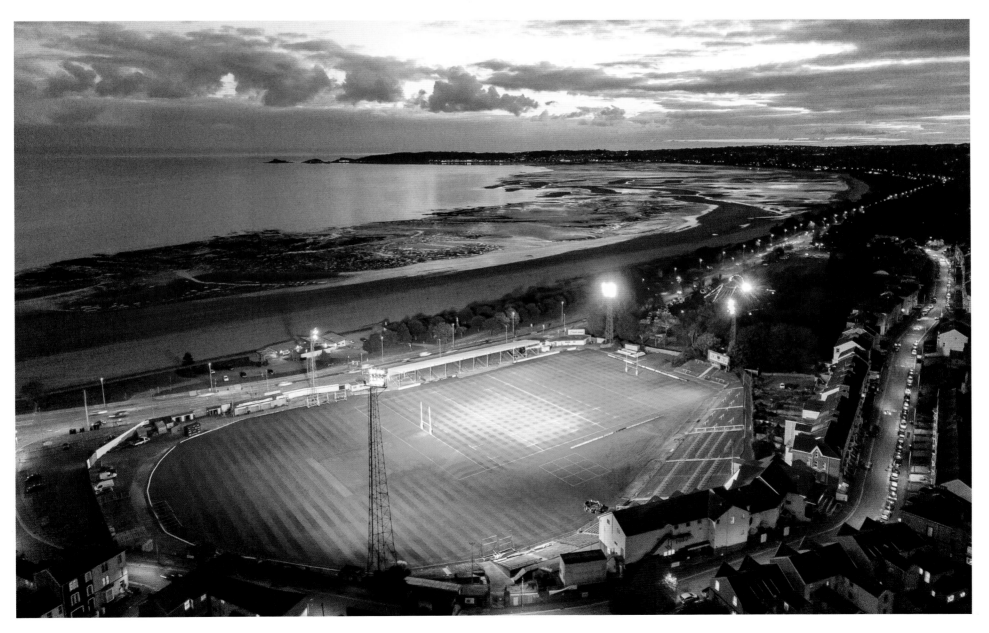

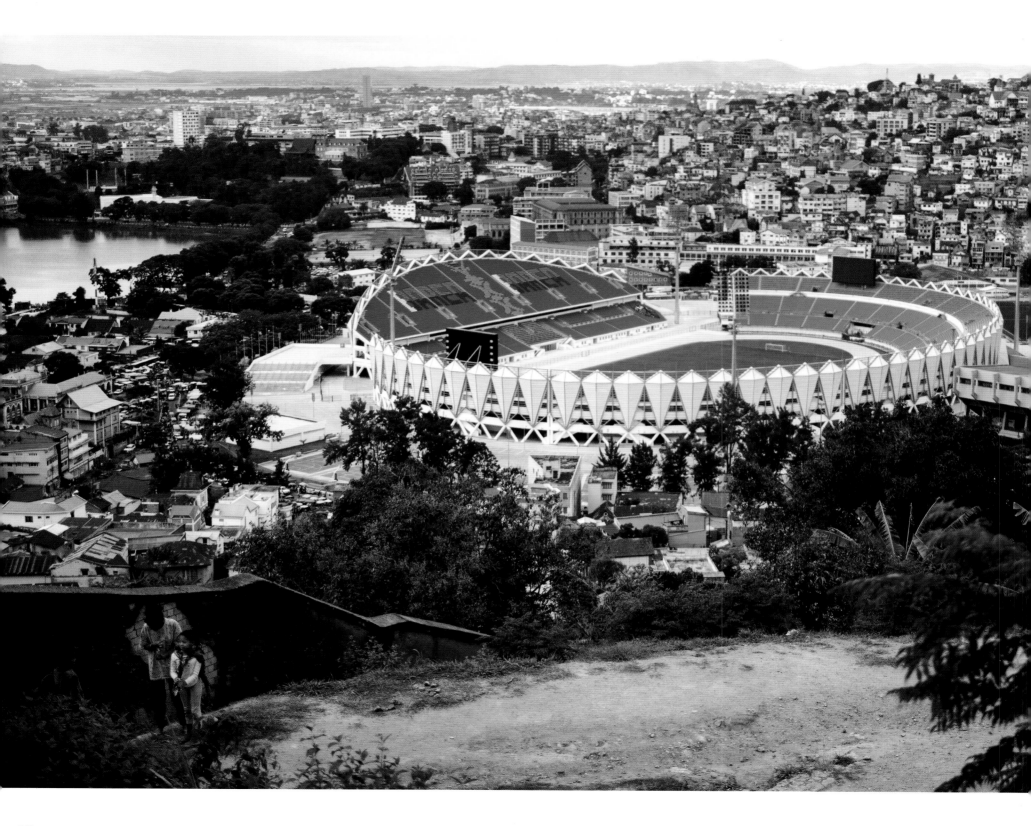

Stade Barea Mahamasina

Antananarivo, Madagascar

Which city boasts the highest number of rugby clubs anywhere in the world, per head of population – Cardiff, Auckland, Durban, London? The answer is Antananarivo in Madagascar. At the last count, the total number stood at 161.

The sport was brought to the biggest island in the Indian Ocean from France at the turn of the 20th century when Madagascar was under French colonial rule. The locals immediately fell in love with the physicality of rugby.

Stade Barea Mahamasina gets its title because Mahamasina is a suburb of Antananarivo, and Barea – the name given to the national football team – was added after Madagascar qualified for the African Cup of Nations football tournament

for the first time in 2019. The venue has also provided the setting for some extraordinary rugby matches. In 2015, Madagascar took on Namibia in front of around 40,000 spectators. A place in the top tier of African rugby was up for grabs. With just 10 minutes to go the Makis trailed Namibia 43-29. The match went into extra time at 43-43 and a last-gasp try meant the hosts won 57-54.

Tragedy, however, struck in 2018, when a stampede during a football match between Madagascar and Senegal resulted in one fatality, dozens injured, and the stadium was closed for three matches. The following year 15 people died following another stampede during a concert.

The government decided to completely redevelop the stadium, and the new, vastly improved Stade Barea represents just one of 100-plus grounds around the world built by Chinese construction companies.

Most of those grounds form part of a strategic foreign policy known as 'stadium diplomacy'. China has provided the capital and manpower to build national stadiums quickly and cost-effectively across the poorest countries on the planet. In return, China gains access to natural resources in those countries and geopolitical influence.

This makes the Stade Barea an exception to the rule, as the Madagascan government paid the full $77 million it took to redevelop the ground, which reopened in 2021. The benches have been replaced by seats, new floodlights were installed, and you can book a hotel room that opens out onto the pitch, or dine at the stadium's restaurant.

Some have questioned the cost, but in a city where sport means so much, the least spectators should expect is to watch those sports in a safe environment.

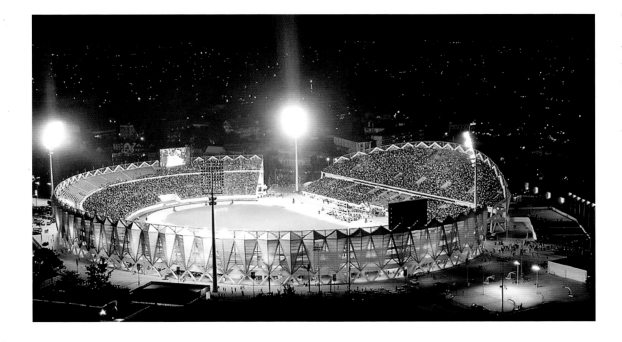

OPPOSITE AND LEFT: The unique shape of the Stade Barea Mahamasina, which can host athletics, football and rugby for the country's 22,000 registered players.

Stade de France

Saint-Denis, Paris, France

By the time Paris hosts the Summer Olympics in 2024, the Stade de France will have staged more major sporting events than any other venue since it opened in 1998, including two Rugby World Cup finals.

Yet, were it not for the intervention of the latest high-profile figure in French sport to become embroiled in a scandal, then 2023 would have been the year that the national team left the Stade de France and moved into a purpose-built new home.

A plan was unveiled in 2013 to move the team from its current home in Saint-Denis, a run-down suburb 10km north of Paris, to Ris-Orangis, a suburb 22km south of Paris. The

Grande Stade FRF was going to be a benchmark for modern stadia, with a sliding, removable pitch, enhanced acoustics, as well as a 'tunnel club' – an executive suite with a perspex screen so well-heeled corporate sponsors could see the players in the tunnel.

Enter Bernard Laporte in 2017 as the new President of the FRF. Laporte campaigned with a manifesto that included ditching Ris-Orangis, and a year later the plan was shelved, resulting

OPPOSITE: Stade de France may be situated in a run-down suburb of Paris, but the kings of France are buried in the Basilica of Saint-Denis.

BELOW: The stadium set up for rugby in 2018.

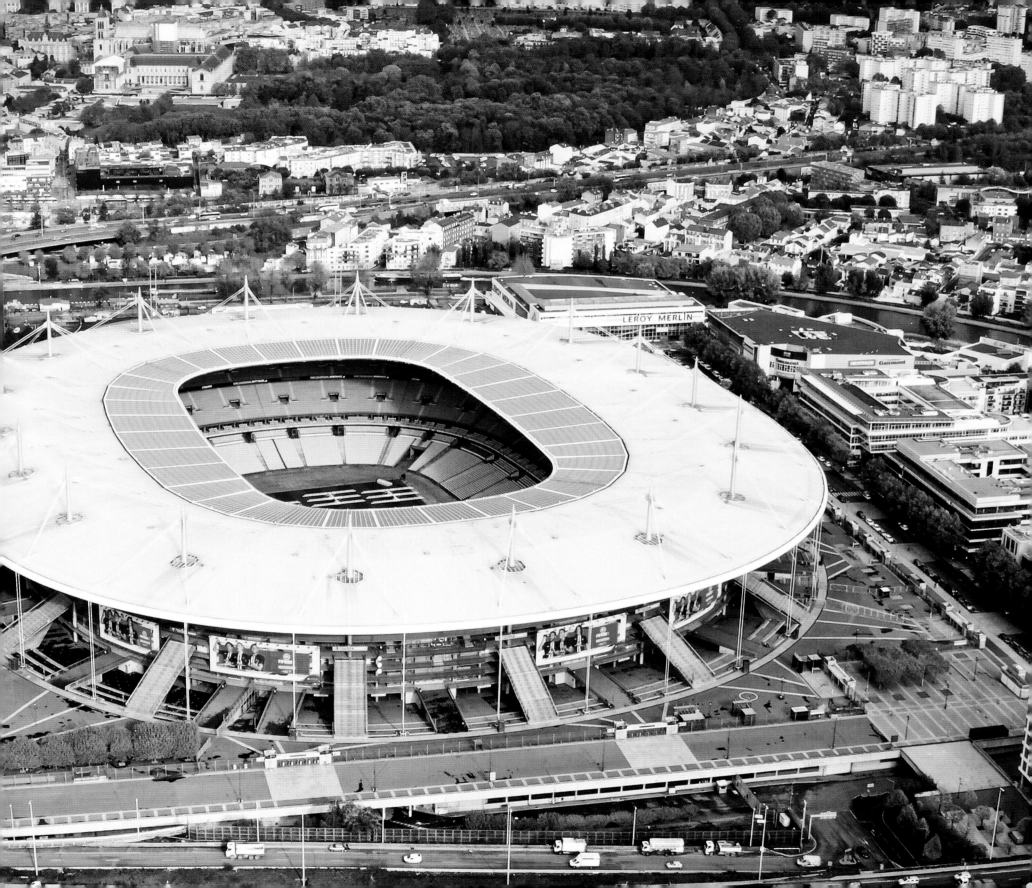

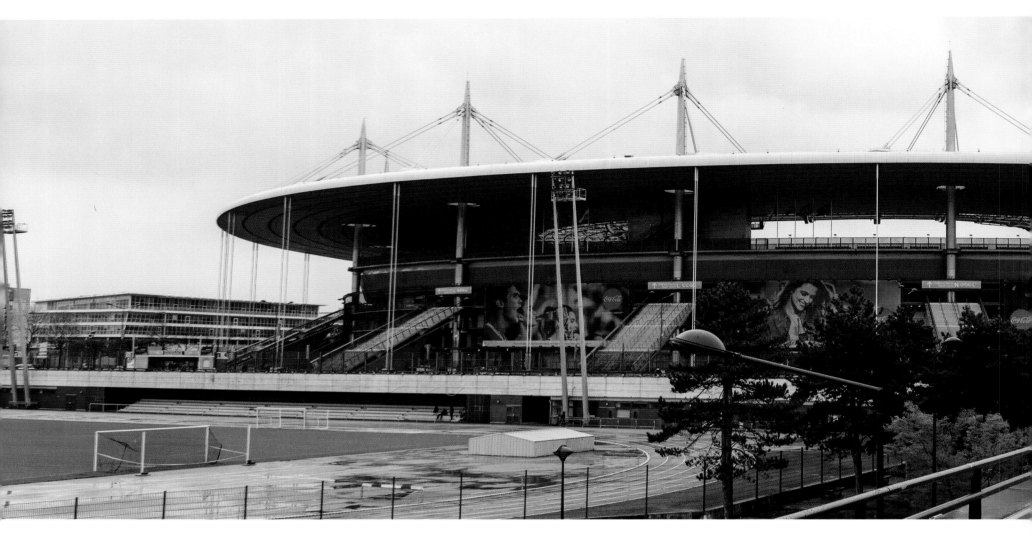

in five years of legal wrangling over building contracts that had to be ripped up.

In late 2022 Laporte was given a two-year suspended prison sentence after being found guilty of a raft of illegal doings; influence peddling, passive corruption and embezzlement. That is some roll of dishonour, although he may have saved the federation from financial disaster. Laporte ruled out Ris-Orangis because it was too expensive, long before rugby had to contend with a colossal slump in revenue caused by lockdowns and the pandemic.

And so the Stade de France will remain the home of French rugby for the foreseeable future. Whether the world's biggest sporting bodies will want to select the ground for finals beyond 2024 is a moot point, because of what happened at the 2022 Champions League Final.

The woeful failure of local policing, local officials and UEFA, combined with the attempts by the French government to put all the blame onto Liverpool supporters should never be forgotten. Fans were indiscriminately teargassed before the game and some spectators were attacked by local gangs on leaving the stadium. The Interior

Minister blamed the chaos on 30–40,000 fake tickets (the figure was closer to 3,000), as well as the fans, but has eventually shouldered some of the blame himself when video evidence told a different story.

While nothing remotely on that scale has happened at any Six Nations matches, plenty of spectators will tell you about the problems of getting into the ground.

It is worth noting that heightened security outside the Stade de France was a response to the events of 13 November 2015, when three

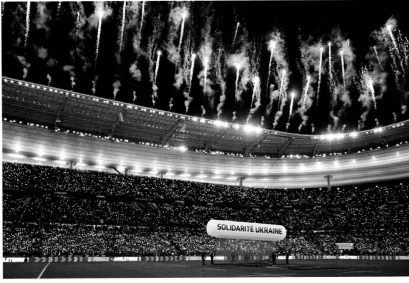

bombs exploded outside the ground as part of a coordinated attack on Paris that resulted in 130 deaths.

Sadly, all of this inevitably detracts from what is an impressive arena. It was one of the first stadiums to have 'flexible seating', which means a section of seats from the lowest tier can be removed, stored underneath the stand, and replaced by moving back the front row seats to create the space for a running track. It is a feature that really should have been factored into the design of London's more recent Olympic Stadium.

The roof, which weighs twice as much as the Eiffel Tower, has a tinted skylight designed to filter out red and infrared radiation but allows blue wavelengths to filter in and helps to keep the turf in good condition.

Although the atmosphere for rugby matches can rely on whether the home fans are behind the team, or booing to express their displeasure, and it doesn't have the history of the Parc des Princes, it remains a first-class stadium, so long as you can get inside without any hassle.

ABOVE LEFT: The stadium has learned lessons following the failure of ticketing and security for the 2022 Champions League final.

TOP: Nicolaas van Rensburg of Montpellier Hérault and teammates lift the Top 14 shield (as sculpted in the statue of Armand Vaquerin that stands outside the Stade Raoul Barrière) on 24 June 2022 at Stade de France.

ABOVE: Fireworks to celebrate France's win over England to complete the Grand Slam in March 2022, and a sign to express their unwavering solidarity with Ukraine.

Stade Jean Bouin

Paris, France

Team: Stade Français Paris

The distance between Stade Jean Bouin and Parc des Princes is just 20 metres, or literally a stone's throw away. They are separated by the width of Rue Claude-Farrère in the 16th arrondissement (district) of Paris. Having two stadiums virtually next door to each other may seem odd, but makes perfect sense. Stade Jean Bouin is home to Stade Français rugby team – or to give the club its full name, Stade Français Club Athlétique des Sports Généraux – and Paris Saint-Germain Féminine football team.

Both teams would normally struggle to fill the Parc des Princes but, on occasion, they will host matches where they could easily sell enough tickets to justify going from one side of the road to the other. An obvious example would be a Champions Cup match in the knockout stages.

The stadium is named after the first great long-distance runner to hail from France. Jean Bouin won Olympic silver in the 5,000m at the 1912 Games in Stockholm, as well as several golds in international cross-country events.

Originally known as Stade Raymond Kopa, after one of the country's greatest and most influential footballers, the ground was redesigned In 2010 by architect Rudy Riciotti. He is best known in design circles for his work on the Museum of European and Mediterranean Civilizations (MUCEM) in Marseille. Riciotti's first task was to make the new stadium strikingly different to its neighbour, and one look at MUCEM shows how that design influenced the exterior of Stade Jean Bouin.

This includes a web consisting of 3,543 fibre concrete panels. There is also an undulating curved roof made up of 1,600 panels that envelops the ground with a layer of reinforced glass underneath. This means the noise created by supporters can reverberate off the glass.

The structure was tested using simulations of conditions that would equate to a minimum of 30 years' worth of exposure to the elements. Plus, like any modern stadium, it ticks the green boxes with 2,800 solar panels and a system for collecting rainwater that is used to maintain and irrigate the playing surface.

OPPOSITE: A Top 14 game with Stade Français playing Racing Metro at the Jean Bouin.

BELOW LEFT: Olympic silver medallist Jean Bouin was killed in action during World War I.

BELOW: Stade Français is one of the most successful French rugby clubs, having been founded in 1883.

Stade Marcel-Michelin

Clermont-Ferrand, France

Team: ASM Clermont Auvergne

Ask any rugby fan which stadium has the best atmosphere and there is one ground that will feature in the top three for anyone who has been there. Stade Marcel-Michelin is the home of ASM Clermont Auvergne in Clermont-Ferrand in central France, and the ground serves as the link between Clermont and Ferrand.

Former player turned commentator Stuart Barnes was asked by *The Times* to choose 'the ten best grounds in the world to watch rugby', and Marcel-Michelin topped his list. 'When Clermont Auvergne are in the mood, this place rocks like nowhere else,' he wrote.

It's not just the atmosphere that makes coming here a memorable experience. From the outside, you can see the Puy de Dôme volcano, although when Barnes said he 'felt the earth move' on his first visit, he was referring to the fervour created by the home fans rather than the volcano, which has been dormant for 8,000 years.

The city is also home to the Cathédrale Notre-Dame-de-l'Assomption which is made from volcanic rock. So a ground made from steel and plastics should be pretty underwhelming by comparison, yet it definitely ranks as a 'bucket list' venue.

The grand opening in 1911 was performed by Marcel Michelin, son of Michelin tyres founder, Andre. Michelin Tyres were founded in Clermont Ferrand in 1889. Marcel would go on to fight with the French Resistance in World War II before being captured by the Nazis. He died in 1945 at Buchenwald concentration camp of a wasting disorder just two months before the camp was liberated by Allied forces.

The Michelin tyre company leases the land on which the ground was built, and the fans who create that intense atmosphere inside the stadium are an amalgamation of twelve supporter groups known as the Yellow Army. The most vocal fans congregate in the Phliponeau Stand, a somewhat unconventional three-tiered structure which was named in honour of Clermont and France winger, Jean-François Phliponeau. On 4 May 1976, Phliponeau died on the Marcel-Michelin pitch, playing for ASM in a triangular tournament against Vichy and Aurillac, when he was hit by lightning.

Stade Marcel-Michelin is the heartbeat of Clermont-Ferrand, and Barnes rightly asserted that 'you are guaranteed one of the great days in sport. Vibrant colour, noise, and a tram that transports you back to the centre of town where the celebration of life continues. What more could you want?'

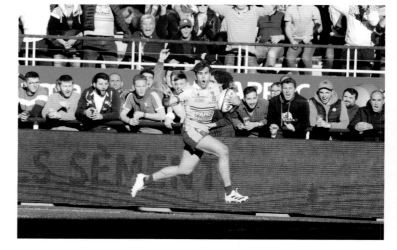

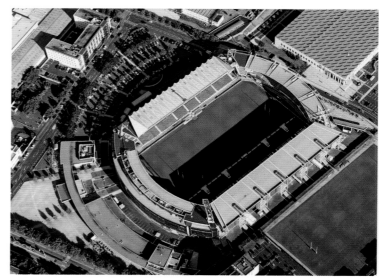

ABOVE RIGHT: Clermont academy graduate Damian Penaud embarks on a small amount of showboating as he scores against Section Paloise in 2021.

OPPOSITE: Clermont Auvergne can count on support from fanbase 'Les Vignerons: La Force Jaune & Bleu.

RIGHT: An aerial view of the Parc des Sports and the Stade Marcel-Michelin.

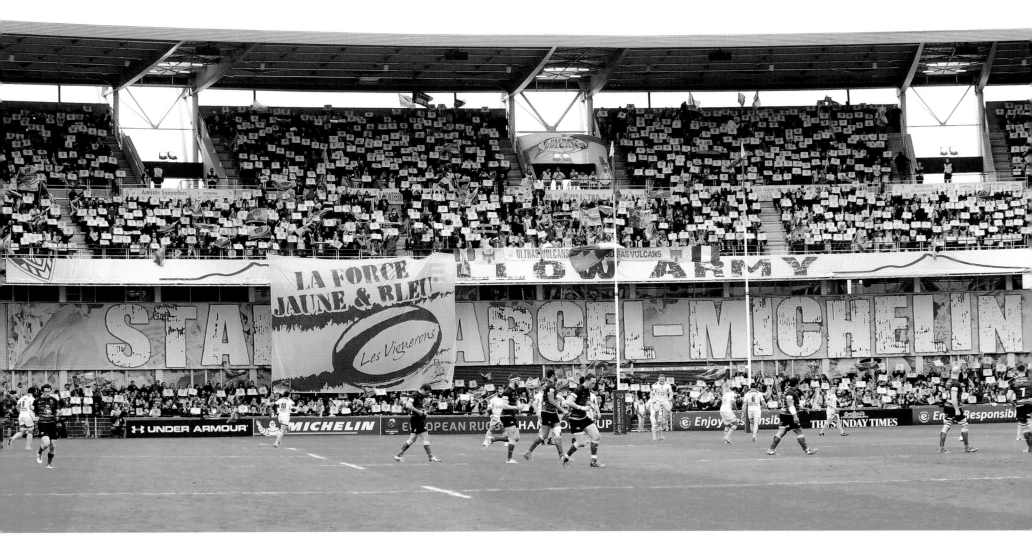

Stade Mayol

Toulon, France

Team: RC Toulonnais

Felix Mayol is one of the most colourful figures to have a stadium named in his honour. A native of Toulon, Mayol was born in 1872. His parents were both actors, and little Felix made his stage debut aged six. Mayol would become a successful entertainer, known for his camp stage persona, and such was his popularity that it is said Charlie Chaplin travelled to Paris to see his act. He was also a prolific songwriter, and an impresario who helped to launch the career of French song-and-dance man Maurice Chevalier.

Mayol bought a large plot of land in Toulon, at the foot of Mont Faron, for 60,000 francs – the purchase was partly funded by selling off the rights to some of his many songs. He then handed over that land to his favourite rugby club, RC Toulonnais.

The inauguration of Stade Mayol took place on 28 March 1920, and the location alone should make it a ground that every rugby fan should want to visit, as it overlooks Toulon's historic harbour on the Mediterranean coast, which used to be the country's key military port.

The capacity is 17,500 but the crowd produces an atmosphere to rival any rugby ground in Europe. 'Stade Mayol is an amphitheatre, there's so much drama,' said ex-Toulon player Dave Attwood in an interview with *Rugby Journal*. 'They're louder than anything you've heard, even Wales v England at the Principality doesn't compare. Passion for rugby in Toulon is on another level here. It's life and blood.'

And that atmosphere is amped up by the *Pilou-Pilou*, a pre-match chant written back in the 1940s by former player Marcel Bodrero. Since 2008, the *Pilou-Pilou* has been led by local tattoo artist Cédric Abellon, whose eyes bulge as he bellows out his lines. Abellon is a character that could have been invented for one of the comics owned by Mourad Boudjellal, the man whose millions transformed Toulon from also-rans to one of the best club sides in Europe, attracting some of rugby's biggest stars, including Jonny Wilkinson, Bryan Habana and George Gregan.

The *Pilou-Pilou* is a stirring call-and-response chant where the literal translation doesn't do it justice (or the women of Toulon, for that matter), but here goes...

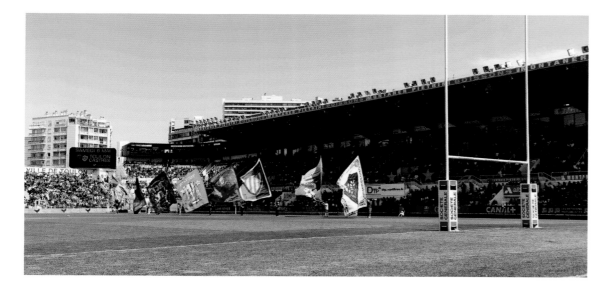

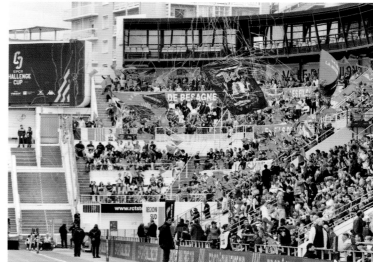

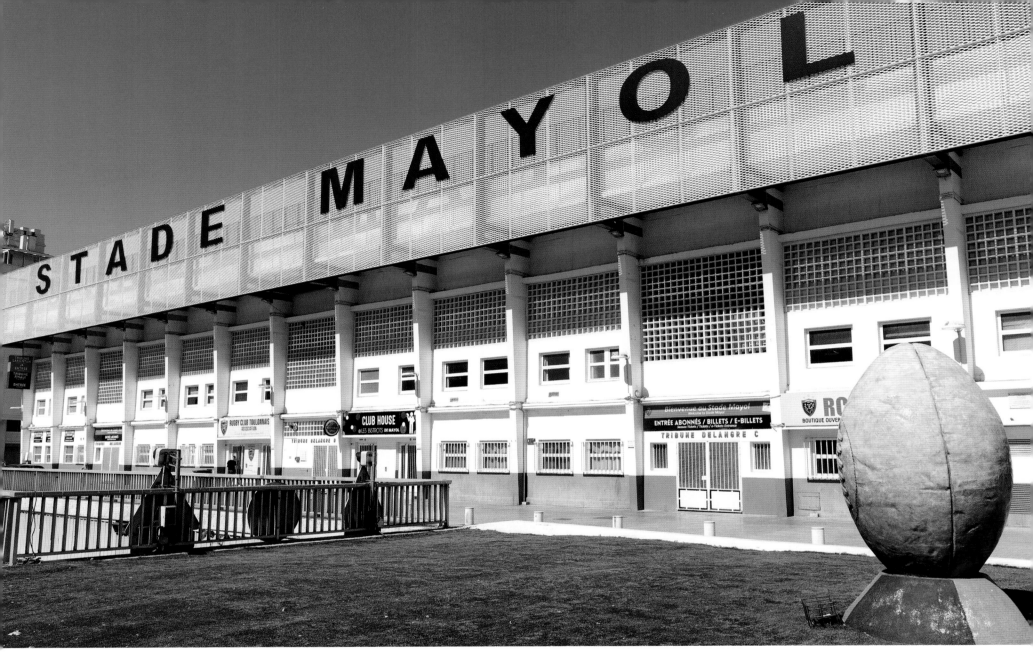

Ah! We the terrible warriors of Pilou-Pilou
Pilou-Pilou!
Who are descending from the Mountain to the Sea!
Pilou-Pilou
With our dishevelled women breastfeeding
our children
In the shade of the tall white coconut trees!
Pilou-Pilou
We terrible warriors let out our terrible battle cry

Aaaaaaarggggghhh!
I said 'Our terrible battle cry!'
Aaaaaaarggggghhh!
Because Toulon
Red!
Because Toulon
Black!
Because Toulon
Red and Black!

ABOVE: The exterior may have all the concrete charm of a 1960s tower block, but what Stade Mayol lacks in design it makes up for in atmosphere.

OPPOSITE: Two views of the stadium on matchday. Someone has described the atmosphere as 'like Cornish Pirates times 10 and with a chant that goes beyond the "Give us an R" of Pirates'.

Stade Raoul Barrière

Béziers, France

Team: AS Béziers Hérault

The Stade Raoul Barrière is a perfectly good rugby ground and has all the facilities one would expect from a mid-sized stadium that opened in 1990. This chapter, however, is all about the team and the coach on which this stadium was built and, specifically, the story behind the statue outside the ground that honours a player for whom the word 'remarkable' doesn't begin to do him justice.

Between 1971 and 1984, AS Béziers Hérault won the French Top 14 title 10 times. It is an achievement that may never be repeated. To give it some context, Stade Toulousain dominated French rugby through the 90s and 00s and won six titles in eight years but could not sustain that level of dominance. Inevitably, over 13 years, players came and went. The one constant was Armand Vaquerin.

He was made for an era when the sport was at its most brutal. Vaquerin not only played hard but partied harder. The circumstances surrounding his death remain a mystery, although the Internet is full of erroneous details of what happened and where. What we *do* know is he died from a gunshot to the head at the Bar des Amis, Béziers, following a game of Russian roulette.

According to one ex-player, Vaquerin's party trick was to pull out his gun and put a bullet into the chamber, then, out of view of the onlookers, knock out the bullet before pointing the gun at his head and pulling the trigger. But to this day nobody is sure if what happened was an accident, foul play or suicide – he was struggling with life after rugby.

An excellent podcast titled *Le Canon sur la Tempe* tells the story of Vaquerin, his impact in Béziers, and why he is so worthy of that statue, which features him holding up the Bouclier de Brennus – the French Top 14 Shield.

The ground itself opened in 1990 and consists of two large stands on either side of the pitch as well as terraces at each end behind the posts. It hosted matches at both the 1991 and 1999 Rugby World Cups.

In 2019, the stadium was renamed following the death of former AS Béziers Hérault coach Raoul Barrière, who introduced new training methods that took the team from also-rans to champions. Barrière was also the coach that recognised Vaquerin's talent and made him an integral part of those brilliant Béziers teams.

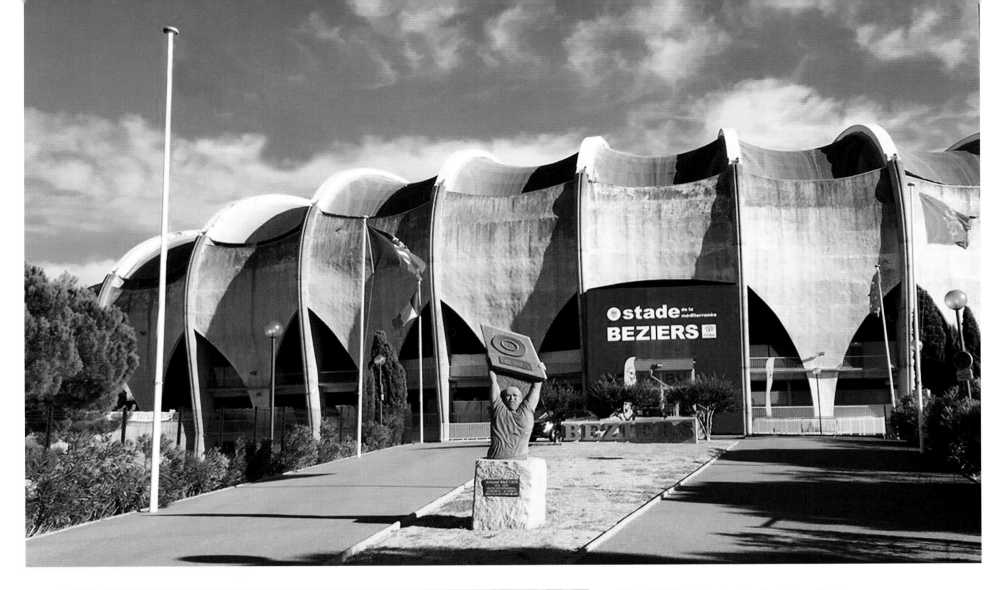

OPPOSITE TOP: Béziers fans stop the traffic on the Champs-Elysees in 1978, after clinching their second champion's title in a row. They beat Montferrand 31-9 at Parc des Princes.

OPPOSITE BOTTOM: Armand Vaquerin (glass in hand, behind the cash register at the bar) and team-mates celebrate their victory over Brive, on 19 May 1975, during the French Rugby Union Championship.

ABOVE: The statue of Vaquerin holding the Bouclier de Brennus shield after Béziers won it again in 1983.

LEFT: Today the Béziers Hérault team play in the Pro D2, the second tier of French rugby.

Stade Vélodrome

Marseille, France

It's the home of Ligue 1 football team Olympique Marseille, but also hosts regular rugby games, including Six Nations matches, as well as playing host to the 2022 Heineken Champions Cup Final, which saw La Rochelle's dramatic 24-21 victory against Leinster.

It hasn't always had a roof over its head. In its earlier guise it was the stage for half a dozen matches at the 2007 Rugby World Cup. Now, with a streamlined roof that looks like it's been designed by those responsible for the aero kit on vélodrome riders, it will be the venue for six clashes at the 2023 tournament.

Throughout this book, we refer to grounds and stands that were named after owners, coaches, benefactors or players, which makes the Stade Vélodrome unique among international stadia by having a section named after Patrice de Peretti a supporter of Olympique Marseille.

During the early years, there wasn't much love for the Vélodrome because it was owned by the city council, whereas the football club had owned its first home, Stade de l'Huveaune. As the name implies, for many years the Vélodrome hosted cycling events – the sloped track around the perimeter of the pitch also acted as an impromptu slide for fans to get onto the playing surface.

The Vélodrome also faced criticism for being an open-air ground, leaving it exposed to the elements, including the Mistral wind that whistles through Marseille. The club and the city finally addressed that issue ahead of France hosting the UEFA European Championships in 2016.

Parisian architects SCAU created an undulating roof made from a Teflon-impregnated fibreglass canvas, which means it requires minimal maintenance.

The redevelopment included eco-friendly features such as a system that recovers and reuses rainwater collected on the aforementioned roof. Finally, it could be said, one of Europe's biggest football clubs has the stadium it deserves, even if the club and the fans continue to fall out.

OPPOSITE: The stadium in 2022 prepared for the Champions Cup Final between Leinster and La Rochelle (Stade Rochelais).

LEFT: The Orange Vélodrome is located within sight of the Mediterranean.

BELOW: The old roofless Stade Vélodrome hosted matches in the 2007 World Cup.

Stadionul Arcul de Triumf

Bucharest, Romania

Team: Romania National Team

The fact that the Stadionul Arcul de Triumf dates back to 1913 reflects Romania's strong rugby heritage and cultural investment in the game. There was a moment back in 1990 when Romania, rather than Italy, was asked to join the Five Nations and make it Six.

'The Oaks' could hold their own against the other northern hemisphere sides, famously humiliating Wales with a 24-6 win in Cardiff. Throughout the 1980s Romania was a leading sports nation, which included finishing second in the medals table behind the USA at the 1984 LA Olympics. Romania was the only communist nation to compete in LA and helped to cement an image in the West of its dictator, Nicolae Ceaușescu, as 'the communist leader it's okay to like'. Ceaușescu's government viewed sporting achievement as a source of national pride.

But behind the iron curtain, people were living in abject poverty. When Ceaușescu's government was toppled in 1989 following a chaotic and bloody two-week revolution, eight Romanian rugby players died. They included arguably its greatest player, Florica Murariu – shot dead by a reservist apparently mistaking him for a foreign terrorist.

The national team went into decline, while a battle is still going on behind the scenes about who is in charge of the game in Romania. In 2018, the original Stadionul Arcul de Triumf was torn down and replaced with a new 13,000-capacity ground. It belongs to the Romanian Rugby Federation. In 2021, however, the Minister for Youth and Sports wanted to take control of the ground, prompting the RRF to respond by saying, 'We will not capitulate and we will fight for our stadium.' By October 2022, the ministry had relented.

The architectural firm behind the Arcul de Triumf is Dico Si Tiganas, a name that won't mean much to anyone outside of Eastern Europe but who is the 'go to' design partnership for stadiums in Romania, with the new national football stadium, the Cluj Arena, and Stadionul Ion Oblemenco among its credits.

The Arcul de Triumf is the least spectacular of those grounds but is home to a unique design feature. The southwest corner of the stadium has no seats. Instead, it provides a clear view of the Caşin Monastery on the other side of the road to the ground.

ABOVE RIGHT: The England team ahead of the Women's Sevens Rugby World Cup Qualifier game between England and the Czech Republic in July 2022.

OPPOSITE AND RIGHT: Caşin Church, or Monastery, is a Romanian Orthodox church. Although the view to it has been preserved, it only dates from 1938 and is twenty-five years younger than the original Stadionul Arcul de Triumf.

Suncorp Stadium

Brisbane, Australia

Team: Queensland Reds

The ground formerly known as Lang Park has the distinction of being one of the few stadiums built on what was once a cemetery. This, of course, serves as a set-up for jokes about people 'dying to get in here' and headlines stating the opposition was 'buried' by the home team ... or vice versa.

The Paddington Cemetery was Brisbane's first burial ground and opened in 1843. It was an awful location, given how often the site would become waterlogged. As more people migrated to the city, officials realised they were going to need a bigger cemetery and built the Toowong Necropolis on the other side of town. Paddington was all but abandoned, except for a smattering of goats grazing, until the local government decided that the land could become a recreation ground.

According to the *Brisbane Times*, 'about 140 bodies and 505 monuments were moved into the nearby Christ Church churchyard where they rested peacefully for another two decades until the 1930s when all but 21 monuments were taken off to Toowong Cemetery and dumped into a gully.' Those 21 monuments still exist in Christ Church, a tiny place of worship that stands in the shadows of the Suncorp Stadium.

The ground was originally named Lang Park after the Scottish-born Reverend John Dunmore Lang, who was instrumental in bringing migrants to Brisbane in 1849, and the first public figure to champion Australia becoming an independent,

democratic state. Prior to becoming a stadium in 1954, the site was a circus venue, an athletics track and a military base.

The original stadium was a bowl with only one covered stand until the city council committed AUS $280m to build a new stadium that would host games at the 2003 Rugby World Cup. When it came to redesigning Lang Park, the architectural firm Populous had to ensure that Christ Church would be preserved within the precinct around the stadium. An artwork titled *Veil and Memory* has been incorporated into the stadium and is an enormous patchwork designed to 'indicate the passing of life in the Jewish and Christian religions, both of which shared this site as Brisbane's first major cemetery'.

Although it is predominantly a Rugby League ground, in 2017 the Suncorp Stadium briefly became the home of the Global Rugby 10s tournament, which then disappeared without a trace after two years. The event sprung up again in South Africa in 2021 but currently seems destined to be rugby's answer to motorsport's A1 Racing – i.e. an interesting idea that turned out a massive flop.

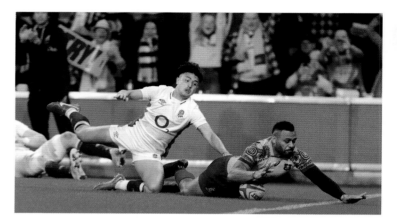

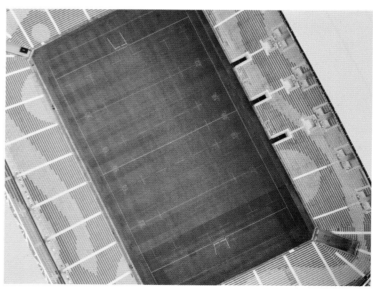

TOP: England's Marcus Smith fails to stop Samu Kerevi going over for the Wallabies at Suncorp, but England edged a three-match Test series in 2022.

ABOVE: An aerial view of the 52,000-seater, nicknamed 'The Cauldron'.

OPPOSITE: The Suncorp ground in July 2022 ahead of the game between England and the Wallabies.

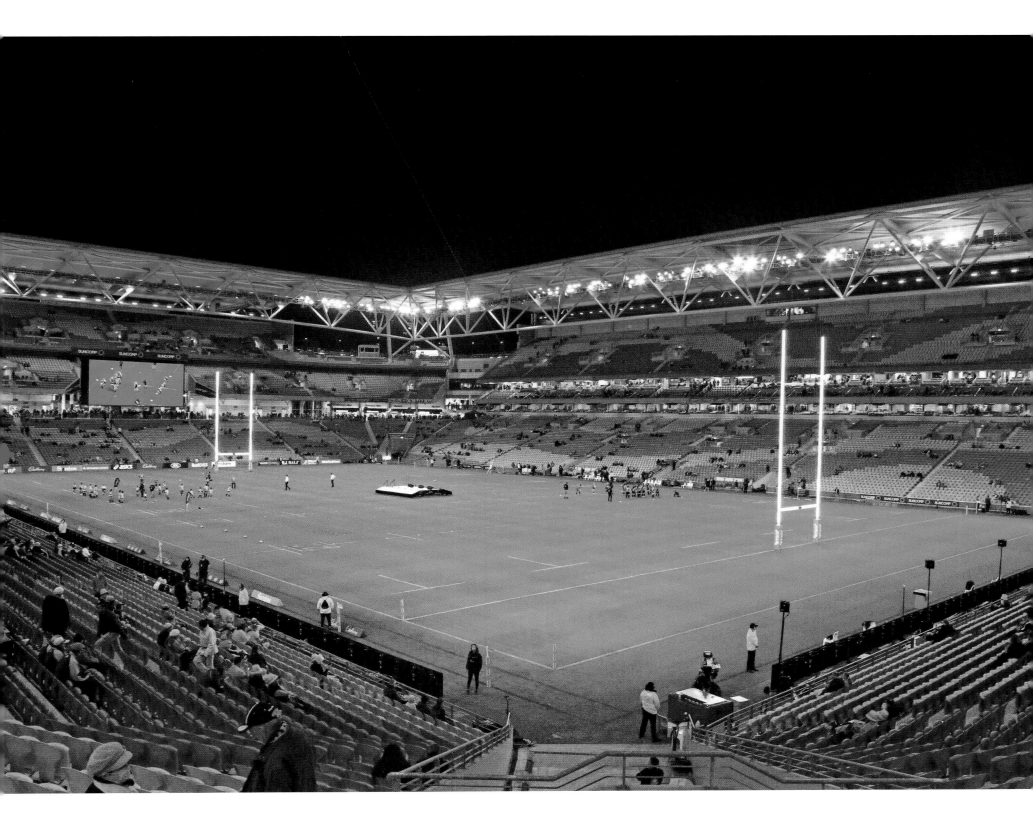

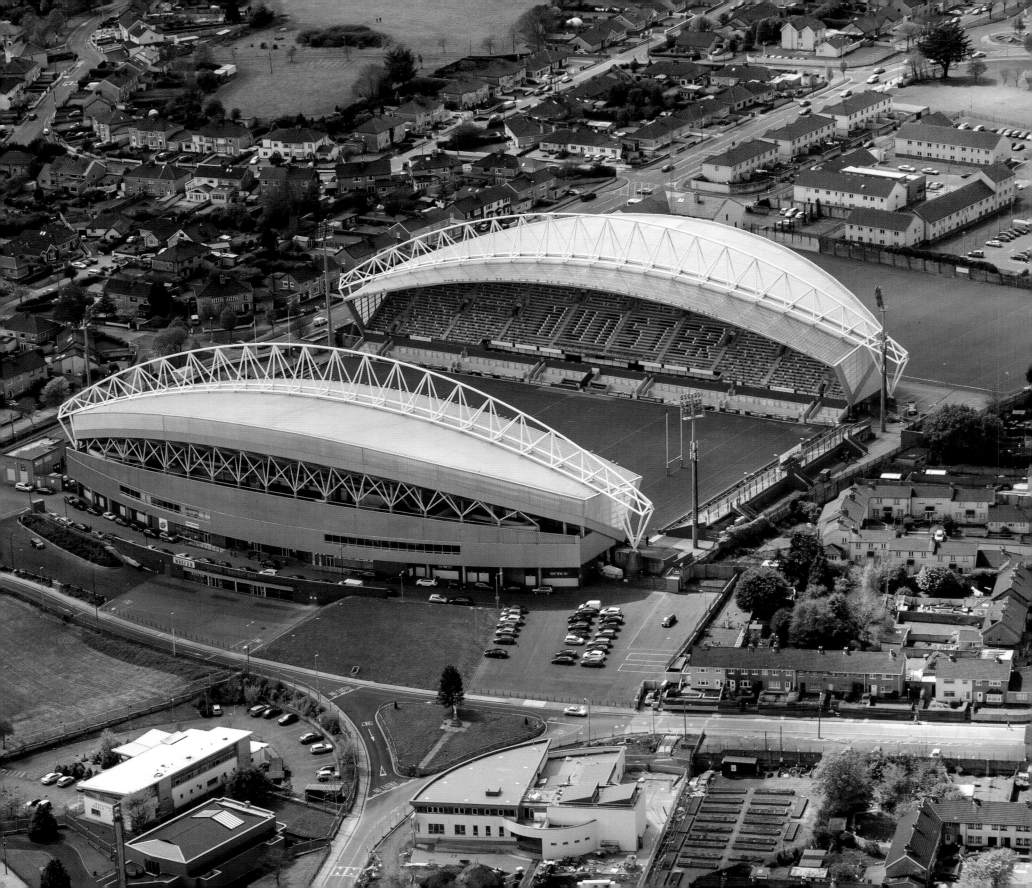

Thomond Park

Limerick, Ireland

Team: Munster

More than 25 years after the amateur era ended, professional clubs still struggle to find a formula for creating success on the pitch and balancing the books off it.

However, if there is one change at club level that has unquestionably improved the game it is the introduction of European club competitions that, in turn, helped to provide funds for a number of clubs to invest in and upgrade facilities that were clearly past their sell-by date.

Thomond Park opened in 1934. The game that gave the ground astonishing status came in 1978 when Munster beat New Zealand 12-0, the first time any Irish team had beaten the All Blacks – a record that stood until 2016. Given the capacity was only around 12,000, the number of people who say they were there almost certainly exceeds the real figure.

The only opposition teams that got to play at Thomond Park were either local rivals, the other provincial sides in Ireland, or teams touring from the southern hemisphere. European club rugby changed all that. By the early 2000s, demand for Champions Cup tickets was such that Thomond Park had to expand. It was always a tough awayday, but when two new stands opened in 2008, suddenly there were more than twice as many home supporters to intimidate the opposition.

The arches that loom over the East and West Stands instantly gave Thomond Park an identity. Other distinguishing factors are the matchday rituals that include the Munster Rugby Supporters Choir, often led by local soprano Jean Wallace, belting out a rendition of 'Stand Up & Fight'. Then there's the deathly silence that falls over the stadium every time a player kicks a penalty.

Former England and Sale fly-half Charlie Hodgson said, 'You're so used to getting jeered and booed but when you can hear a pin drop, at Thomond Park, it's the most eerie thing...', adding, 'when I knew I was going to retire, I said I always wanted to go and watch a European Cup game at Thomond Park, because the atmosphere that is generated there is incredible.'

Is it the best rugby ground in the world, as some polls would suggest? Your opinion may be swayed by where you sit in the ground, given the North and South Terraces are exposed to the elements. And sell-out ties are very much the exception nowadays. Then again, it is hard to knock Thomond Park when players want to be there simply to experience a match as a fan.

OPPOSITE: Visitors have no trouble working out where the rugby stadium is located in Limerick.

TOP RIGHT: If you prefer to stand, there are still terraces at either end of the ground, something absent from Aviva.

ABOVE RIGHT: A distant Thomond Park viewed from the bridge over the Shannon in Limerick.

RIGHT: Munster and Ulster scrum down at Thomond Park in October 2022. Munster have the support of Shannon Airport behind them.

The Tump

Clydach Vale, Wales

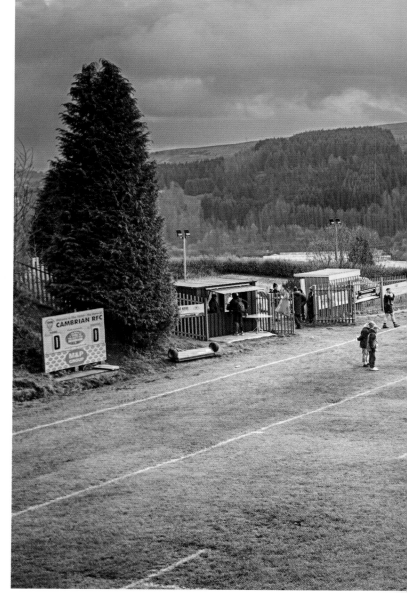

Team: Cambrian Welfare

A mile away from the home of Cambrian Welfare RFC is a memorial wheel and garden in Clydach Vale that commemorates the lives of 64 miners who died following tragedies at the local colliery in 1905 and 1965, along with another seven who died at the nearby Gorky Colliery in 1941.

Two years after an explosion claimed 31 lives in 1965, the colliery closed down, ripping the heart out of the community. Yet, the legacy of the miners lives on, not just through the memorial, or the relatives and friends who lost loved ones in 1965, but also through the rugby club

As Cambrian Welfare chairman Jonathan Davies (not the fly-half or the flanker) explains, the reason why this picture postcard ground exists was that around 100 years ago miners took their pickaxes to a patch of land and levelled it.

'The ground is at the top of a mountain, which is why it's known as "The Tump",' says Davies.

'There wasn't really a team as such, and there were no leagues back then, but playing rugby was something good for the miners to do at the weekends and the pitch has been there ever since.'

The team that calls The Tump home was only formed in 1982, by Davies' dad and a couple of his mates. 'Much the same as the miners. It started off as something to do at the weekend, but then it got serious.'

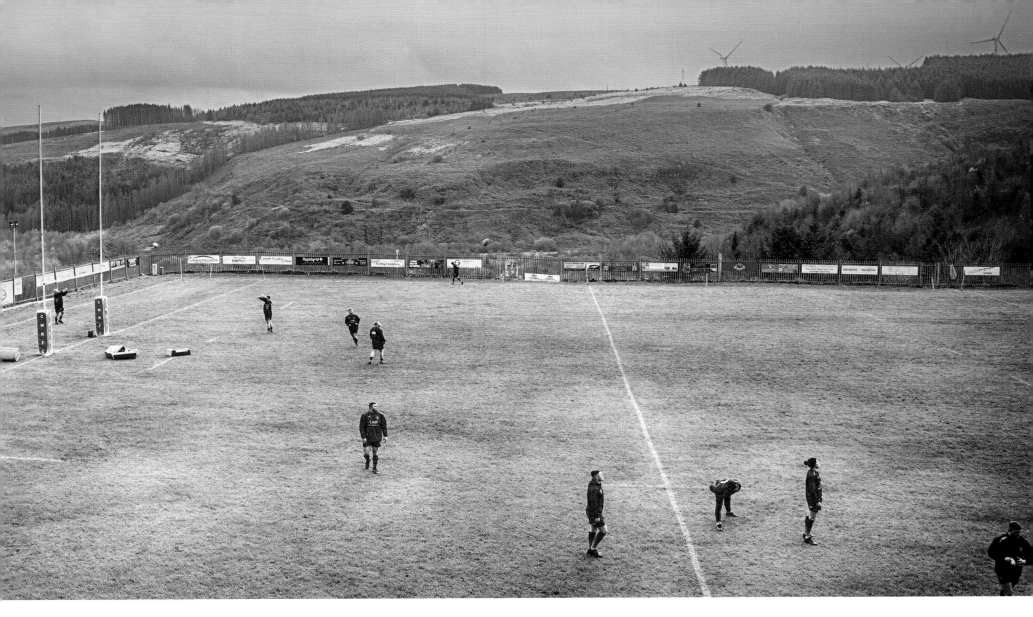

So serious that the club has won a string of trophies, including the now defunct Welsh District Cup on three occasions. The reason the club got its name is because the playground where the rugby field is situated was known to the locals as Welfare Park, although it is more than just a moniker.

'We're in a socially deprived area,' says Davies. 'There isn't much for kids to do here. But they get to play rugby for free, and we recently decided to set up a "boot bank". A lot of parents can't afford to give their kids a good pair of rugby boots, so when an older lad grows out of a pair, then we put them in the boot bank, ready for another kid to use.'

At a time when many kids would prefer to play football over rugby, Cambrian is bucking the trend. 'When kids' rugby started 15 years ago, we had around 27 children on the books, now we've got 275.'

ABOVE: Flat land not prone to regular flooding has always been at a premium in the Valleys, and Cambrian's ground was hewn out of a mountainside.

OPPOSITE: Club infrastructure at the ground is minimal.

Twickenham Stadium

Twickenham, England

Yes, you can argue that the atmosphere is better at other international grounds, there are too many 'corporates' for England games, and the location isn't exactly the best for transport links, especially when trying to get home after a game.

One could also argue that the best way to experience Twickenham is to go to an important club or cup game that is held there, when the balance of pure, full-throated rugby fans is closer to 100%.

However, it is still a mightily impressive venue. With a capacity of 82,000 it is the second biggest stadium in the UK and bills itself as the largest rugby-dedicated stadium in the world. While it is unlikely that anyone would choose to build a ground of that size today in the suburbs (Wembley could easily take on the Six Nations and the Autumn Internationals), the counterargument is that it is located within one of England's rugby heartlands, surrounded by a cluster of historic clubs including Harlequins,

OPPOSITE: An aerial view of the stadium shows it embedded in suburbia, and a suburbia that doesn't particularly like the idea of expanded use.

BELOW: Gerald Laing's bronze statue *Core Values*.

Rosslyn Park, Richmond/London Scottish, Ealing, Esher, and — in its heyday — London Welsh.

It was originally the site of a 10-acre market garden growing cabbages when William Williams was tasked with finding a home for English rugby in 1907. Having handed over £5,500 12s 6d, it opened as a sports venue in 1909, and it earned the nickname 'Billy Williams' Cabbage Patch'. History would repeat itself when, during World War II, one of the car parks was turned into allotments to help with food shortages as part of the British government's 'Dig for Victory' plan.

Twickenham was the first ground to host a rugby match broadcast on television: the 1938 Calcutta Cup match between England and Scotland. Over time, stands were repaired and replaced, but by the 1980s Twickenham had become a

typical British sports ground, meaning that it was outdated.

in 1988, architect Terry Ward was given the job of transforming Twickenham in a £60 million project that included redesigning the North, East and West stands — he said that he wanted to 'create a stadium for England that would give them a five-point advantage in every home game.' In 2005 the South Stand, which only opened in 1981, was also knocked out and rebuilt.

Even if you don't see a game, the ground is worth a visit purely for the World Rugby Museum. What started as a small collection of memorabilia first displayed under the South Stand in 1983 grew to the point where a dedicated museum was opened in 1996, and

is now home to artefacts about the game from around the world.

Then there are the magnificent bronze sculptures of rugby players outside the ground, including the 27ft-high *Core Values* statue. It was the creation of the late British artist and sculptor Gerald Laing, who was a product of Andy Warhol's New York pop art movement from the 1960s. Officially unveiled in 2010, a year before Laing passed away, the statue represents the 'core values' of England Rugby: teamwork, respect, enjoyment, discipline and sportsmanship.

Trivia lovers will appreciate that the first recorded streaker at a rugby match happened here in 1974. Aussie accountant Michael O'Brien ran naked across the field for a bet during a charity match between England vs France to raise funds for the Paris Air Disaster Appeal. Not all subsequent attempts have been so virtuous.

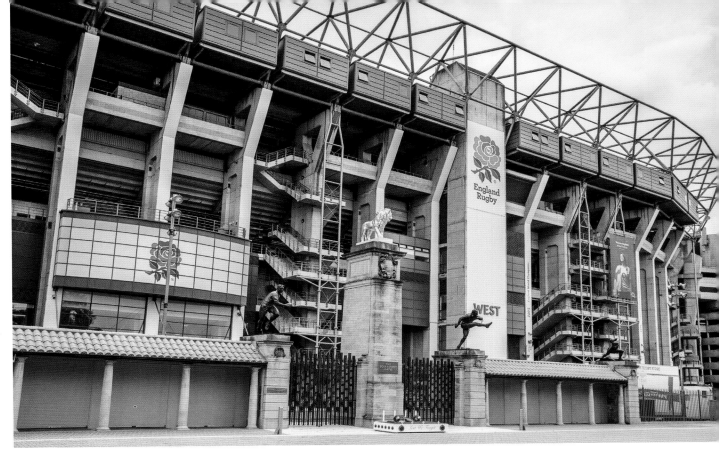

OPPOSITE TOP LEFT: Players from the Red Roses are now included in the exterior mural, and Twickenham will host their first TikTok Women's Six Nations finale with France in 2023.

OPPOSITE TOP: Unlucky for some: the 13 players from the Premiership Rugby teams during the Gallagher Premiership season launch at Twickenham in September 2022.

OPPOSITE MIDDLE: Twickenham was the venue for the 2022 Gallagher Premiership Rugby final, Leicester vs Saracens. Freddie Steward (Leicester) catches a high one.

OPPOSITE BOTTOM: Whereas Alaska can get moose and bears on the pitch, at Twickenham it's cats, dogs and the very occasional fox.

ABOVE RIGHT: The West Stand complete with gilded lion standing guard over the Rose and Poppy Gates.

RIGHT: To celebrate the return of the Premiership in 2020, the Twickenham pitch was adorned with portraits of Joe Marler, Maro Itoje and Faf de Klerk.

University of Cape Town Rugby Fields

Cape Town, South Africa

Team: Ikey Tigers

Ever since 1883, this has been the home ground for the University of Cape Town (UCT) Rugby Football Club, aka the 'Ikey Tigers'. That is all due to end soon as the Tigers have plans (and the funds) to build a new stadium, which isn't allowed at UCT because it is protected as a heritage site. And, frankly, why would you want to spoil this site – albeit one with a very complicated history.

The university is situated on the eastern slope of Devil's Peak and provides one of the best vantage points from which to look out over the city. This astonishing piece of landscape was bequeathed to UCT by Cecil Rhodes. His brutal brand of English exceptionalism resulted in the annexation of large swathes of Southern Africa and, directly or indirectly, the deaths of countless African people. A statue of Rhodes had stood between Jameson Hall – renamed Sarah Baartman Hall in 2018 in memory of a 19th-century slave – and the rugby fields, but was finally pulled down in 2015 after years of protests.

The rugby team also had to contend with controversy after establishing a rivalry with Stellenbosch – South Africa's answer to Oxford vs Cambridge. Stellenbosch players were nicknamed 'Maties' (short for 'Tamatie') after the colour of their blazers, which was a tomato shade of maroon. The Stellenbosch Song Committee returned the gesture by calling their opponents 'Ikeys' – UCT had a number of Jewish students in the early 20th century and an 'Ikey' (short for Isaac) was a derogatory name derived from an Irish folk song, 'Ikey Moses King of the Jews'.

The university Students' Representative Council objected to the name on the grounds that it was anti-Semitic and was due to meet their Stellenbosch equivalent on 20 May 1921 to discuss the issue, but failed to check the train times – there was no train to Stellenbosch on a Friday – and the meeting was cancelled. What happened next is that both teams took their respective epithets, and embraced them. What was once considered a slur is now a badge of pride, and to be an Ikey means you've played on this hallowed turf and represented a team that has produced dozens of South African internationals.

LEFT AND OPPOSITE: Established in 1829 as the South African College, the institution gained university status in 1918. This is the Upper Campus at Groote Schuur on the slopes of Devil's Peak.

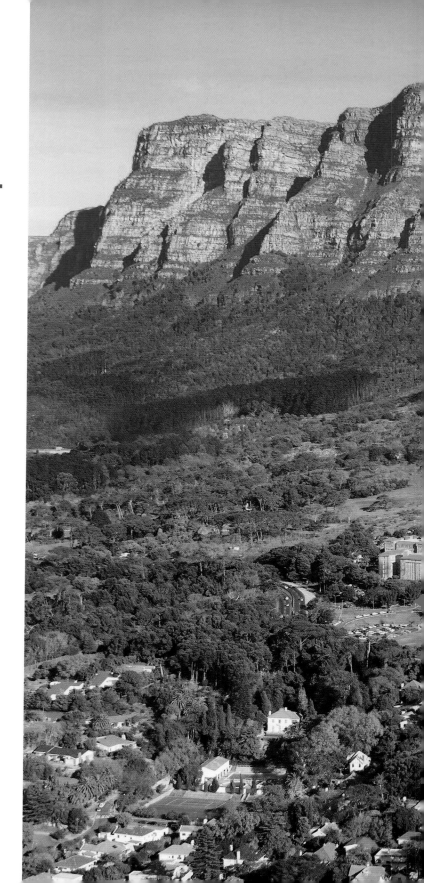

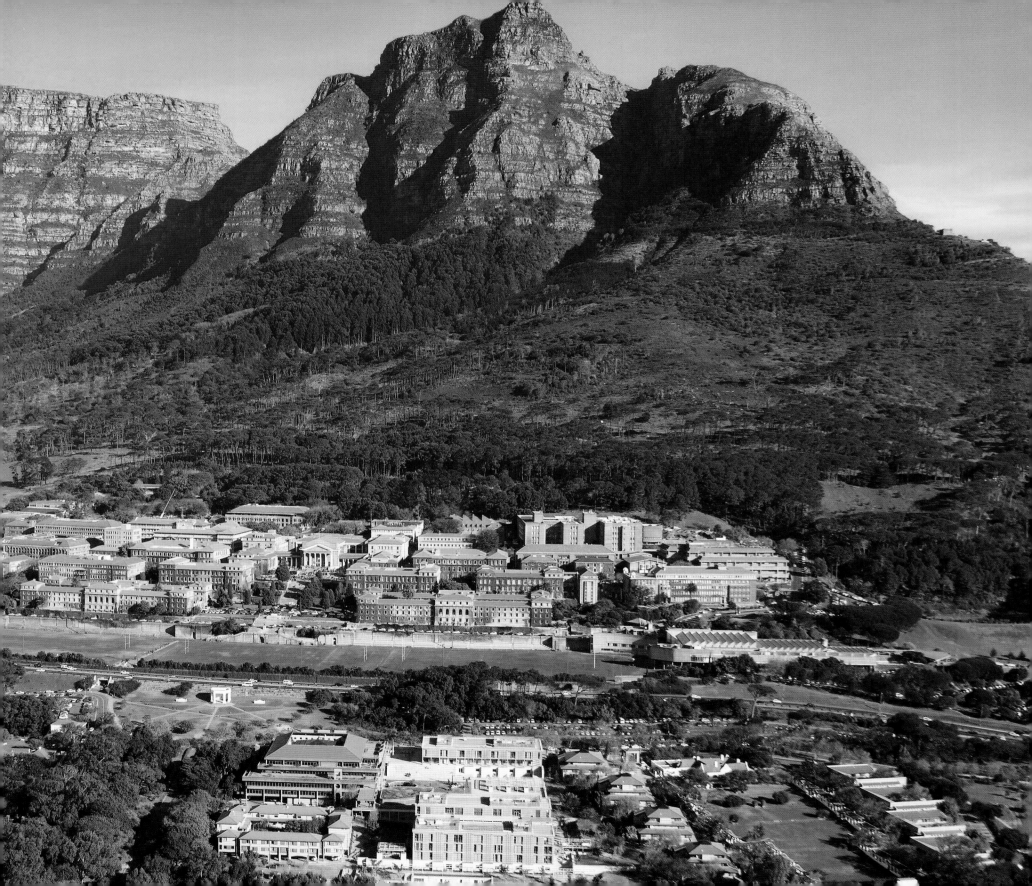

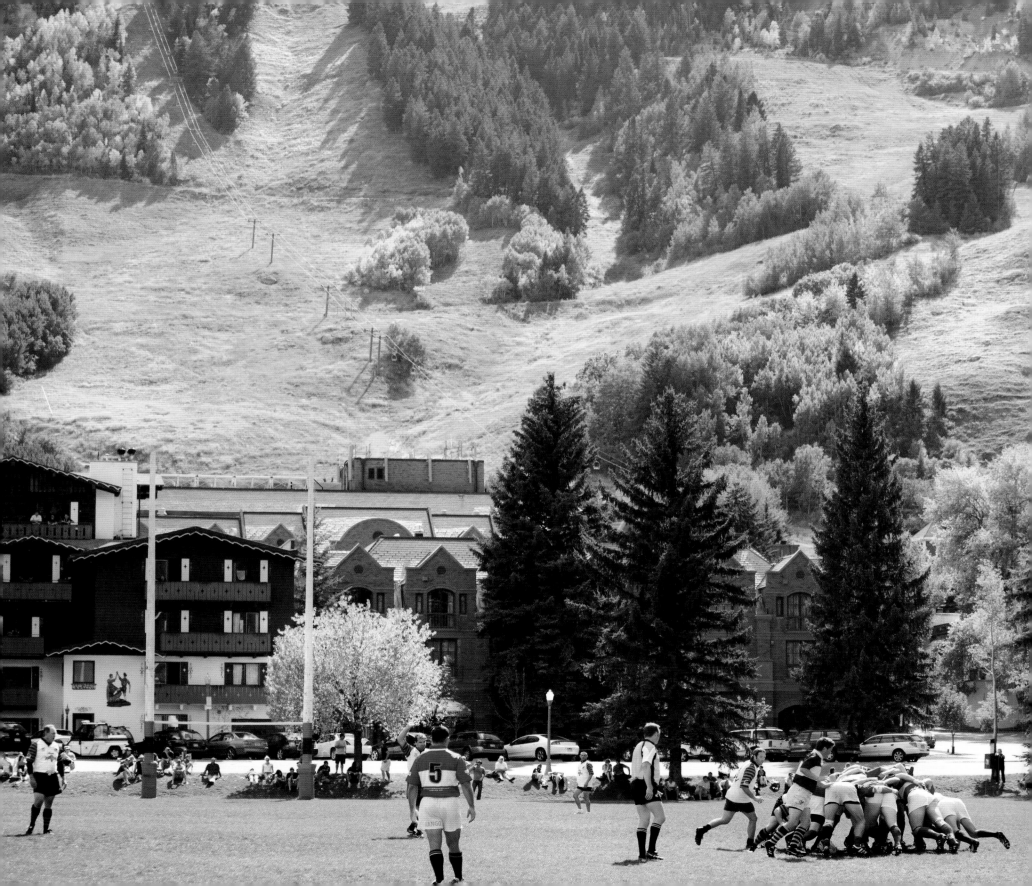

Wagner Park

Aspen, USA

Tournament: Ruggerfest

Rugby clubs, especially those at grass roots level, are made up of people who collectively and individually have a 'can do' attitude. To demonstrate this point, we give you Aspen Ruggerfest, which is said to be America's oldest continuous annual rugby tournament.

The first Ruggerfest was held at Wagner Park in 1968 and was an idea generated by Eastern Rockies Rugby Football Union President Terry Fleener along with Steve Sherlock, a local ski instructor. Wagner Park had been an unkempt, unloved and overlooked park in Aspen, a mountain resort in Colorado, but Sherlock saw its potential. He struck an agreement with the city council where, in return for cleaning up the park, he would get a permit to hold a rugby festival. Sherlock then erected some makeshift posts and Ruggerfest was born.

According to the organisers, 'It wasn't very difficult to get teams to travel to Aspen for the first Ruggerfest, and Sherlock's band of rag-tags did well for a bunch of hooligans, most of whose first experience of rugby was when the whistle blew to start their game.'

The posts were upgraded and replaced three years later by large spruce poles that were cut down from the Highlands Mountain and hauled into town by horses. Ruggerfest now regularly pulls in around 40 teams each year and past entrants include Garryowen (Ireland), Manley (Australia), Cardiff H.S. Old Boys (Wales) London Welsh (England), The Olde Watsonians (Scotland) and Valence Sportive (France).

It's not hard to see why they would want to make the trip. Aspen is in the White River National Forest surrounded by the peaks of the Elk Mountain Range, which form part of the central Rocky Mountains. And while it's sometimes amusing in the UK to have play interrupted by a dog on the pitch, in Aspen it might occasionally be a black bear.

Wagner Park has Aspen's ski resort as a backdrop. Soon after the tournament is held in the third week of September, those verdant mountains become snow-capped peaks and Aspen is transformed from a small town into one of America's busiest ski resorts.

OPPOSITE: Located in one of America's top ski resorts, Ruggerfest is not short of summer accommodation. Or chair lifts.

BELOW: Aspen is located at 2,438 metres (7,908 feet) above sea level and so visiting teams need to adjust to the oxygen levels before they play.

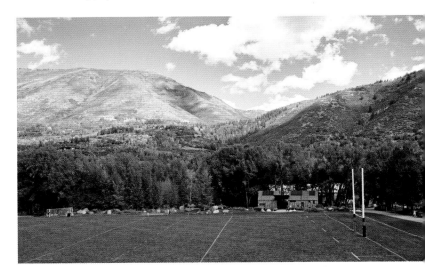

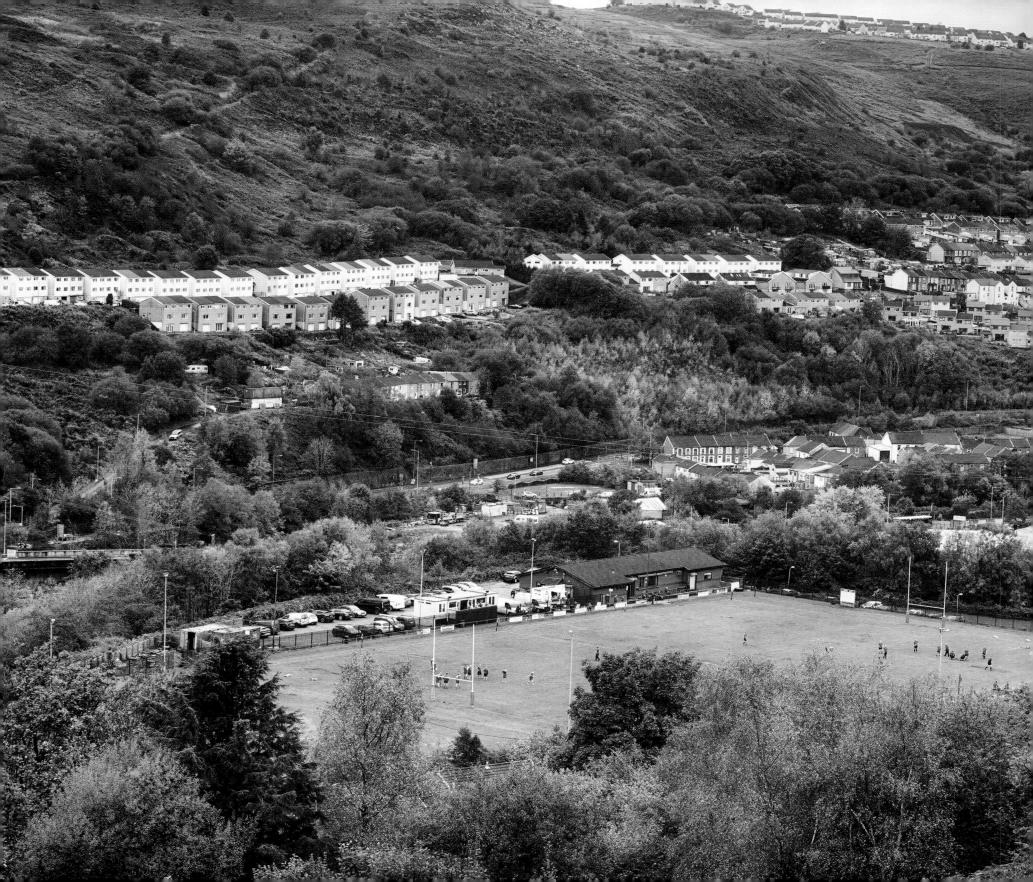

Welfare Ground

Porth, Wales

Team: Porth Harlequins RFC

On 13 July 1985, the most famous fundraising gig of all time, LiveAid, took place at Wembley Stadium. Meanwhile, around 160 miles away the Welfare Ground in Porth hosted the first ValleyAid concert, which also raised money for humanitarian causes.

The idea for ValleyAid came about through a group of ladies who lived in Porth and were members of Greenham Common Women's Peace Camp who famously campaigned against nuclear weapons.

They suggested doing a local version of the mega gig in London, and the line-up included Motörhead's lead guitarist Phil Campbell. The choice of venue was wholly appropriate given the Welfare Ground's origins. 'The land was a donation to the community from the Miners' Welfare Fund and the local colliery owners, Powell Duffryn,' explains club secretary Christian Rees. 'The ground is on the site of what used to be an iron slag tip. It was for the whole community to use, not just the rugby team, and the clubhouse now stands on where the tennis courts used to be.'

Porth is Welsh for 'gate' and is known as the 'Gateway to the Rhondda' because it is the meeting point of Rhondda Fawr and Rhondda Fach valleys. The first rugby match was played here in October 1934, and the senior team currently plays in League One East Central.

Also, slowly but surely, the club has seen the minis, juniors and women's sections continue to grow, to the point where hundreds of kids

and adults play for Porth Harlequins. This has become increasingly important to grassroots clubs in Wales. Post-pandemic, playing numbers have been dwindling among the over-30s leading to multiple matches being cancelled every weekend.

Hopefully, one or two of those juniors go on to play the game at a higher level, but they will have to go some to match the achievements of the greatest player to hail from Porth. Cliff Jones won 13 caps for Wales and was a member of the team that beat New Zealand 13-12 in 1935. He went on to become President of the Welsh Rugby Union and in 1991, a year after Jones had passed away, he was inducted into the Welsh Sports Hall of Fame.

OPPOSITE : At the heart of Valleys rugby, Porth sits at the confluence of the Rhondda Fawr and Rhondda Fach rivers, halfway between Tonypandy and Pontypridd.

BELOW: Like many local clubs across the nation, the pandemic has seen a falling roll of available players.

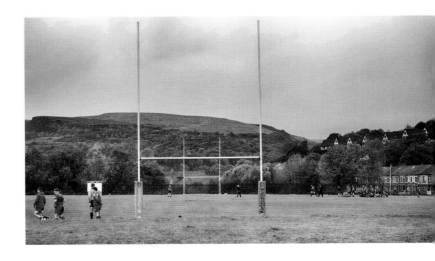

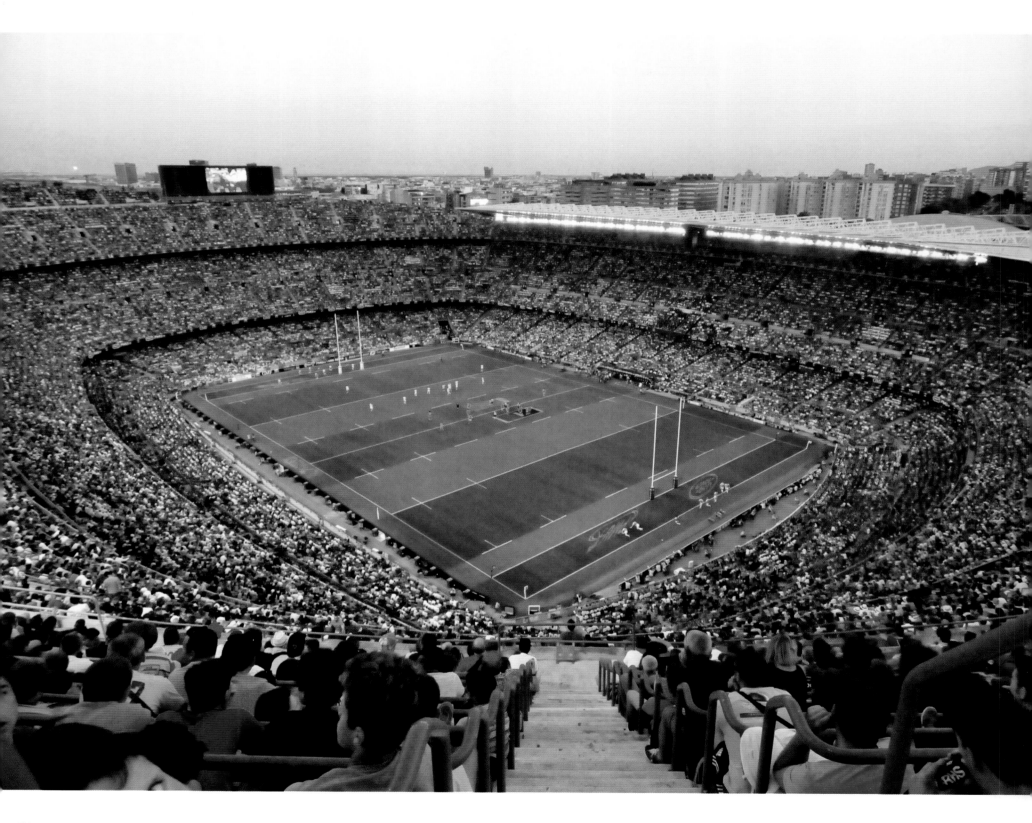

They Also Play Rugby Here

Barcelona, Milan, Los Angeles

Firstly, a disclaimer: as we're sure you're aware, none of these venues could be called rugby grounds. Along with other famous venues like Croke Park, Wembley and Soldier Field each one has hosted rugby matches and each is remarkable in its own way.

Barcelona's Camp Nou opened in 1957 and would become a safe haven for the Catalans to speak in their own language, which had been banned under General Franco's regime. In 2016, with France preparing to host the UEFA European Championships, the French Rugby Federation moved the Top 14 final between Racing 92 and Toulon to Barcelona. Supporters for both clubs travelled in large numbers – especially Toulon – and the attendance was 99,124, a world record for a club rugby match.

In a similar vein, only one top-level rugby game has been held at the Giuseppe Meazza Stadium aka the San Siro in Milan, and also attracted a full house of 80,000 when Italy entertained the All Blacks in 2009. New Zealand hadn't played in Italy until 1977 and has only visited sporadically since then. So any match involving the All Blacks becomes the hottest ticket in town.

The stadium was built in 1925 and was modelled on English grounds that were built specifically for football and, therefore, didn't have a running track. That All Black game sparked a debate about whether Italy should play more games outside of Rome, but the chances of another contest being held at the San Siro are slim, at least in its current guise. The ground will be demolished after the 2026 Winter Olympics and replaced with a new arena said to be more in the style of the Mercedes-Benz Stadium in Atlanta.

The Los Angeles Memorial Coliseum is one of the most recognisable stadiums in the world. Commissioned in 1921, it was completed in 1923 as a memorial to Los Angeles veterans of World War I. By 2028 it will have become the only venue to have hosted the summer Olympics on three occasions, including 1932 and 1984.

In 2021, this became the home of the short-lived Major League Rugby team LA Giltinis. The *Los Angeles Times* sent photojournalist, Luis Sinco, along to cover a game, having never previously seen a rugby match. 'My main takeaway: Rugby is a jolly good spectacle,' he wrote. 'Big guys crashing into each other without much body protection makes for interesting, Romanesque amusement. Maybe the next league franchise should be called The Neros.'

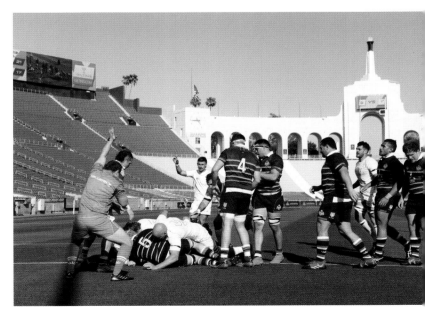

OPPOSITE: Barcelona's Camp Nou filled to capacity for the 2016 Top 14 Final.

ABOVE RIGHT: Milan's San Siro Stadium welcomed the All Blacks in 2009.

RIGHT: The LA Giltinis take on the New England Free Jacks in Los Angeles in 2021.

Stadio Flaminio

Rome, Italy

The 'Keeping It Modern' project was founded in 2014 by the Getty Foundation to preserve notable works of modern architecture. An eclectic mix of buildings around the world have received a grant from the project, including the foundation Cultural Heritage without Borders in Sarajevo, the Engineering Building at the University of Leicester and, yes, the Stadio Flaminio in Rome.

From 2000 to 2011 this was the home of Italian rugby until it hosted its last game when Wales beat Italy 24-16, by which stage the ground no longer suited Italian ambitions — with a capacity of 32,000 it was the smallest of the Six Nations venues by almost 20,000. By the time Italy left, to play at the Stadio Olimpico, less than two miles away, the old ground had turned into the site of an archaeological dig. Shortly before that final game, traces of a burial ground which held 50 tombs from the first century BC had been found close to one of the entrances into the Flaminio.

Whether, as one archaeologist suggested, the man who designed the stadium knew about the burial ground and decided to carry on regardless remains a matter of conjecture. Stadio Flaminio was built for the 1960 Rome Olympics on a site that had previously been the national stadium, and is still considered to be one of the most significant works in the canon of architect Pier Luigi Nervi, whose other credits include the UNESCO headquarters in Paris. Not only could

it host football and rugby matches but also had four gyms built into the complex along with an indoor swimming pool that could be found under the East Stand.

But by 2012, the ground had been decommissioned and left to decay. Then, in 2018, Keeping It Modern managed to secure listed status for the Stadio Flaminio. However new legislation introduced in 2020 means that the ground isn't necessarily safe from being bulldozed.

In recent years it has become an annual event for somebody to step forward with a plan to redevelop the ground followed by silence. The game in Italy is in rude health, but the Stadio Olimpico is a frustrating place to watch rugby — a 'curate's egg' of a ground that is wonderful on the outside but underwhelming on the inside. When one of those plans to rebuild the Stadio Flaminio becomes a reality, then fans would welcome a return to their old home.

OPPOSITE: Three photos of a deteriorating Stadio Flaminio, left to the graffiti artists while politicians and interest groups haggle over its future.

RIGHT: Two images from Stadio Flaminio on a bright spring day ahead of a Six Nations match.

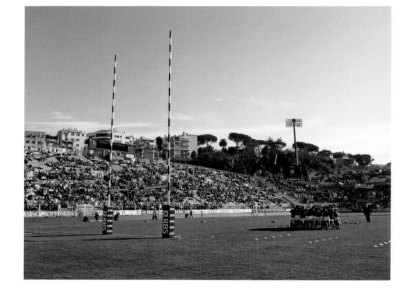

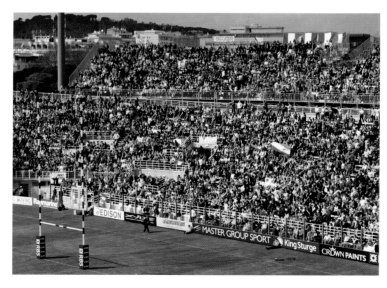

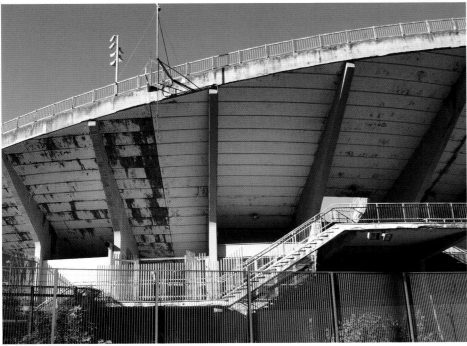

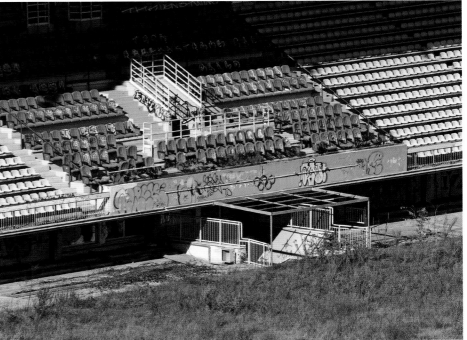

Index

Picture Credits

Kevin Rudge lives in Ystrad Mynach, near Caerphilly, and is the official photographer for Pontypridd RFC. He has been photographing club rugby since 2017 and regularly travels to games in the Indigo Group Welsh Premiership. He has also photographed women's rugby for *Rugby Journal*. He played for his school, Monmouth RFC, and during his time in the Royal Navy. His last game was played in Sharjah,UAE, whilst serving on HMS *Andromeda*, a Leander class frigate on patrol during the first Gulf War. His photography appears with the credit Cwm Calon and often his major challenge is keeping his camera dry.

Conor Doherty studied Film & Media Studies in college before setting up his own business CONDOH Photography (www. condohphoto.com). Telling stories through images has been his passion as long as he can remember. Based in County Sligo on the west coast of Ireland, he's spent the last 10 years working in commercial, event and wedding photography, alongside his interest in photographing the incredible landscapes of Ireland.

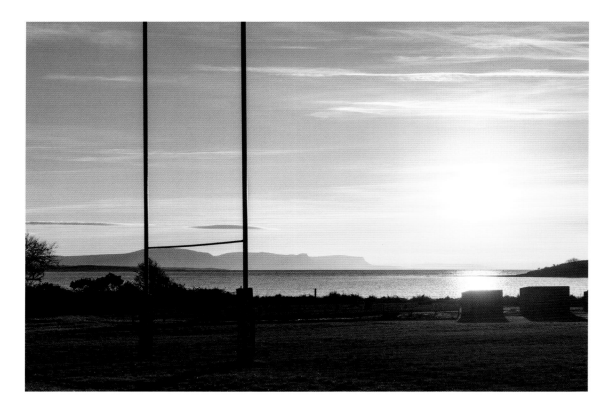